PREPPY

CULTIVATING IVY STYLE

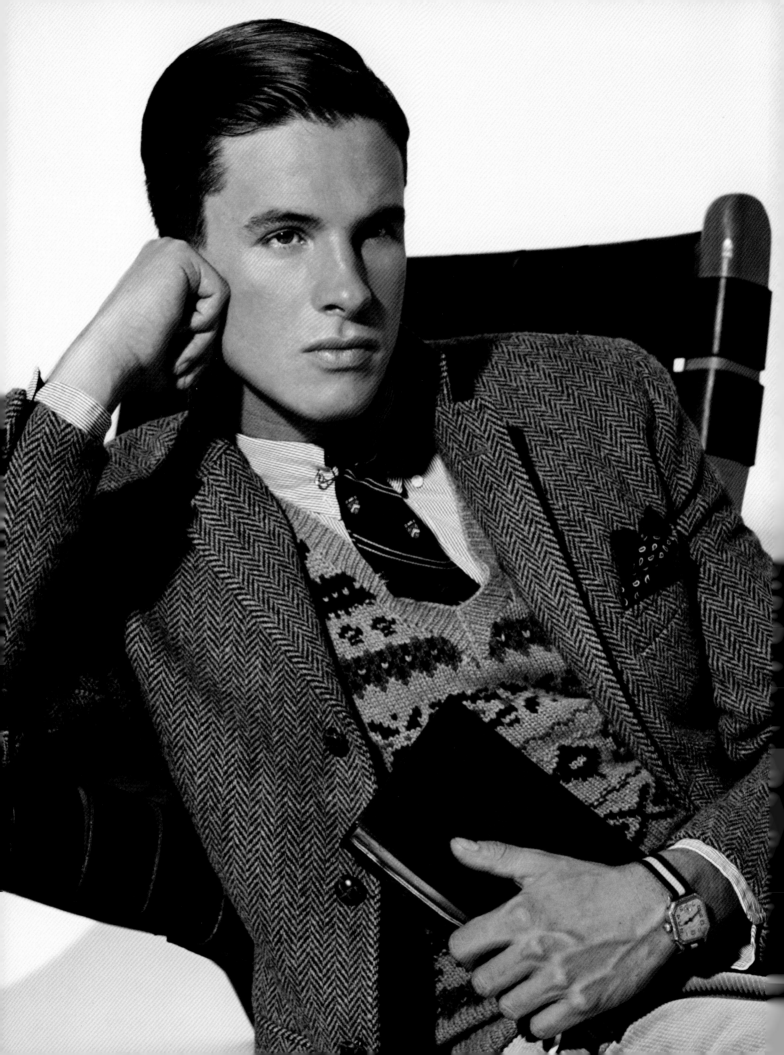

PREPPY

CULTIVATING IVY STYLE

JEFFREY BANKS AND
DORIA DE LA CHAPELLE

New York · Paris · London · Milan

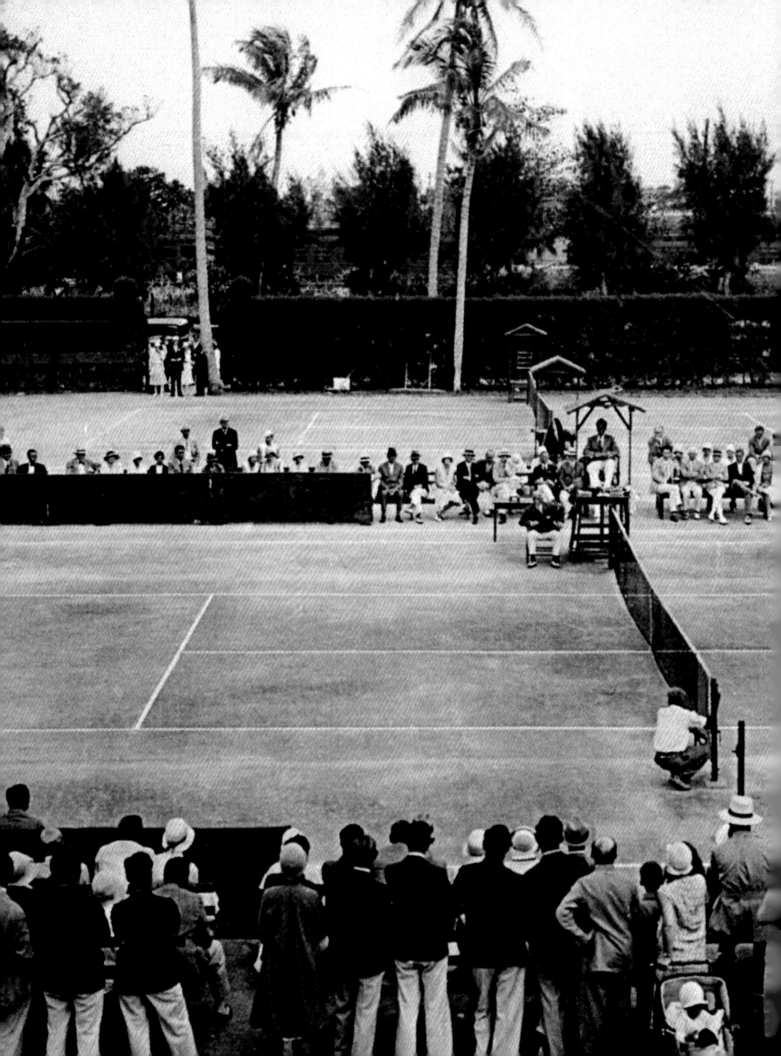

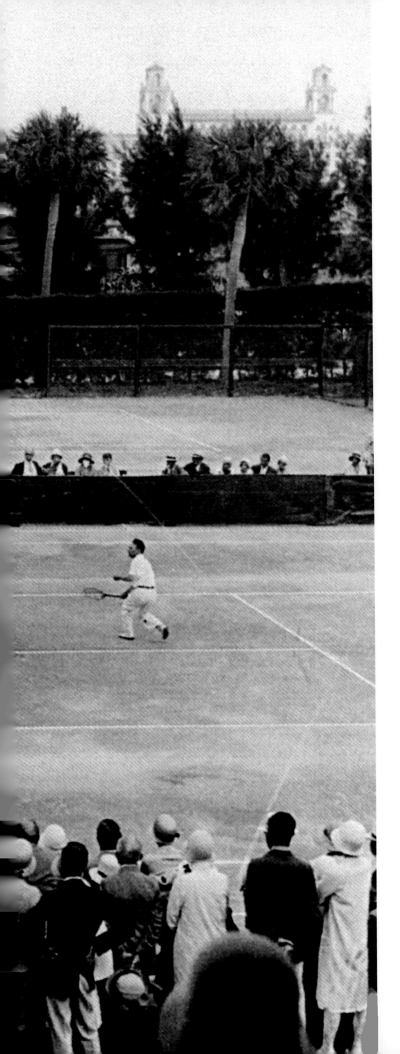

CONTENTS

FOREWORD 1
by Lilly Pulitzer

INTRODUCTION:
A PREPPY'S PROGRESS 2

THE "GOOD-BREEDING"
GROUNDS 28

LEGACY OF THE
SPORTSMAN AND
THE LEISURE CLASS 44

PURVEYORS TO
THE PRIVILEGED 66

BORROWING
FROM THE BOYS 86

ASPIRATIONAL
PREPPY 108

EVOLVED IVY 132

ENDNOTES 162

PHOTO CREDITS 165

ONLINE PREP 166

ACKNOWLEDGEMENTS 168

LEFT:

Tennis at The Breakers, Palm Beach, ca. 1920.

FOREWORD *by Lilly Pulitzer*

I am a bit surprised when people ask me about fashion because I always think fashion is the last thing I'd know about. I plan on learning a thing or two from *Preppy: Cultivating Ivy Style,* and I am delighted to be included in its pages.

While I don't believe I know much about "fashion," I do have some ideas about clothes and on how to dress. Fashion should be easy. It should be comfortable, and it should fit the way you live. Since I have primarily lived in resort locations like Palm Beach, I work with cottons in bright, cheerful colors. When I first began designing clothes, I was working at an orange juice bar, so I liked practical clothes and prints that hid stains (like orange juice). Thus, my style evolved out of what seemed sensible, cheerful, and easy for me. The first people who wore my clothes were my friends who appreciated the way my clothes looked and worked for me, and, with their encouragement, I kept making more clothes and loved every minute of it.

My style philosophy is simple: if the clothes fit the way you live, then they'll be stylish in a way that becomes you. Most importantly, clothes should work for you, which is the first reason I got into business. For a long time now, my clothes have officially been classified as preppy. I admit that a lot of my friends probably went to some prep school along the way, but I never thought of them, or my clothes, as preppy. I am delighted that my clothes are timeless enough to be worn by several generations in a family at the same time! I am also proud that my clothes are practical and made of natural fabrics that look and wear well over time—an idea that is still modern and meaningful to the way we live within the environment. If my clothes fit some way into preppy style, I hope it is because they succeed at what I started out to do: to make attractive clothes that are easy to wear and fit the way we live in the modern world. I am grateful to Jeffrey and Doria for including me in their beautiful book.

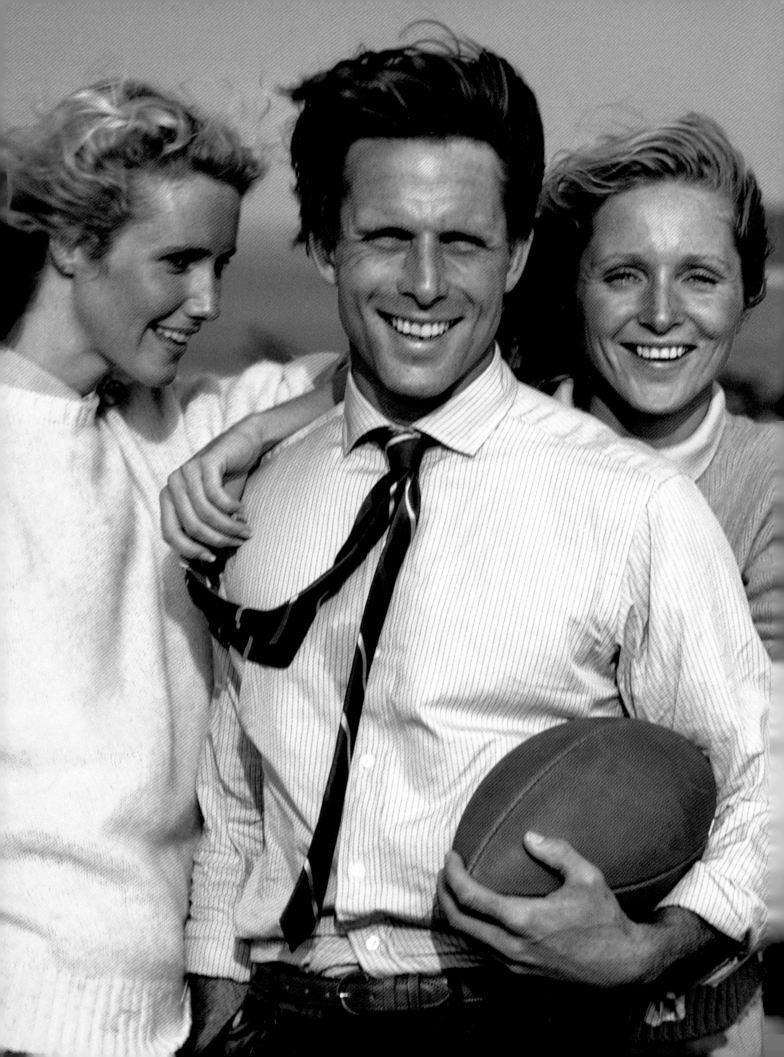

INTRODUCTION:
A PREPPY'S PROGRESS

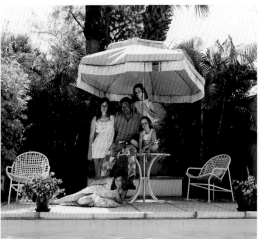

The windswept and privileged style known as Preppy has always been acknowledged as an inherently American phenomenon, a fashion—or anti- fashion as some have called it—whose imagery perpetually connects us to idyllic college days, sport, and the spirit and vitality of youth. Preppy's origins are rooted in the grounds of the elite Ivy-League universities of the 1920s, where young, WASPy, and wealthy gentlemen invented a relaxed new way for collegians to dress by co-opting athletic clothes from the playing fields, mixing them with genteel classics, and decking themselves out with caps, ties, pins, and other regalia to signify membership in a prestigious club or sport. They then embellished the look with the best possible accessory: an air of complete and utter nonchalance.

OPPOSITE:

The essence of prep: touch football, tie askew, windblown hair, and winning smiles. Ralph Lauren collection, 1980.

ABOVE LEFT:

The men's Ivy League look wasn't lost on the ladies. By the early 1950s the same Brooks Shetland crew-neck sweaters guys wore on eastern college campuses were co-opted by the girls—albeit sometimes with rounded collars and circle pins.

ABOVE RIGHT:

Prize Pulitzers: Palm-Beachers living the Lilly lifestyle, 1967.

Sportive, relaxed, and offhandedly elegant, the seemingly unstudied style actually belied some serious effort. Ivy-Leaguers of the 1920s were obsessed with detail: the roll of a collar, the width of a lapel, the vent of a jacket, and the vital question of whether a shirt cuff should possess one button or two, and a sport coat two buttons or three—quirky little elements that helped form the preppy canon. The clothing details were made out to be of such consequence that we find Princeton alum, F. Scott Fitzgerald, still fretting over them in his first novel *This Side of Paradise,* written shortly after he left college. In the elite, insular, and often snobbish collegiate world, one's identity *was* in the details: what a man wore, how his tie was tied, where his hair was parted and what club he joined were of paramount importance. Among the reasons behind Ivy League style's resounding popularity with college students was the immense peer pressure to conform and its close relative, the deep need to belong.

While the world and fashion itself has changed beyond recognition in the near-century since the youthful style emerged, buoyant and boyish Preppy has remained stalwartly the same, straying only a little from the "ironic blend of rumpled and conservative"[1] look it established in the 1920s. But recently, Preppy has begun to enjoy a major breakthrough, morphing into a hip style for both men and women—a closer

cousin to the slim, refined Ivy League clothes of the '50s and '60s than the pumped up "prep-on-steroids" that defined the '80s. The reasons seem clear: what better response to the excesses of the previous decade and the economics of the present than the sharp good looks of blazers and button-downs, Fair-Isle sweaters, or skinny ties and sleek Ivy League suits? Preppy is a grounding force, a reminder of the security and

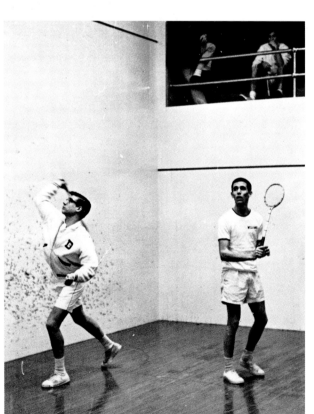

LEFT:
Squash courts at Deerfield Academy, 1961.

OPPOSITE:
Groton School students, 1966-67.

FOLLOWING PAGES:
Madras men: part of the Deerfield Academy graduating class of 1961 in their guaranteed-to-bleed madras jackets—a sweeping Ivy trend in the late 1950s–early '60s.

4

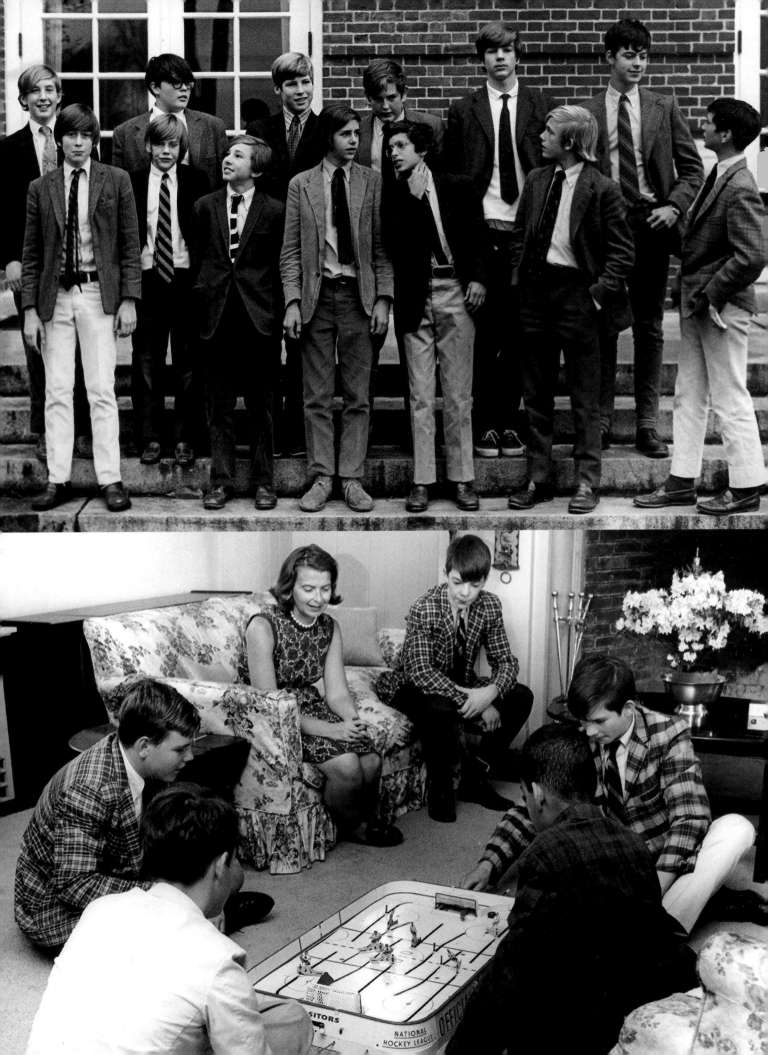

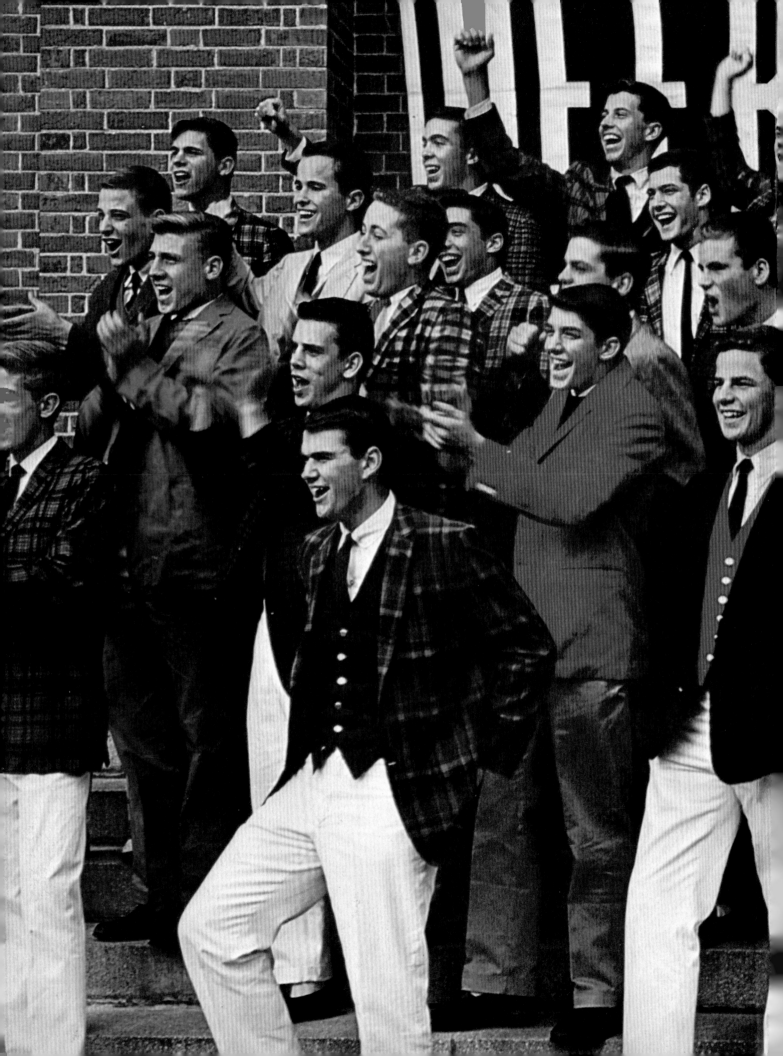

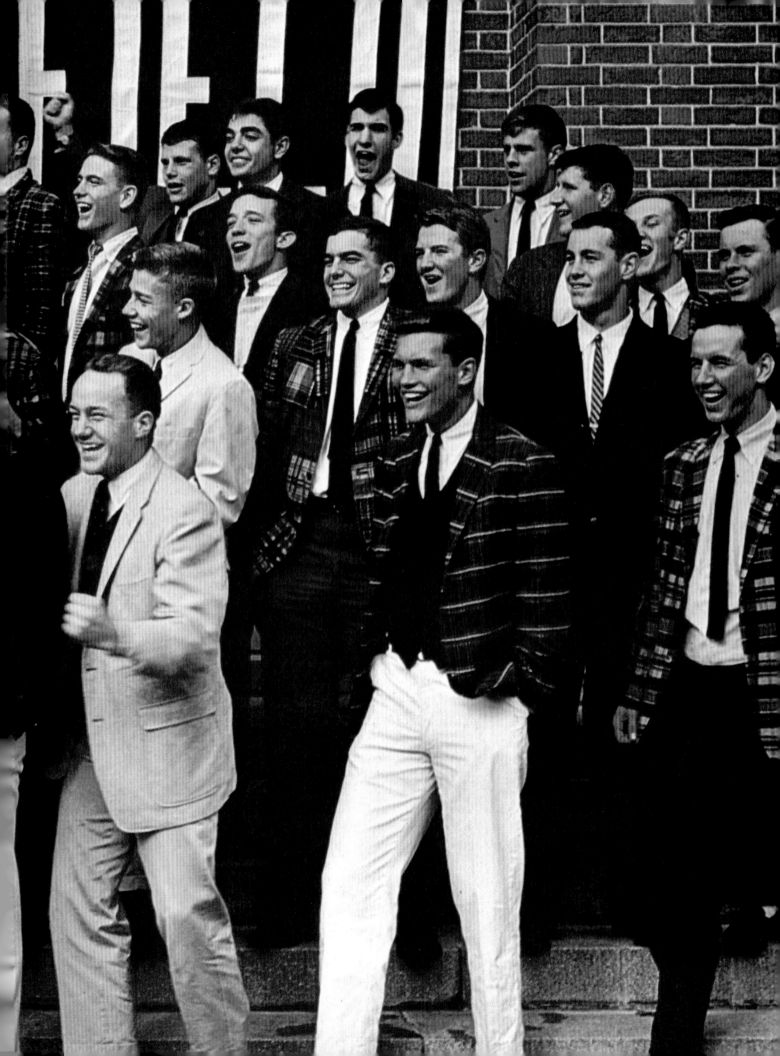

8

BELOW:

Maybe the ankle really IS the new erogenous zone—skull and cross-bone embroidered corduroys high over sockless loafers.

RIGHT:

Moonlight on the snowy campus of Princeton.

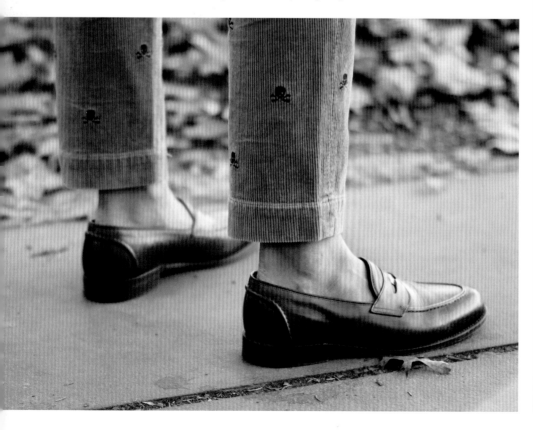

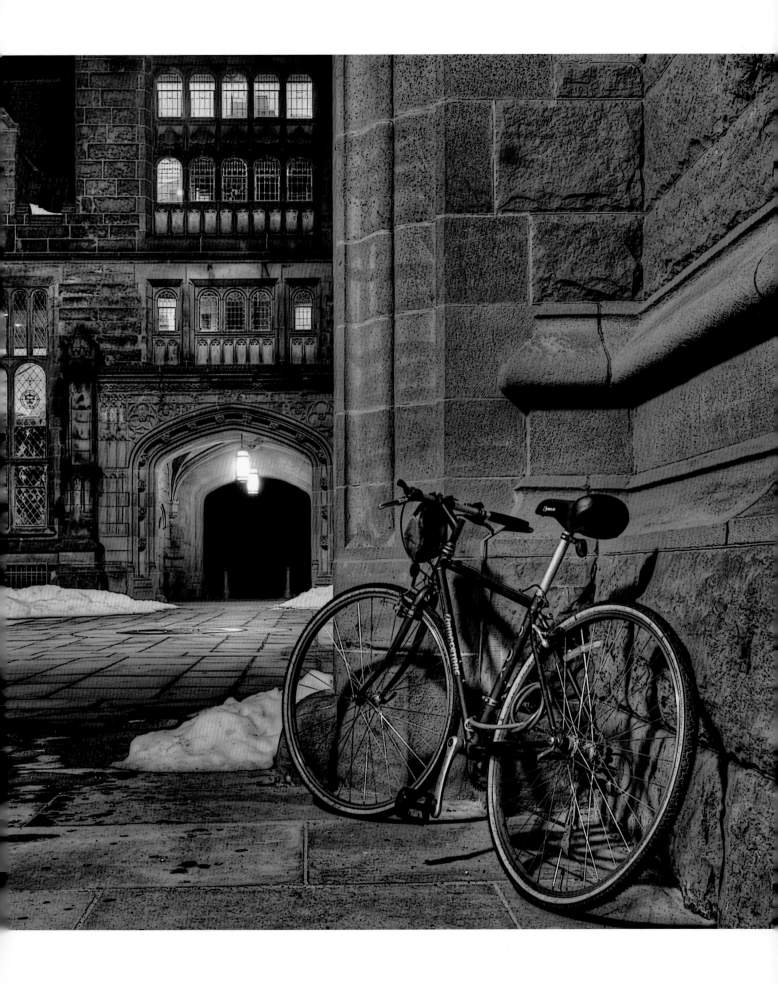

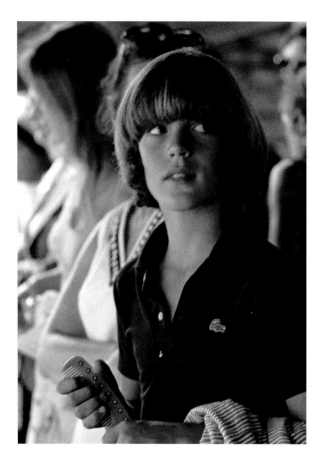

ABOVE:
John Kennedy, Jr. sporting a Lacoste polo shirt, at a tennis match played to raise funds for the Robert Kennedy Foundation, 1972.

OPPOSITE:
Equestrienne First Lady Jacqueline Kennedy at the Piedmont Foxhounds Races. Upperville, Virginia, 1961.

propriety of old-school ties, and a platform for the appealing irreverence of the young. Unlike "of-the-minute" runway fashion, preppy doesn't have a "sell-by" date but can be blended into wardrobe indefinitely—a concept near and dear to the hearts of the thrifty, WASP Ivy-Leaguers who pioneered the look. And beyond the conservatism, there is a boatload of persuasive arguments warranting the return of prep. Its attitude is full of insouciant schoolboy/schoolgirl charm, even if the schoolboy is celebrating his 20th college reunion. Preppy always exudes self-confidence and good breeding; its uncomplicated lines and fresh colors are easy to wear and don't require the style savvy of a Rachel Zoe or Joe Zee to put them together.

And fueling it's soaring popularity, preppy has gone global, gaining a new layer of sophistication as large classic brands woo a hipper clientele. Young black designers have experimented with new proportions. The Japanese, who have been devotees of Ivy League fashion since the 1950s, have influenced the direction of preppy by giving it a post-modern point of view, initiating some of the trends taking root today, like the revitalization of good, old American heritage brands, such as Woolrich or Gant. Even the venerable L.L.Bean has emerged from the Maine woods to start a designer collection. Of course, you can still buy Bean's durable duck boots, but preppy designer Tommy Hilfiger has offered another option: Hilfiger has "re-booted" the classic duck boot, adding five inch heels to elevate the waterproof old stand-by to new fashion heights—like the runway.

Americans have always had a longstanding tradition of preppy role-models—actors, athletes, or social swells who were often photographed in their own sporting clothes—to inspire us with their "bred-in the-bone" American class, well before the actual word "preppy" was coined: Connecticut Yankee Katherine Hepburn showed

off her style on the golf links in an argyle sweater and tweed skirt (*p. 57*); hugely rich, eccentric aviator and businessman Howard Hughes, whom Hepburn used to date, sported natty golf-knickers (*p. 56*); Philadelphian Grace Kelly looked like American royalty in her cashmere twin-set even before she became the real-life Princess of Monaco. All of them, in their own graceful lives, lent authenticity and background to the style. So did Jacqueline Kennedy Onassis, whose hacking jackets, pearls, and simple, body-skimming shifts look as right—and subtly preppy today—as when she wore them almost fifty years ago. And perhaps most memorably, the young President John F. Kennedy, sailing off Hyannis Port, his sun-streaked hair, oxford button-down shirttails, and rolled-up khakis all catching in the wind, endowing preppy style with a nonchalance and cool that imprinted our souls.

Now, in the second decade of the new millennium, the evolution of preppy style—whether straight-up and traditional or tweaked and served with a twist—is being discussed for different reasons. In an article for *The New York Times*, written on the eve of the confirmation of Elena Kagan as a Supreme Court Justice in June 2010, Noah Feldman paid tribute to the old "Protestant elite" for "hewing to their values of merit and inclusion…which 50 years ago eventually persuaded our great Ivy universities to open admissions to urban ethnic minorities and women." Feldman adds, "this era of inclusion was accompanied by a corresponding diffusion of the distinctive fashion (or anti-fashion) of the Protestant elite class…the style now generically called 'prep.'"[2]

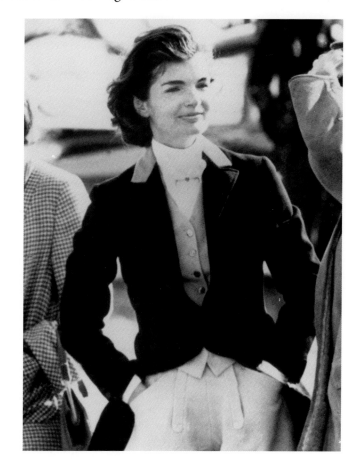

Intrinsically American, preppy has indeed progressed, reflecting, in its way, the social and educational progress our country has achieved. What started out as an exclusive, white-Protestant, male, clubby way of dressing for the Elite Few has morphed into an inclusive, multi-racial, multi-ethnic, multi-religious, pan-gender, meritocratic way of dressing for the Elite New. Aspirational preppy is the American dream, and it speaks eloquently for us all over the globe.

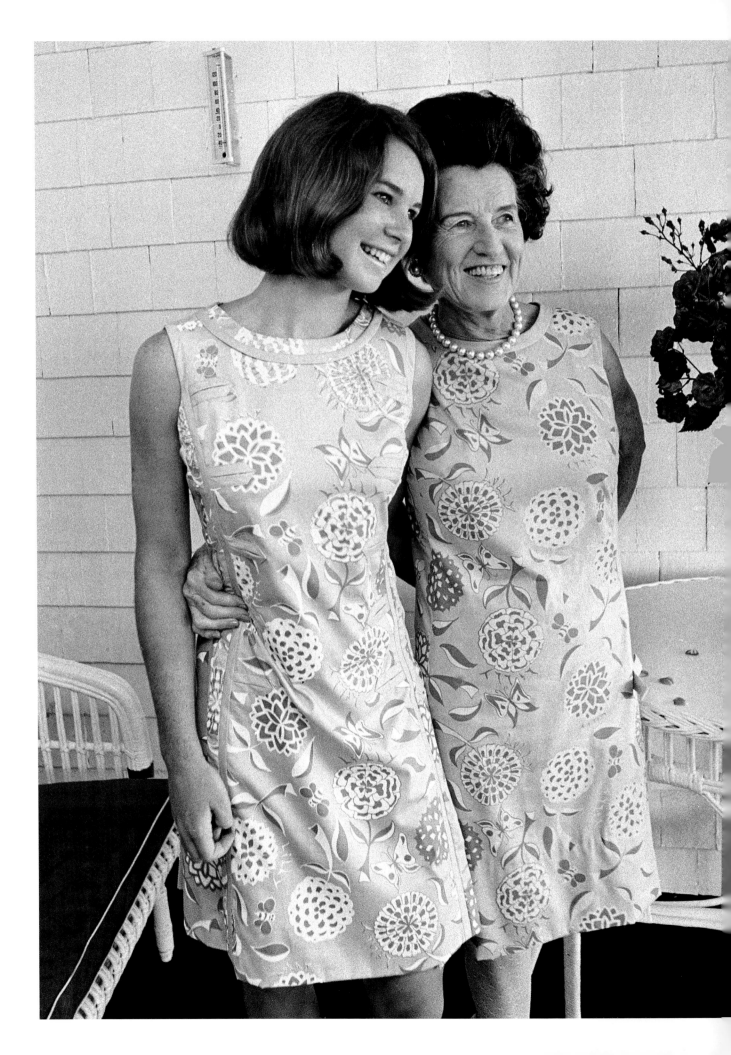

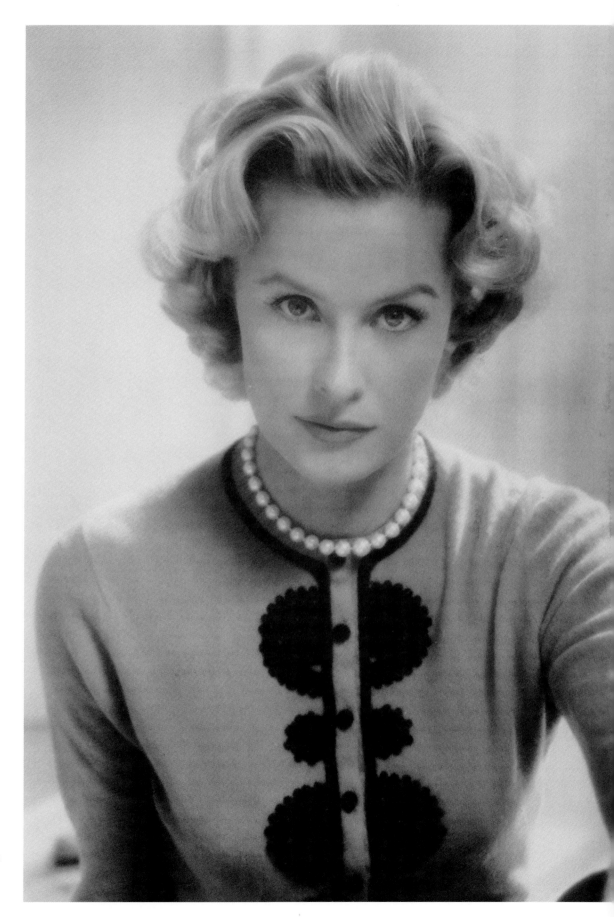

OPPOSITE:
All in the family…
Rose Kennedy and
her grand-daughter,
Kathleen Kennedy,
in matching Pulitzer
shifts: proof that
Lillys look lovely on
all generations.

RIGHT:
Cardi and pearls:
Patrician actress
Dina Merrill in an
embroidered cashmere
cardigan, an elegant
emblem of the 1950s.

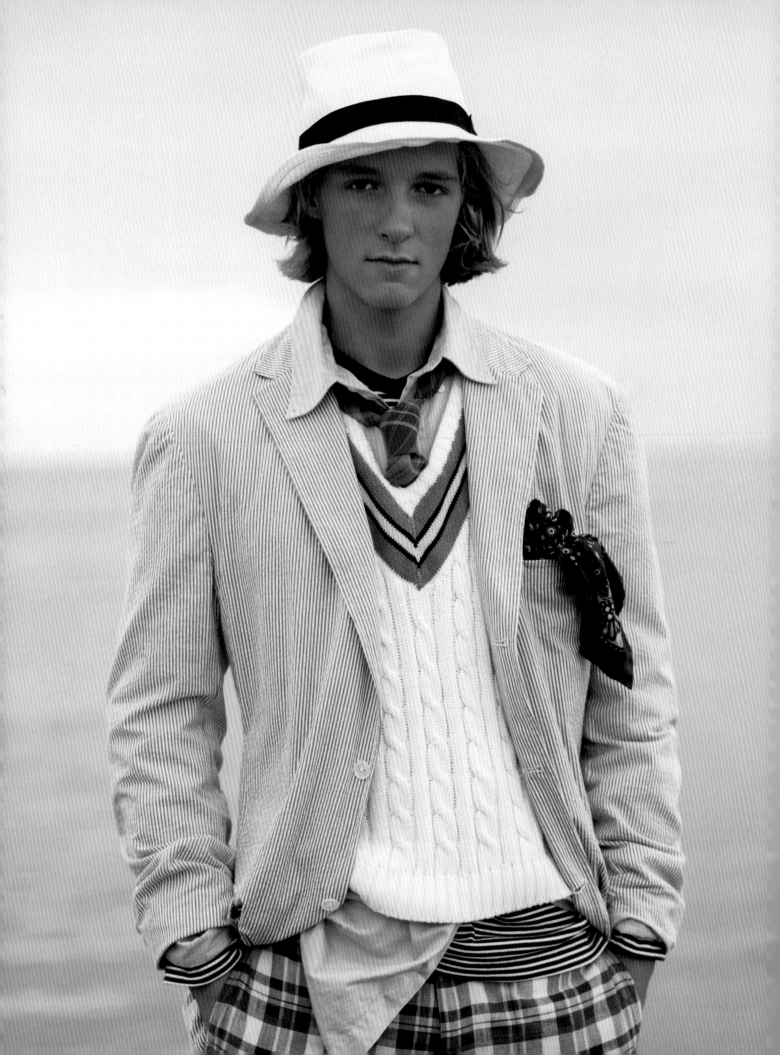

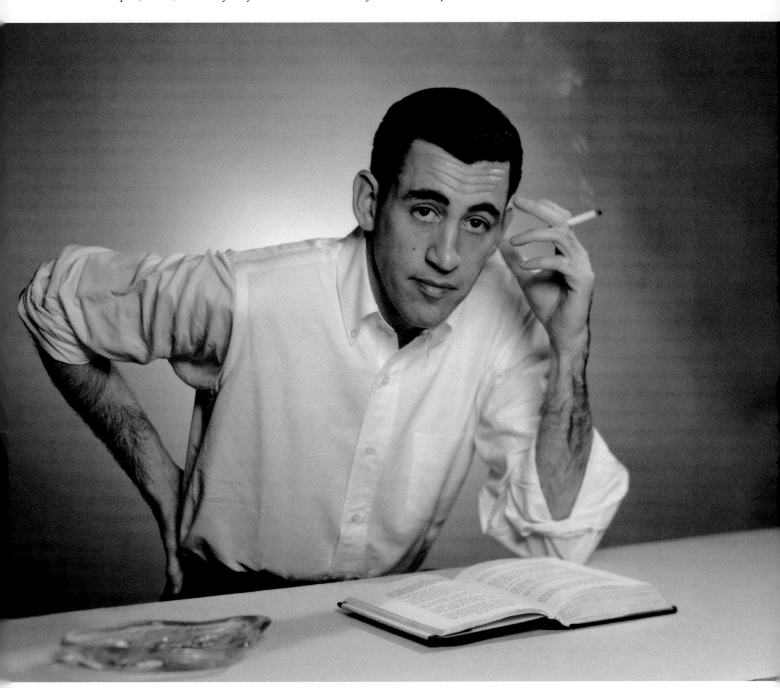

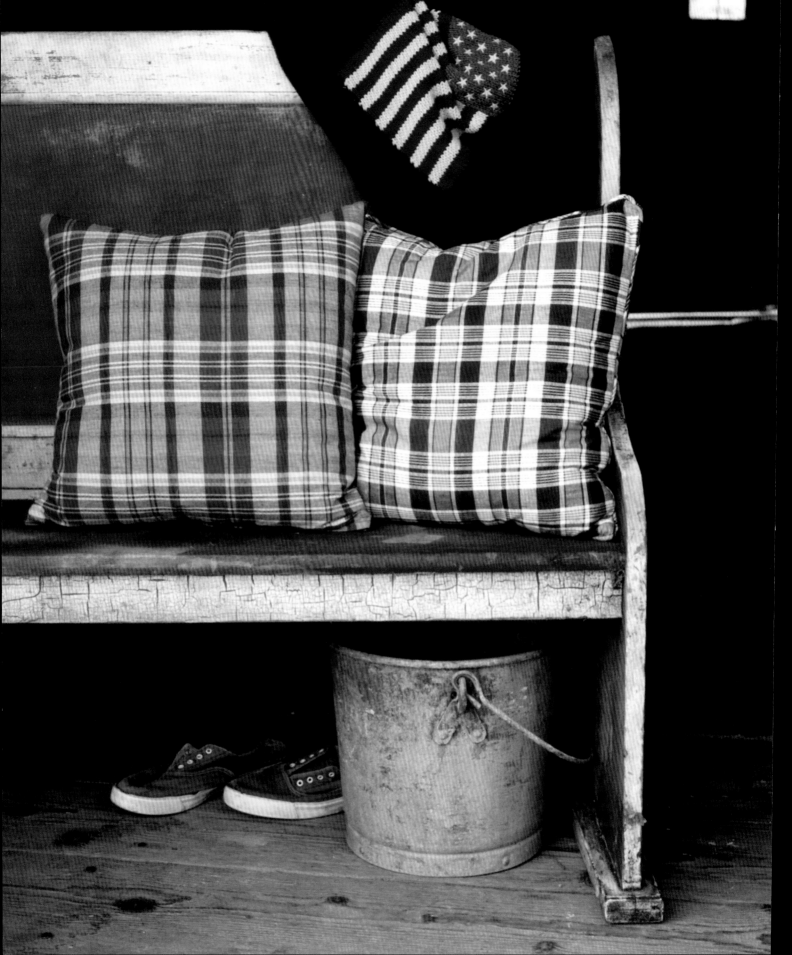

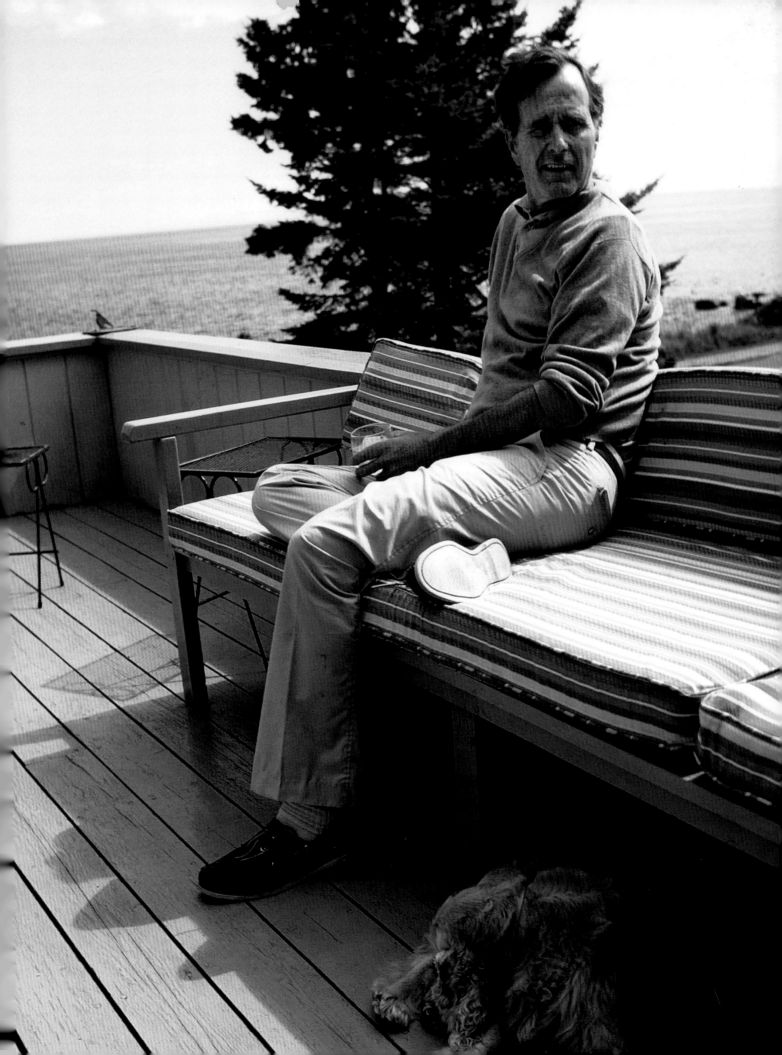

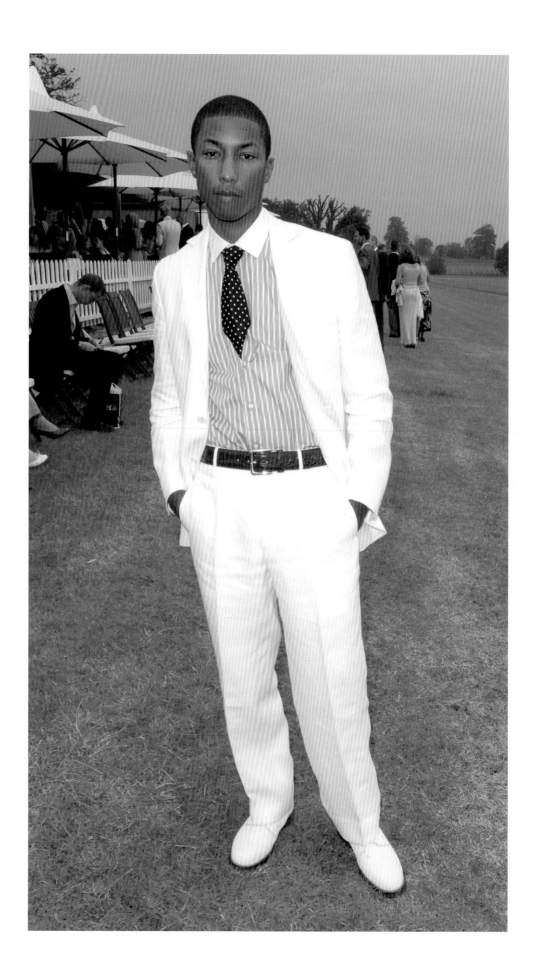

*Pharrell Williams, rapper,
songwriter, and producer
sporting his preppiest look at the
Audi Challenge Polo Match, in
Midhurst, England, 2006.*

OPPOSITE:

*The Fairbanks on the fairway:
American matinee idol Douglas
Fairbanks and his film star son
Douglas Fairbanks Jr. on the golf
course, 1930.*

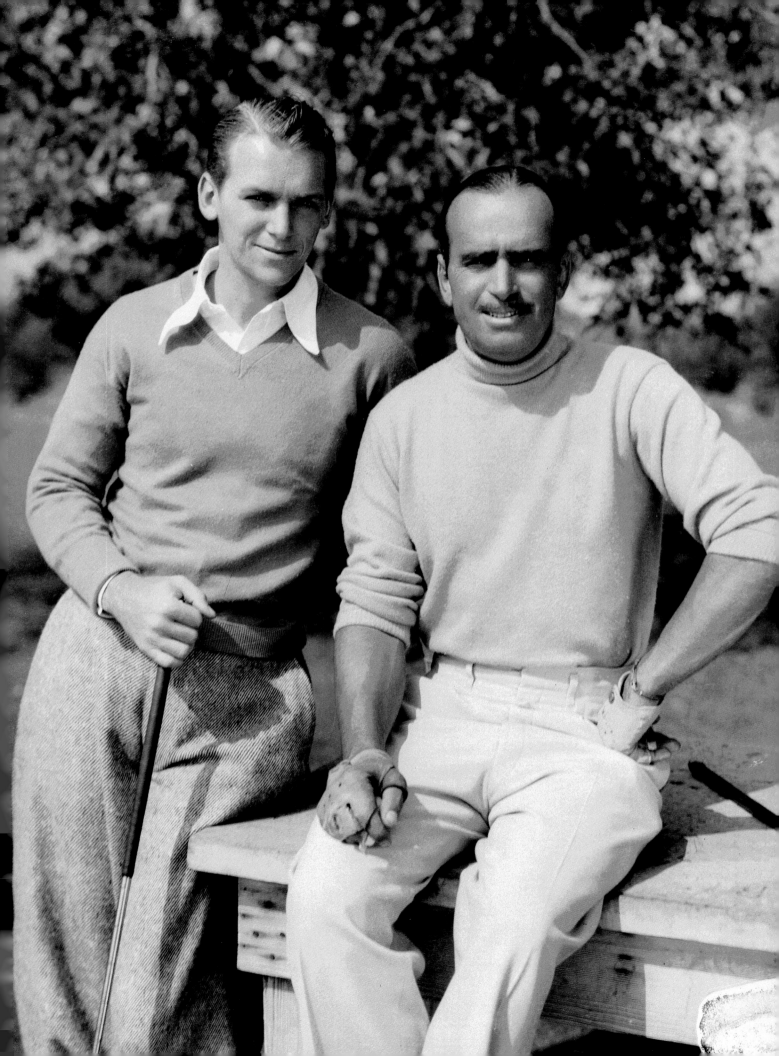

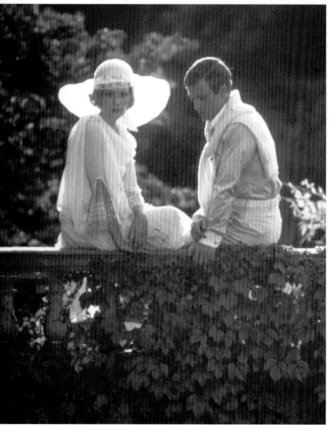

In the movie Love Story, working class Radcliffe girl, Ali MacGraw, called her wealthy Harvard boyfriend, Ryan O'Neal, "Preppy," launching the word into common parlance.

Daisy and Gatsby in summer whites: Actors Mia Farrow and Robert Redford are the leads in the 1974 movie version of The Great Gatsby, from the novel by F. Scott Fitzgerald, for which Ralph Lauren designed the period costumes.

The Royal Tenenbaums (2001), starring Luke Wilson, Gwyneth Paltrow, Gene Hackman, Ben Stiller, Angelica Huston, and Danny Glover, is said to be the inspiration for Tommy Hilfiger's Fall 2010 "The Hilfigers" advertising campaign, with its dysfunctional but hilarious family. It is believed The Royal Tenenbaums itself, was, in turn, inspired by J.D.Salinger's "The Glass Family Stories." If that is true, then Franny of Franny and Zooey might be considered a distant cousin of Chloe, youngest of "The Hilfigers" (sort of).

Tommy Hilfiger's fashionably preppy, slightly dysfunctional, multi-ethnic, fictional and fun family advertising campaign, complete with tailgating in the woodie station wagon. Fall, 2010.

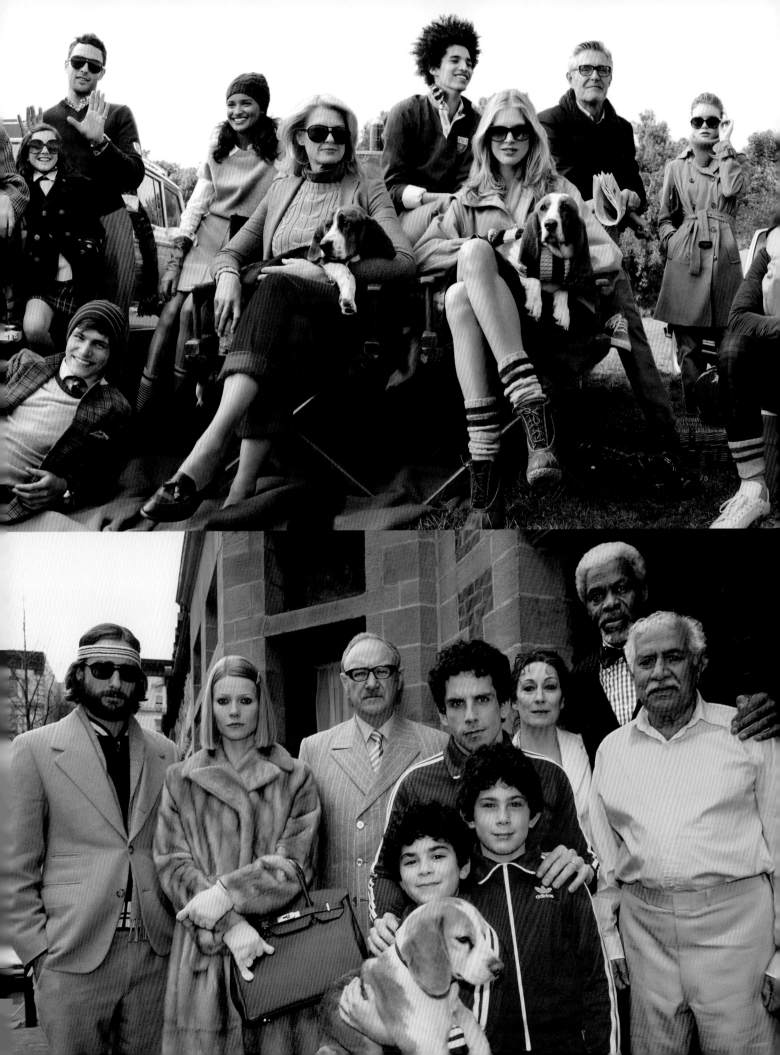

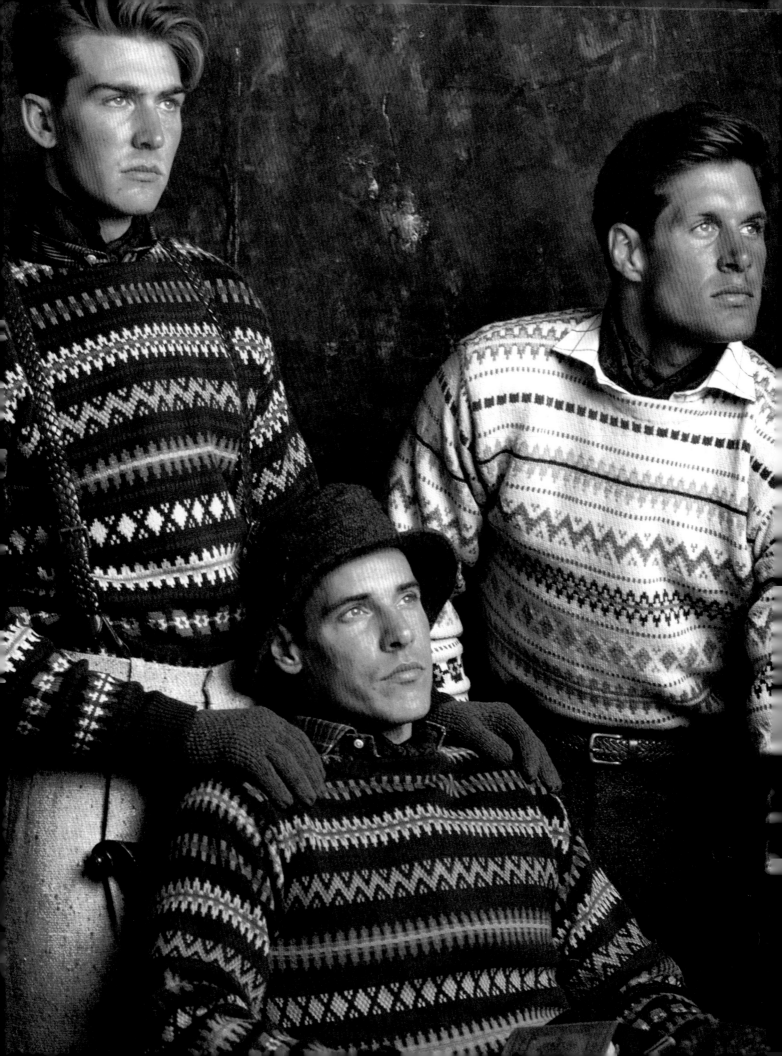

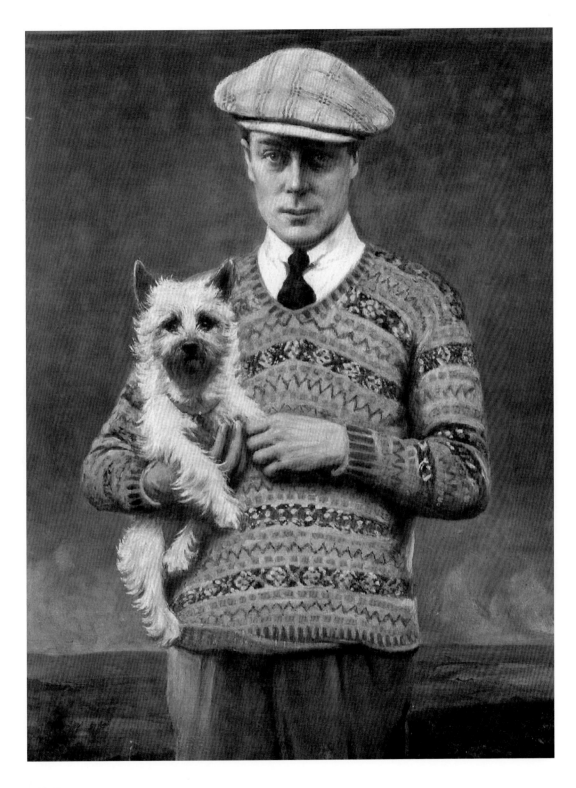

ABOVE:

The Prince of Wales revived a small island's entire economy when he sported Fair-Isle sweaters on the links. Pictured here, at Royal St. George's golf course, for the Walker Cup, 1930.

LEFT:

Fairest of the Fair Isles: Jeffrey Banks' patterned sweaters, with no two rows alike. Designed with a boat neck and knit of worsted wool for a smoother finish, 1983.

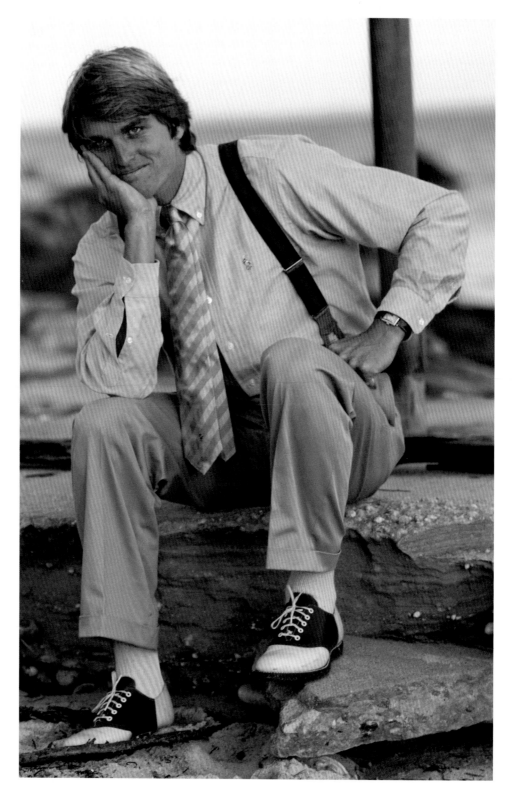

ABOVE:

Surfer Buzzy Kerbox in Polo Ralph Lauren khakis, blue shirt, and saddle shoes, 1980.

OPPOSITE:

Ralph Lauren's striped schoolboy blazers for girls in different lengths, 1989.

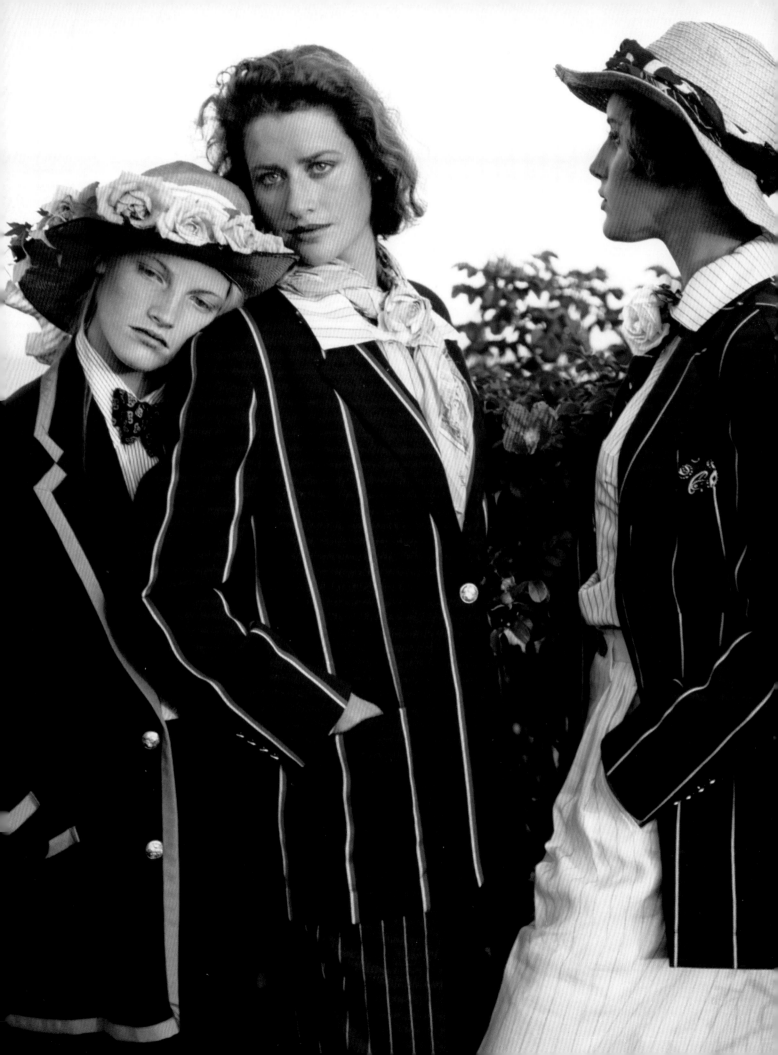

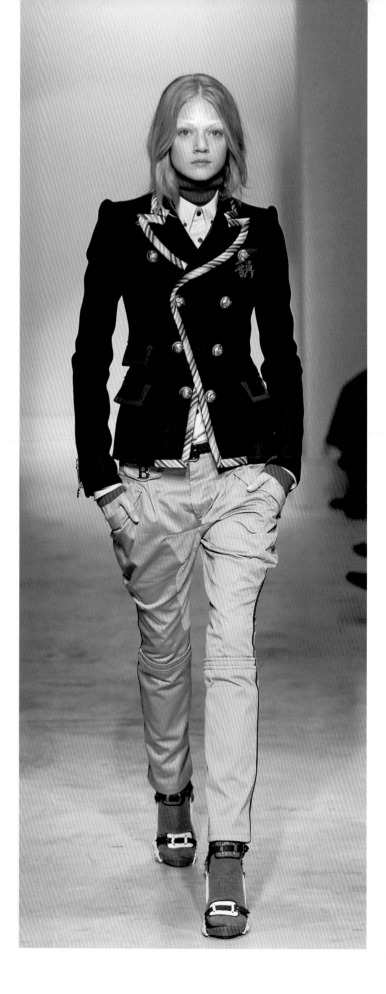

Balenciaga's slim-fit, double-breasted boy-blazer, made glam for a girl. Fall, 2007.

Seoul man: Korean prepster photographed in Dosan Park: button down shirt, repp tie, cardigan vest, and plaid jacket over narrow cotton twill pants.

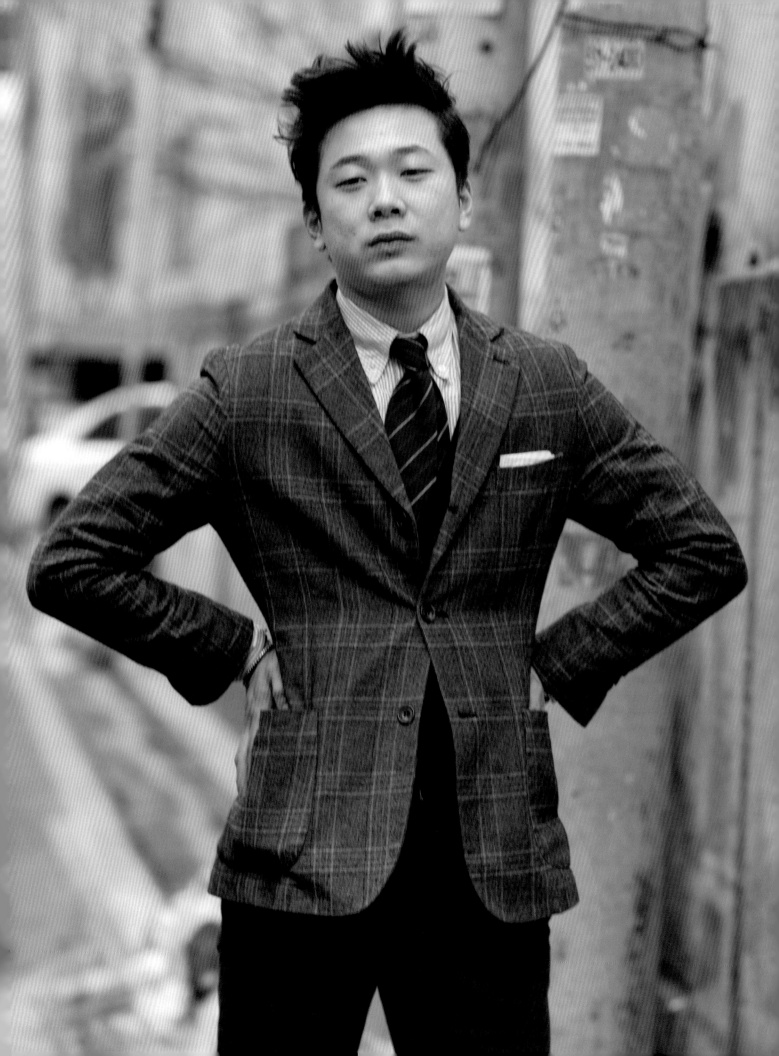

THE "GOOD-BREEDING" GROUNDS

He had acquired that particular reserve peculiar to his university, that set it off from other universities. He recognized the value to him of such a mannerism and he had adopted it; he knew that to be careless in dress and manner required more confidence than to be careful.[1]

WINTER DREAMS,
F. SCOTT FITZGERALD

I n the early decades of the twentieth century, after the first World War, American men seeking a way to define themselves, created a new ideal of style centered on an exuberant, young masculinity and a greater measure of leisure time. Nowhere was this notion cultivated more successfully—or snobbishly—than at the "good-breeding" grounds of America's elite Ivy universities, where the concept of sports-influenced clothes first took root. The cream of the East Coast's Ivies—Harvard, Yale, and especially Princeton—provided a singularly fertile environment for the growth of this athletic-inspired sportswear, a casual, nonchalant style that came to be known as "Ivy League,"[2] still recognized as distinctively American around the world.

OPPOSITE:

Artist J.C. Leyendecker's illustration for ribbed Interwoven socks, 1924.

ABOVE LEFT:

Poler's recess at Princeton, 1929. During final exam period after 9pm, students were allowed to open their dorm windows and explode fireworks, shoot blanks, blow horns, and generally let off steam for a period of ten minutes. Said to be "probably the most juvenile" of all campus customs, the recess began around the turn of the century and ended shortly before World War II.

ABOVE RIGHT:

Phillips Andover freshmen in their signature blue caps, 1951.

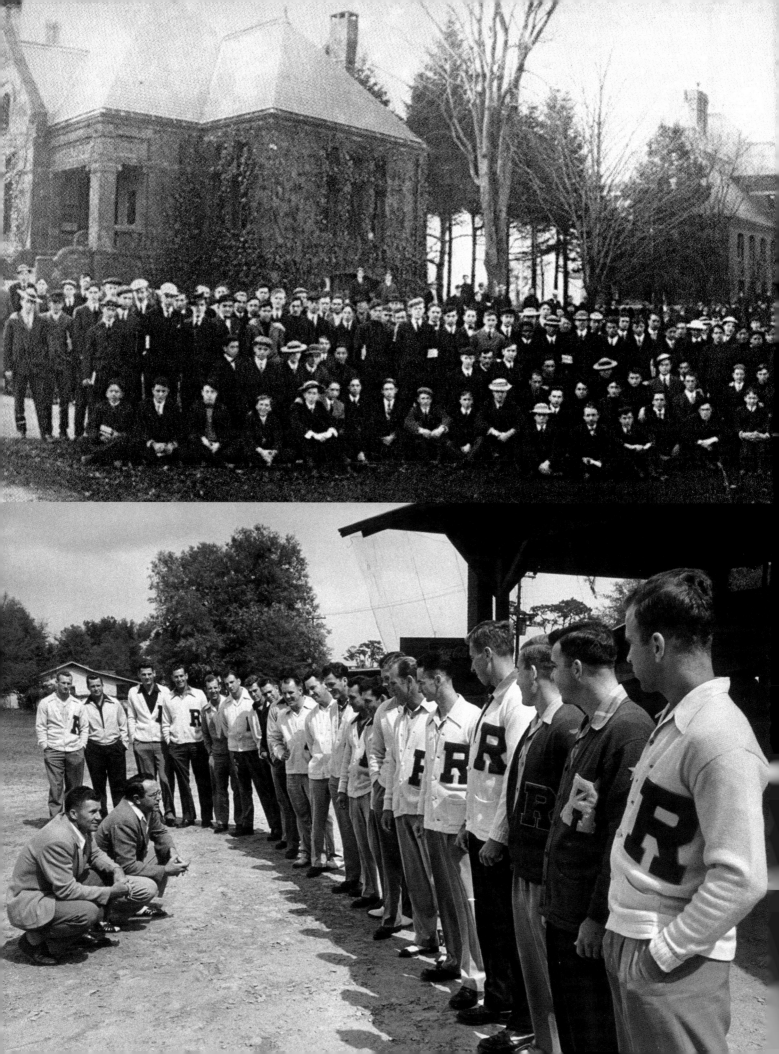

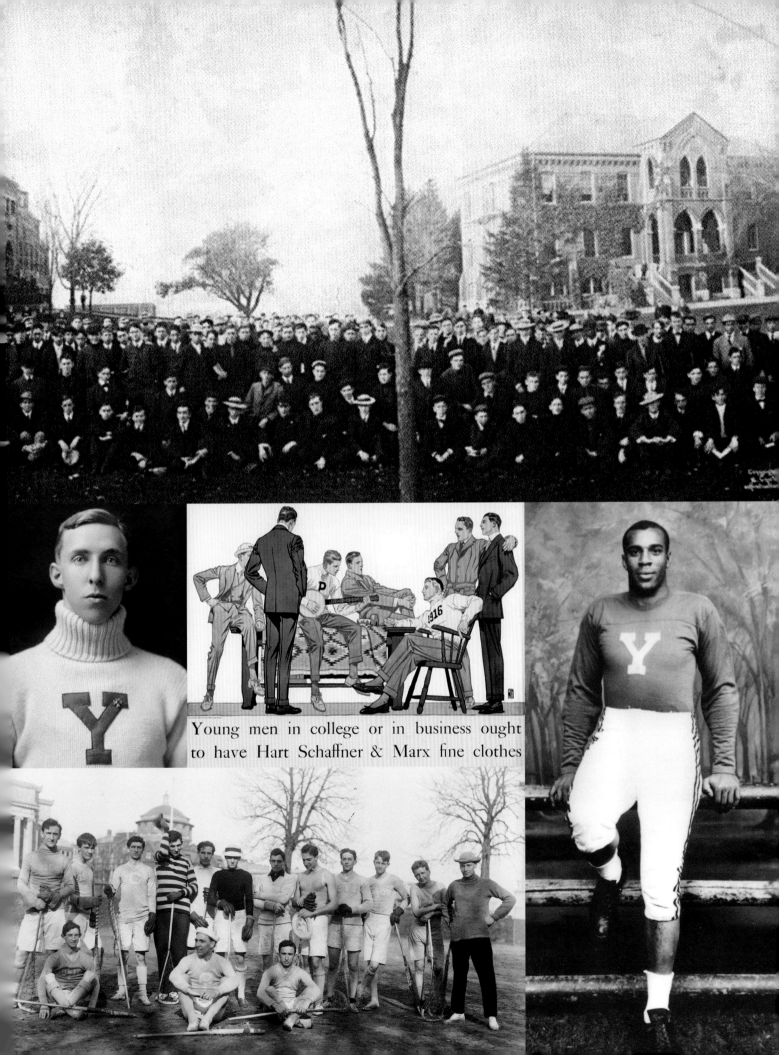

Young men in college or in business ought
to have Hart Schaffner & Marx fine clothes

Of all the elite schools, Princeton had the most propitious environment in which to foster a cohesive new campus style. The student body was largely homogeneous (WASPy and wealthy), and a majority of its students entered the university from a handful of preparatory schools, where they had already met and socialized together. Princeton's many clubs, especially its private eating clubs, encouraged a strong sense of brotherhood and loyalty among their members, who literally wore their pride on their sleeves in the form of club-related regalia, ribbons, badges, pins, hatbands and caps. These very selective clubs demanded conformity and got it: admittance to a club would often come down to the subtle details of how a man dressed.[3] Princeton's geographic location also contributed to cultivating a singular campus culture: unlike the bustling towns of Cambridge and New Haven, Princeton was bucolic and surrounded by sprawling farms, which buffered the campus from distracting urban influences. All of these elements produced a socially stratified environment where the clubs ruled and conformity was king.[4]

The writer F. Scott Fitzgerald, himself a Princetonian (class of 1917) and a member of the illustrious Cottage Club, detailed the emphasis on wearing the right stuff in his first novel, *This Side of Paradise*. Tom D'Invilliers, a friend of the protagonist, Amory Blaine, rails about his classmates' superficiality and snobbery when it comes to behavior and dress: "I want to go somewhere where people aren't barred because of the color of your necktie or the roll of your coat." Amory assures Tom that it is too late. "Wherever you go now, you will always unconsciously apply standards of 'having it' or 'lacking it.' For better or for worse, we've stamped you. You're a Princeton type."[5]

If peer pressure and clubbiness contributed to conformity on campus, the ascendance of the athletic programs at the Ivies and the rapidly emerging social status

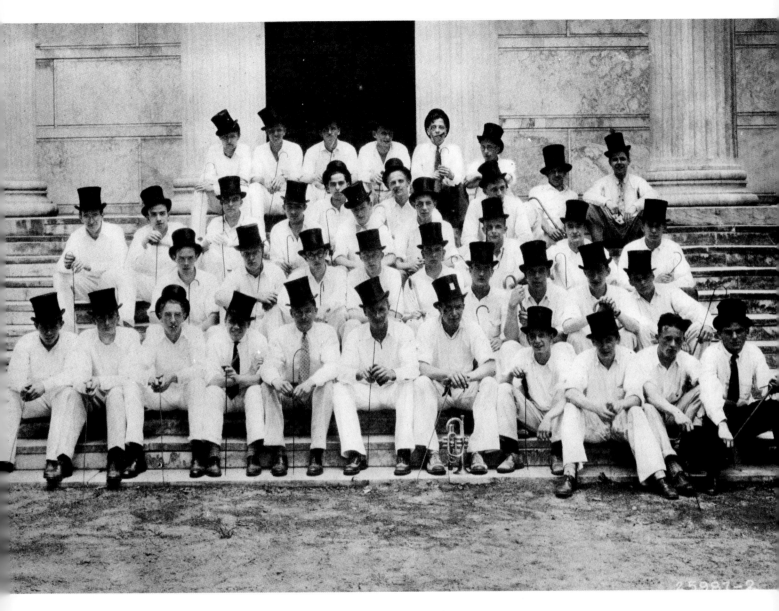

ABOVE:

Princeton's 1928 sophomore class assembled for the Top Hat parade, an annual ritual of that era.

OPPOSITE:

American novelist and Princetonian F. Scott Fitzgerald natty in a belted, tweed Norfolk jacket, 1925. His first book,
This Side of Paradise, *detailed the style snobbishness prevalent at Princeton in the 1920s.*

PREVIOUS PAGES (TOP ROW):

1903 portrait of the entire student body at Phillips Academy, one of America's oldest and most revered preparatory
schools, founded in Andover, Massachusetts in 1778.

PREVIOUS PAGES (BOTTOM ROW L TO R):

Rollins College football players line up in their letter sweaters for famed coach Joe Justice; Yale's letter sweater;
Columbia Lacrosse team, 1908; Hart Schaffner & Marx's 1920s advertisement: "Young men in business or in college
should have Hart Schaffner & Marx clothes"; Levi Jackson, Yale's first black football captain, class of 1950.

of its sports and players is what drove sports clothing straight from the playing field to the campus and into town. The comfort and casual ease that athletic clothes possessed were enormously attractive and, coupled with a new obsession with fitness, sportswear provided students the opportunity to participate in a "manly" activity—or at least appear as though they were.[6]

Since Princeton men were most likely born to families with affinity for the links and the courts, the clothes associated with these sports—genteel *plus-fours* or knickers for golf, Oxford lace-up shoes, and creamy white flannels for tennis—were among the first active sports clothes to make the transition from sporting events to social events. These were quickly followed by functional attire from other sports. Blazers, said to have originated with the British Navy, became associated with boatsmen of another sort— the university's crew teams, whose snappy navy jackets were emblazoned with the Princeton team crest.

The hard-earned varsity letter sweater conferred upon the wearer a great deal of status—and even more status on the girlfriends who borrowed them. At Princeton, the letter sweater was so popular it spawned multiple styles: a ribbed cable-knit turtleneck pullover and a loose fitting, shaker-stitched wool boatneck. Both were black and emblazoned with a large letter "P" in orange felt.

Students at the Ivies during this era also popularized articles of clothing that had originally been worn in other contexts. The sports jacket, for example, one of the articles of dress most closely associated with Ivy Leaguers, was modeled after the hunting habit of the Duke of Norfolk. In its original incarnation, the "Norfolk" was a belted jacket in a mélange of heathery tweeds or checks designed for grouse shooting, with a full sack-cut featuring box pleats front and back, providing mobility for the hunter's arms; it was worn with knickers and a matching cap. The Norfolk jacket went from shooting game to shooting "birdies" on the golf course, where it became a standard costume for gentlemen on the links. The knickers that golfers wore with abandon did not make the conversion to off-campus wear, but did segue into the hunting world, where they were less likely than regular trousers to be caught by brambles, or to get wet in the brush.[7] Later, in the 1930s, the Norfolk enjoyed a run on the ski slopes in Sun Valley, Idaho, with actors Douglas Fairbanks Sr. and Jr. embracing the rugged, outdoorsy look.

Sports shoes also emerged from the collegiate athletic culture into the mainstream. Golfers took to wearing the heel-less shoes called brogues, originally worn by field

34

and bog workers in Scotland and Ireland. These shoes
sported signature holes called "brogueing," which allowed
water to seep out, keeping the workers' feet dry. Fringed
tongues added the function of additional waterproofing.[8]
Rubber-soled athletic shoes made of white buckskin were
the choice of tennis players and later, two-toned black and
white or brown and white bucks called saddle shoes became a hallmark of collegiate
style for both men and women.

Another shoe classic that gained traction in the 1930s was the penny loafer, a
style which already had traveled extensively by the time it arrived on American college
campuses. Conceptually related to the Native American moccasin, the loafer was
somehow transplanted to Norway and discovered by American collegians touring
Europe. G.H. Bass was officially responsible for introducing the Weejun (derived from
the word Norwegian) to America in 1936 and the penny loafer (with a copper Lincoln
tucked into the slot of its vamp) became *de rigueur*.

As often happens with youth, sometimes collegiate clothing took a purely faddish turn: during the 1920s, burly raccoon coats roared back onto the men's collegiate fashion scene (they had previously been popularized during the late 1880s). Students wore them to college football games, with commodious enough pockets to stash a flask of brandy. The "rah-rah raccoon" became the rage and an icon of its era: the festive fur implied that its wearer had not only Jazz Age cool, but also the wherewithal to buy it. It didn't take long for fashion journalists to jump on the Ivy trend that had surfaced at Princeton. The students are said to have reveled in their newfound status as style-setters, and considered it their duty to create a recognizable Princeton "look." These efforts were rewarded by the press, who lauded their talents, and by the manufacturers and retailers who would freely use the terms "Ivy League' or "collegiate" to describe their wares. Soon, even the word "Princetonian" referred not only to a student of the university, but to the cut of a jacket or the style of a shoe. The commodification of the Ivy League had taken root in fashion and popular culture as a whole.

OPPOSITE:
Raffish raccoon coats were the rage for men on campus during several different decades—most famously in the 1920s and briefly in the 1980s.

FOLLOWING PAGE LEFT:
J.C. Leyendecker's oarsman illustration for the cover of Collier's *magazine, ca. 1920. Known for his covers for the* Saturday Evening Post *and Colliers* magazine, *his drawings were thought to define the fashionable American male of the early 20th century.*

FOLLOWING PAGE TOP RIGHT:
Laurence Fellows' 1930 illustration for Esquire magazine depicting elegant regatta spectators in red and navy, striped blazers often with insignias, cream colored flannel trousers, and neat caps or boaters.

FOLLOWING PAGE BOTTOM RIGHT:
The Princeton Varsity rowing crew warming up on Lake Carnegie prior to the Cornell-Yale race. Crew was highly popular at Princeton in 1930, a year in which over 100 men tried out for the rowing teams.

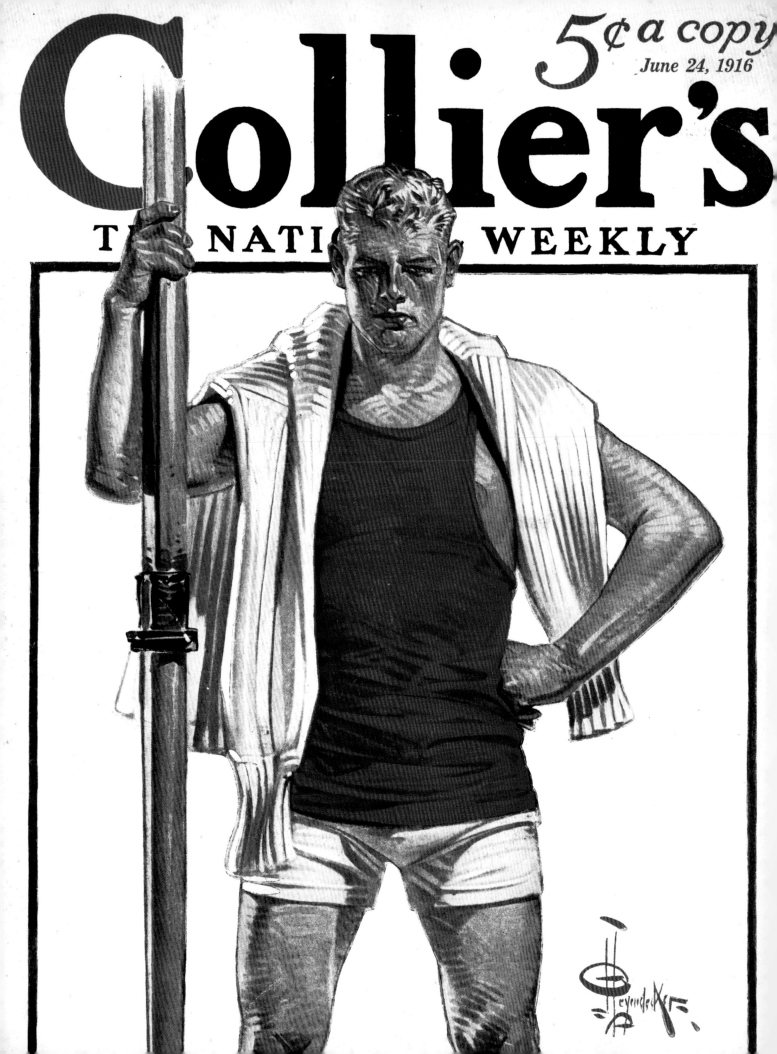

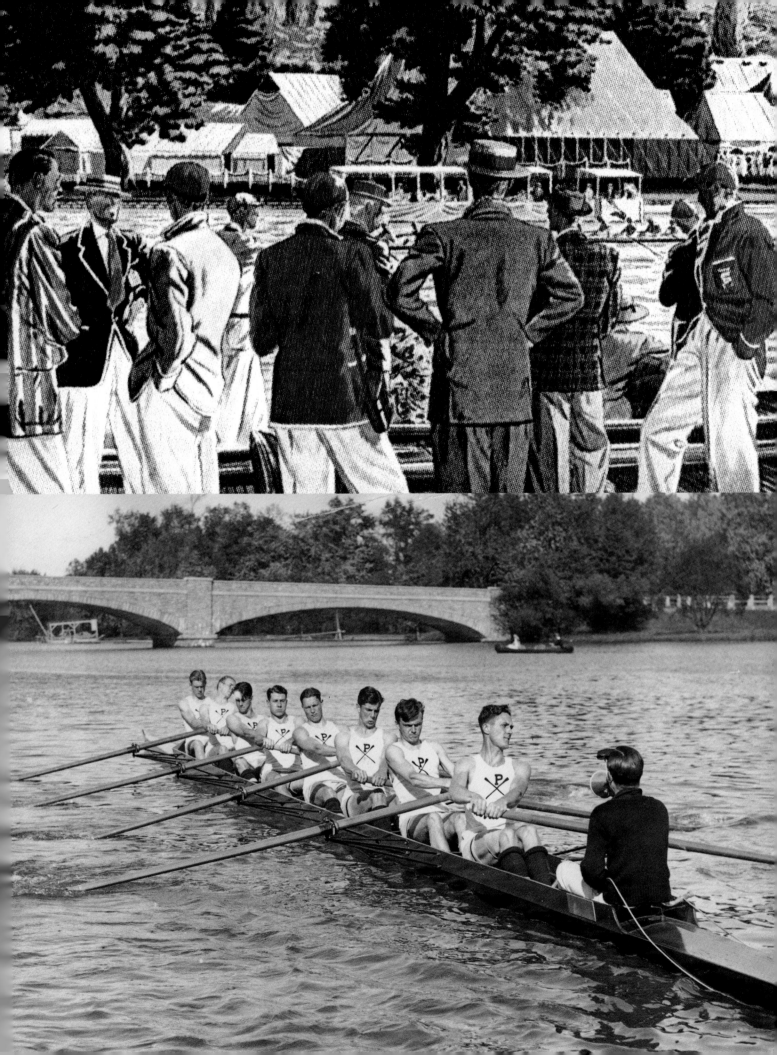

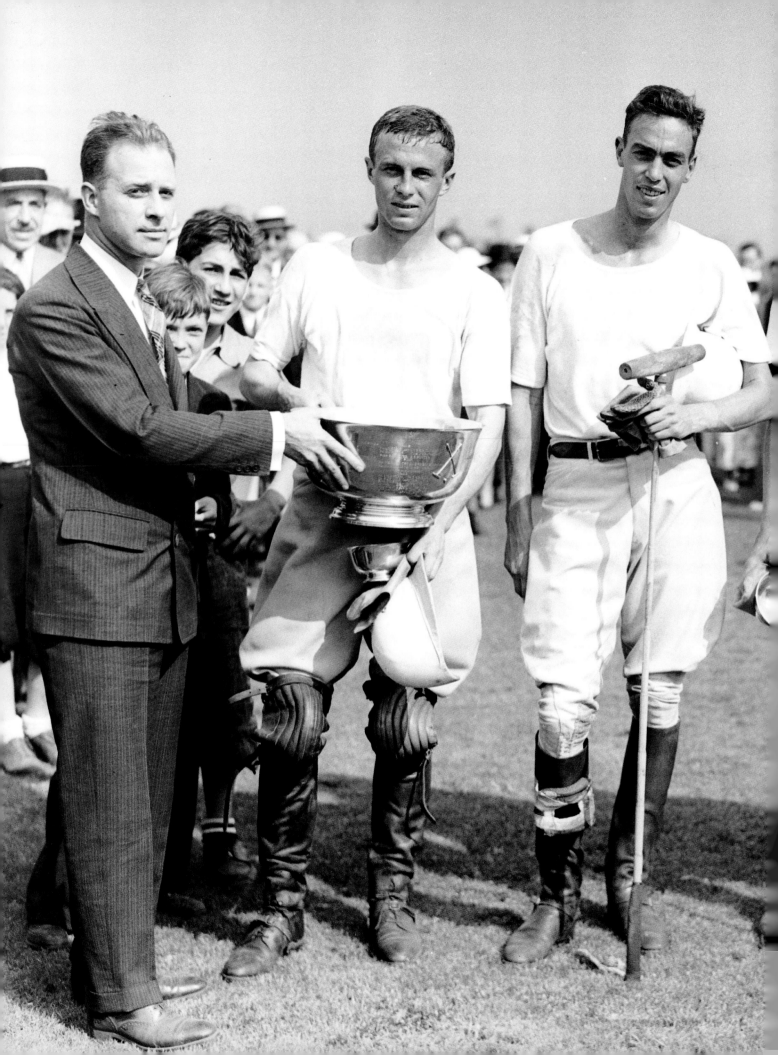

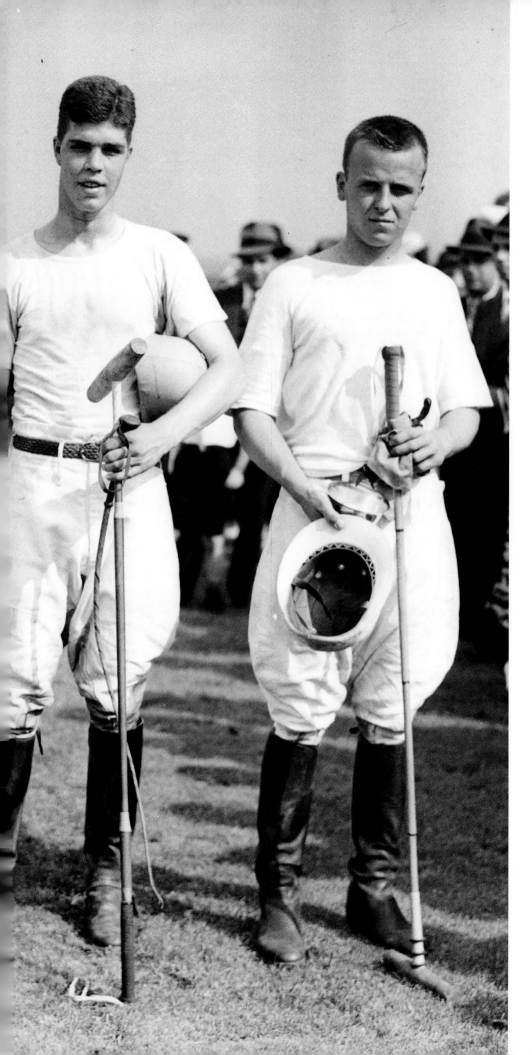

The Yale Polo Team: intercollegiate Polo finals at Governors Island, NY, 1935, where Yale defeated Harvard 10-2 for the Championship. Jay Secor (Capt), Robert Wilson, Peter Dominick, and Peter Grace.

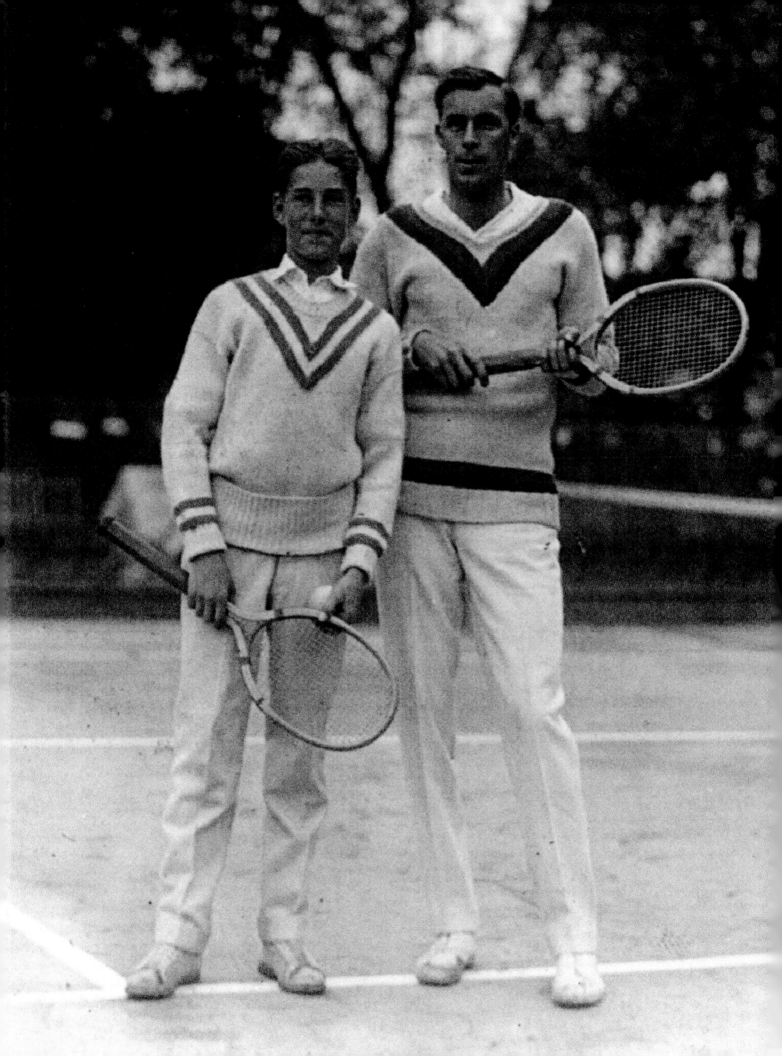

LEGACY OF THE SPORTSMAN AND THE LEISURE CLASS

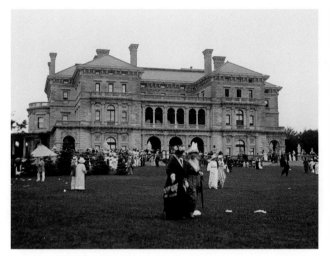

While the influential Ivies and prep schools were honing the notion of casual sportswear-inspired looks for everyday dressing, their elegant elders, the leisure-loving smart set, who favored such watering holes as Palm Beach, Newport, and the Cote'd'Azur, were also cultivating the habit of wearing sporty clothes as streetwear—although their streets were more likely to be palm-fringed avenues than collegiate quads.

First among his class—or anyone in the world, for that matter—was Edward, the peripatetic Prince of Wales, whose consummate sartorial savvy was evident wherever he traveled. Like many men of leisure, he adored the pleasures of the links and the hunt, and

OPPOSITE:

U.S. tennis great Big Bill Tilden and a student in classic V-neck cabled sweaters, popularized by Tilden for pre-tennis warm-ups and post-tennis cool-downs. The tennis sweater was too good-looking to be relegated to the game and was quickly absorbed into everyday classic sportswear.

ABOVE LEFT:

1914: Fête Champêtre at "The Breakers" in Newport, Rhode Island, formerly the Cornelius Vanderbilt House.

ABOVE RIGHT:

The illustrious illustrator of equestrian sport and country life, Paul Brown, depicts the preppiest sport of them all: Polo.

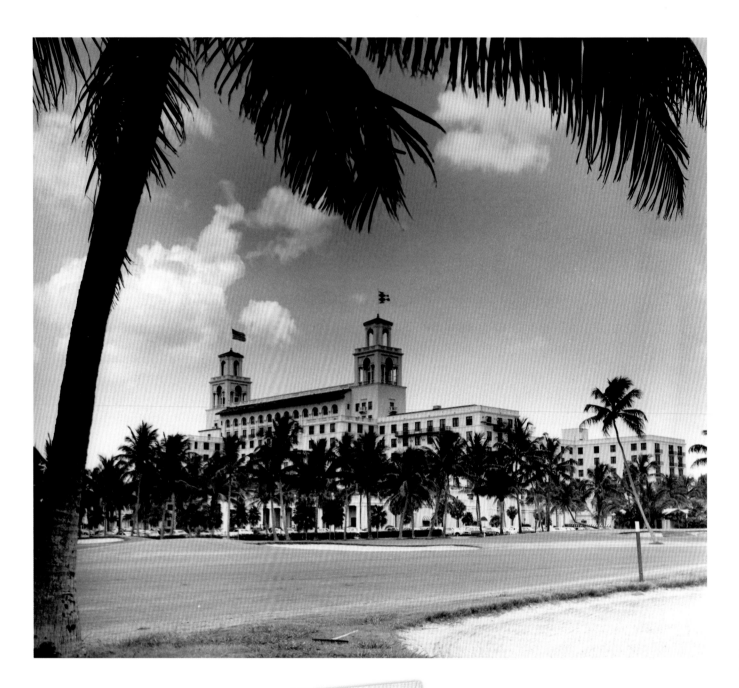

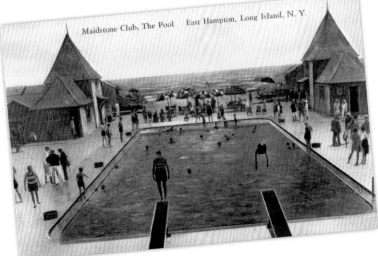

Maidstone Club, The Pool East Hampton, Long Island, N. Y.

Palm Beach's palatial watering hole:
The Breakers Hotel and country club.

The Maidstone Club pool, East Hampton,
New York, ca. 1928.

The future Duke of Wales golfing with friends
in "plus fours" at Royal St. George's in
Scotland, 1930.

seamlessly adapted the clothes he wore for sport to his social life. He was said to have had the uncanny ability to inject an element of nonchalance into whatever he wore, and in the case of resortwear, his choices often reflected his modern fashion sensibility, and exuded a relaxed, casual demeanor. He insisted upon unstructured clothes, with no stiffness or lining, over which he might add a silk scarf tied at the neck. Edward chose jackets from his Balmoral country closet and wore them with more sophisticated elements in seaside towns. The look, according to Katell le Bourhis, was a pastiche of city, country, and sporty, referred to as *chic fatigué*—a French expression for a kind of easy casual stylishness.[1] The first of the International Set to be seen in the classic blue and white striped bateau-necked sailor's shirt of the sort worn by rakish Venetian gondoliers (followed by Coco Chanel, Gerald Murphy, and Picasso, among others), Edward had no fear of faltering. When he dared to wear a red, yellow, and green tartan "lounge suit" (an unstructured version of the traditional suit) in Cap d'Antibes in summer, he ignited a madness for plaid dinner jackets, cummerbunds, and swim trunks that spread to resorts on both sides of the pond.

American bluebloods like the Biddles and Drexels and Dukes also made the glamorous rounds of Newport, Nassau, Palm Beach, and the French Riviera. They showed up in crisp navy blazers with white flannel pants and took strolls on steamy Palm Beach afternoons in seersucker—the crinkly, bantam-weight fabric transplanted from the tropics. These sartorial details were followed closely by American journalists, who predicted—correctly—that what the fashionable swells wore in Palm Beach in the winter would foretell what their readers would be clamoring for come the following summer.

Influential in their own right were the dashing Hollywood actors of the day. The young screen and style icons Gary Cooper and Cary Grant could pull off such insouciant gestures as weaving a tie through the belt-loops of their trousers or wrapping silk ascots around theirs neck without looking like they had tried too hard. On the other end of the spectrum was Spencer Tracy, who with his everyman, lived-in looks and humble manner was considered to be a real "man's man." His accessible, rough-and-tumble style also had a broad influence on men's fashion, such as his combinations of tweeds and casual attire for both business and pleasure.[2]

The elite athletes who competed at the international level in tennis and golf changed not only the look of their sports, but in some cases, the way the games were played, as cooler, more comfortable clothes led to greater speed and freer motion.

Clothes for tennis, which had always been known as an "upper crust" sort of sport, started out as stiff as the wooden rackets with which the game was then played. Long-sleeved, starchy collared shirts with ties and white flannel pants were "what was worn" on the court into the twentieth century. In 1926, however, when the young international tennis champion, Frenchman René Lacoste invented a lightweight cotton pique knit shirt, he transformed not only tennis, but sportswear history. His shirt featured a ribbed collar and cuffs and a longer shirttail in back so the shirt wouldn't come untucked from the player's shorts while reaching for a ball. Lacoste ingeniously personalized the shirt with a symbol of his own nickname, "Le Croc," which was either a reference to his aggressiveness on the court or to his profile. Several years after he took to the court in the crocodile shirt, the Lacoste shirt began to be manufactured in France where they developed a huge following among men (and later, women). Amazingly, it wasn't until the 1950s that these shirts were exported to the United States (where they were

The Cote d'Azur was one of the favorite playgrounds of wealthy Americans in the 1930s. Photographer Jacques Henri Lartigue captures yachters in Bandol on the famed Mediterranean coast, 1933.

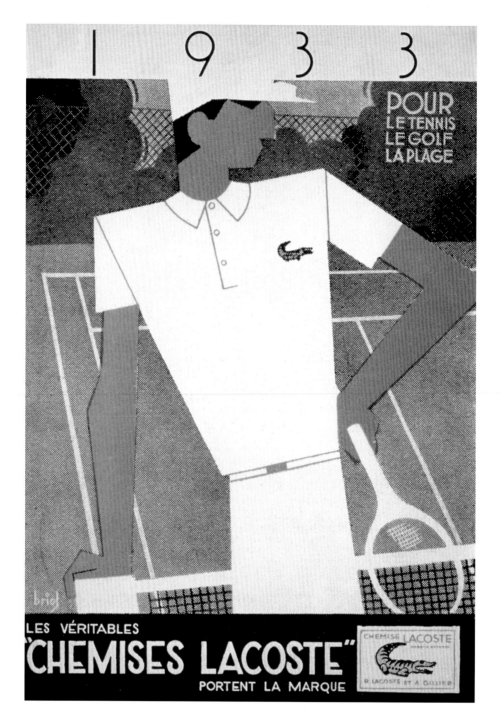

ABOVE:

Rocking the "croc": This chic 1933 advertising poster for the Lacoste shirt emphasizes its suitability not only for tennis, but also for golf and beach. The "croc" logo was an immediate success in France, but not until after World War II did it make its way to the United States, where it quickly gained status among the Ivy League and country club sets. Clearly, the style was in the crocodile.

OPPOSITE:

French tennis sensation Rene Lacoste ("Le Croc") won the Davis Cup in 1932 at Wimbledon but is best known for simplifying tennis wear and adding an embroidered crococdile motif to his shirt, an early hallmark of preppy style.

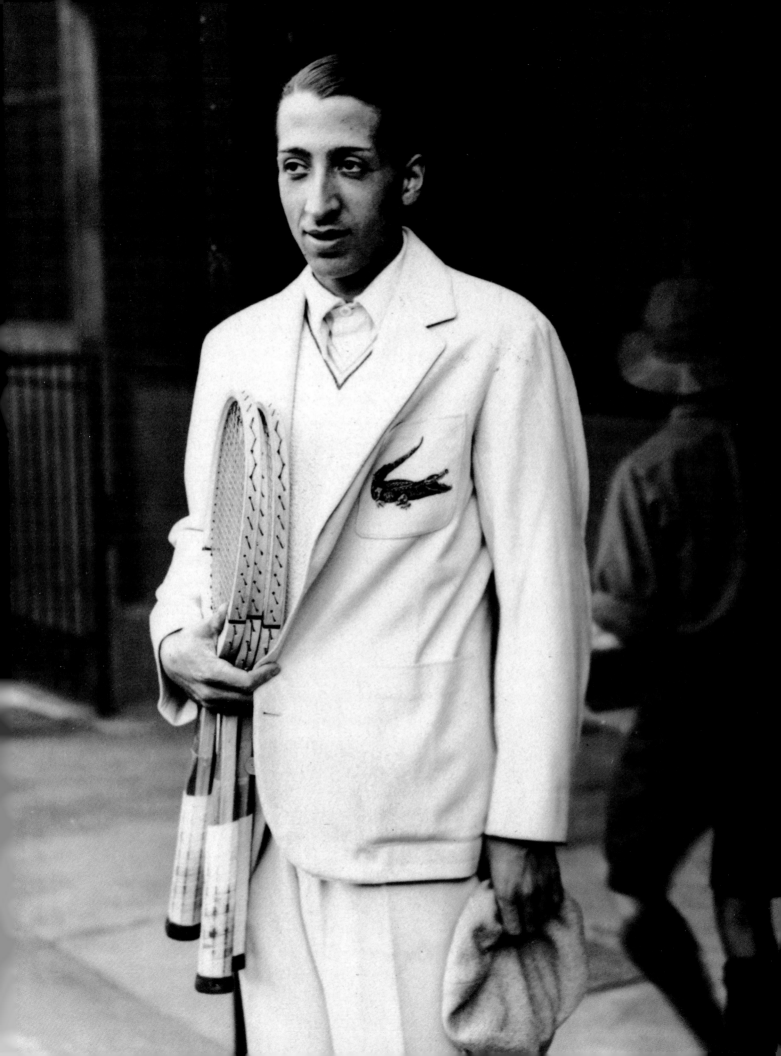

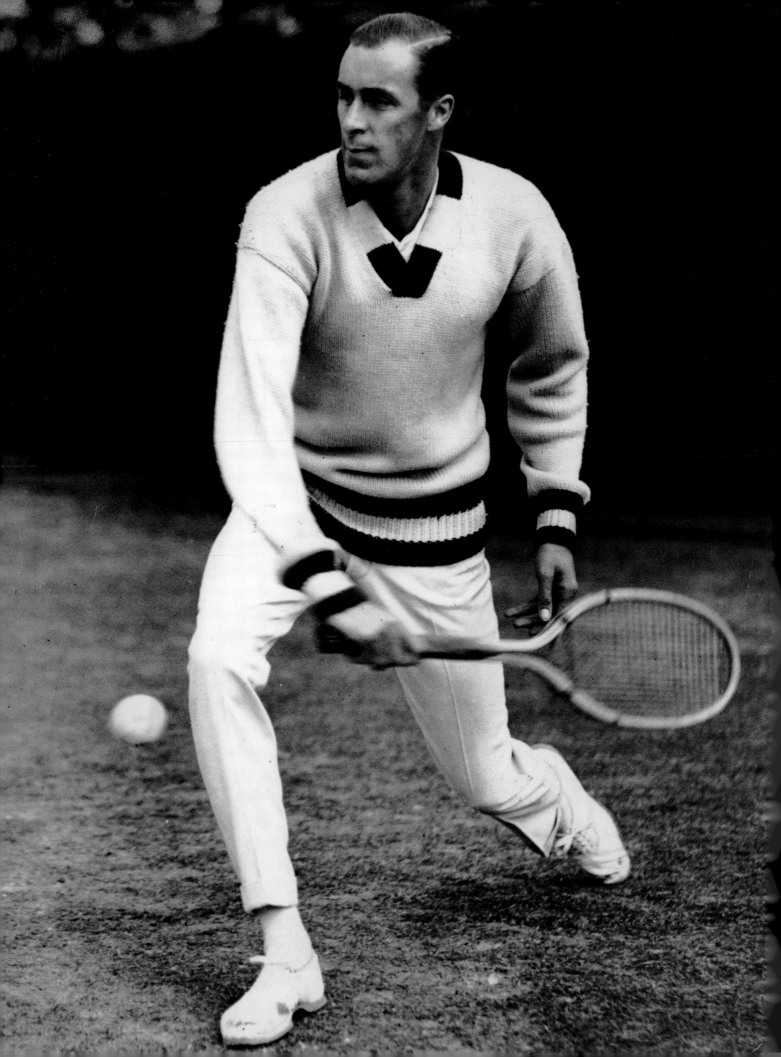

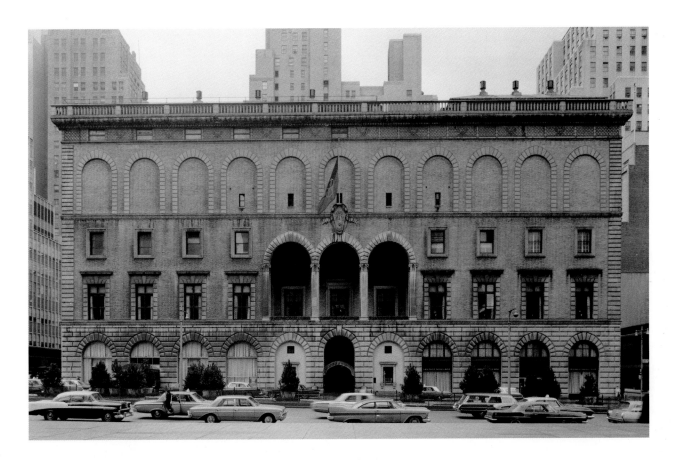

later manufactured as well). Lacoste's gift to tennis was the prototype for every logo-breasted sport shirt that followed it. The original Lacostes are still sold, virtually unchanged from the original, all over the world.

Another style attributed to the tennis court, the V-neck cable knit tennis sweater, became associated with Big Bill Tilden, the great American tennis champ of the 1920s and '30s (when in fact, this style had been adapted from English cricket players). Wearing a white sweater striped with burgundy and navy at the neck and waist, both before and after his tennis games, Tilden underscored its usefulness as active sportswear and casual daywear. Never one to miss a good style, the Prince of Wales, not a tennis player, also took to sporting the sweater, lending it an upper-class cachet outside of the game. The iconic good looks of the tennis sweater smacked of class and clubbiness and became a classic that (like the polo shirt) thrives today, virtually unchanged since its inception.

The adventuresome Edward, Prince of Wales, again led the pack of style setters when he ventured to the golf links in "plus-fours" (pants that stopped four inches below the knee), otherwise known as knickers, which he paired with a mélange of tweeds and tartans. At St. George's

OPPOSITE:
Bill Tilden, 1924.

ABOVE:
The ultimate gentleman's sports club: the esteemed Racquet and Tennis Club built in 1918 on Park Avenue, stretching from 52nd to 53rd Streets. The ultra-exclusive R&T is home to one of the few "court tennis" (or "real tennis") courts left in the world—of the kind frequented by royals such as Henry VIII.

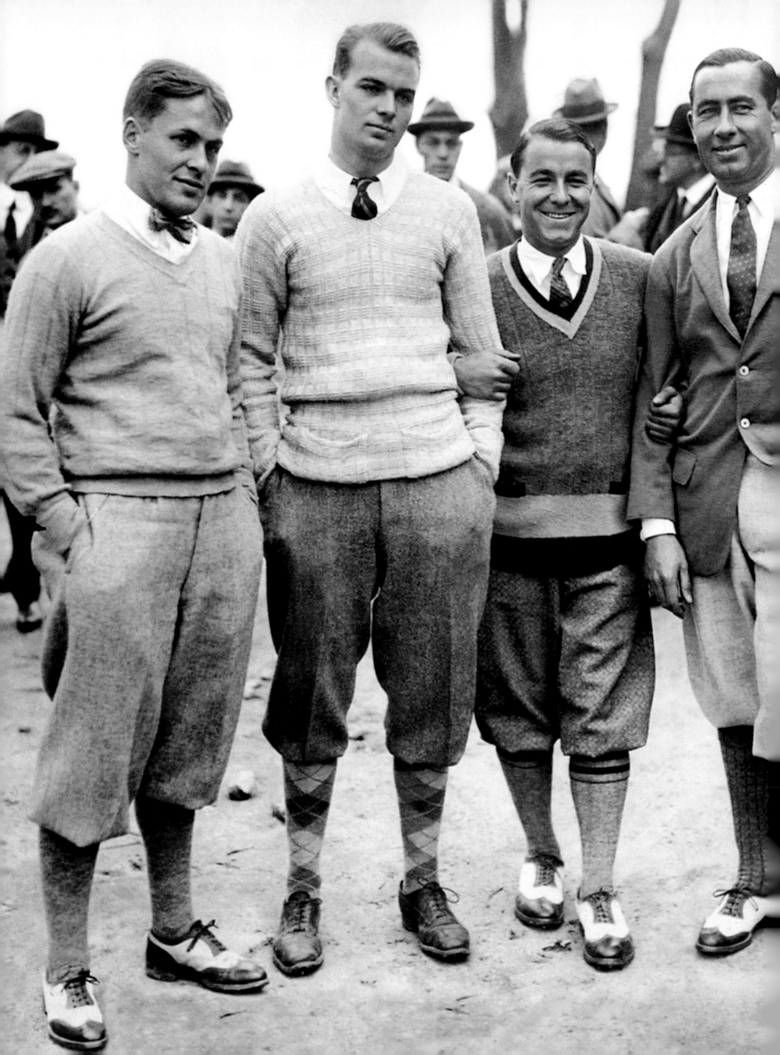

in Scotland, Edward also introduced to golf the intricately patterned, beautifully colored sweaters and socks knitted in Fair Isle (a small island of the Shetlands off Scotland). He is said to have single-handedly rescued the moribund knitting industry in the Shetlands by playing a round of golf and allowing photographs to be taken of him in his hand knit Fair Isle sweater. The image captured the minds and pocketbooks of people all over the world who rushed to order the sweater worn by the prince, paving the way for generations of preppy Fair Isle-sweatered, capped, gloved, and scarved men and women to come.

While golf knickers cut quite a figure (they briefly became somewhat of a college fad), their life on campus and in town was short. Golfers eventually replaced the huntsman's knickers with casual, full-length pants; and, as the sport gained in popularity and expanded from exclusive golf clubs into the more democratic municipal golf courses, the style-setters were less the aristocratic amateurs and more the accessible professional golfers like Bobby Jones, who wowed the crowds not only with the way he wore his clothes, but with the way he whacked the golf ball.

Elite sports and sportsmen were undeniable influences upon men's style in the 1920s and 1930s, as greater emphasis on athletics and greater access to the sports themselves evolved. Given a more fluid social structure and a more relaxed attitude toward dressing, Americans were more likely than the British—who were still bound by class restrictions— to integrate these styles into everyday life, appreciating their relaxed looks and functional details. But the Ivy bred, sport-minded way of dressing was about to get a boost from a powerful new source: America's inventive men's purveyors.

One of America's all-time champions, Bobby Jones, left, natty in "plus-fours" (pants four inches below the knees) or knickers, with Jess Sweetser, Gene Sarazen, and Walter Hagen at Augusta National. Jones was known not only for his superb golf form but also for his refined sense of style.

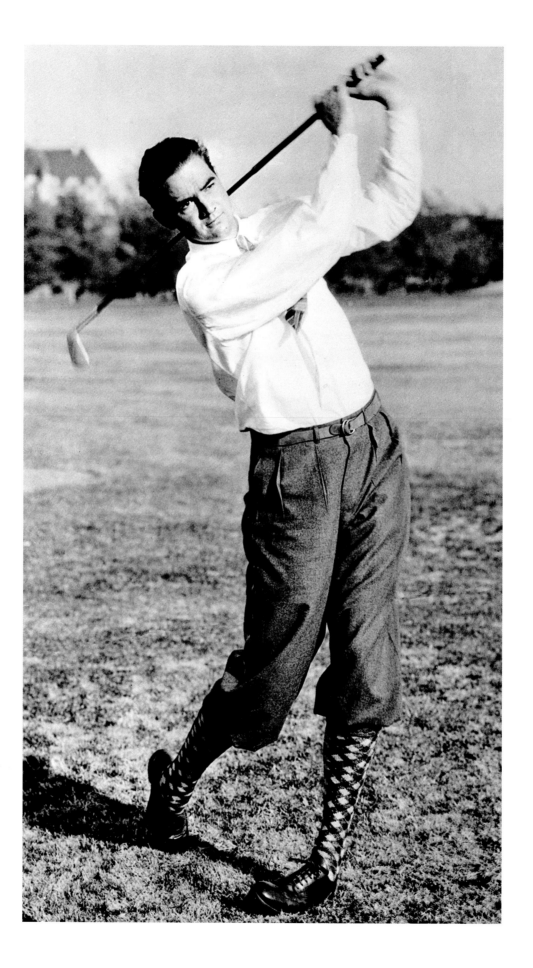

RIGHT:

Reclusive billionaire Howard Hughes playing a round of golf in his golf knickers, ca. 1935. Hughes was known for dating legions of Hollywood actresses, among them Katharine Hepburn (opposite).

OPPOSITE:

Katharine Hepburn as Pat Pemberton in the film Pat And Mike *with Spencer Tracy, 1952. Hepburn shows off her argyle in style—and her athletic form.*

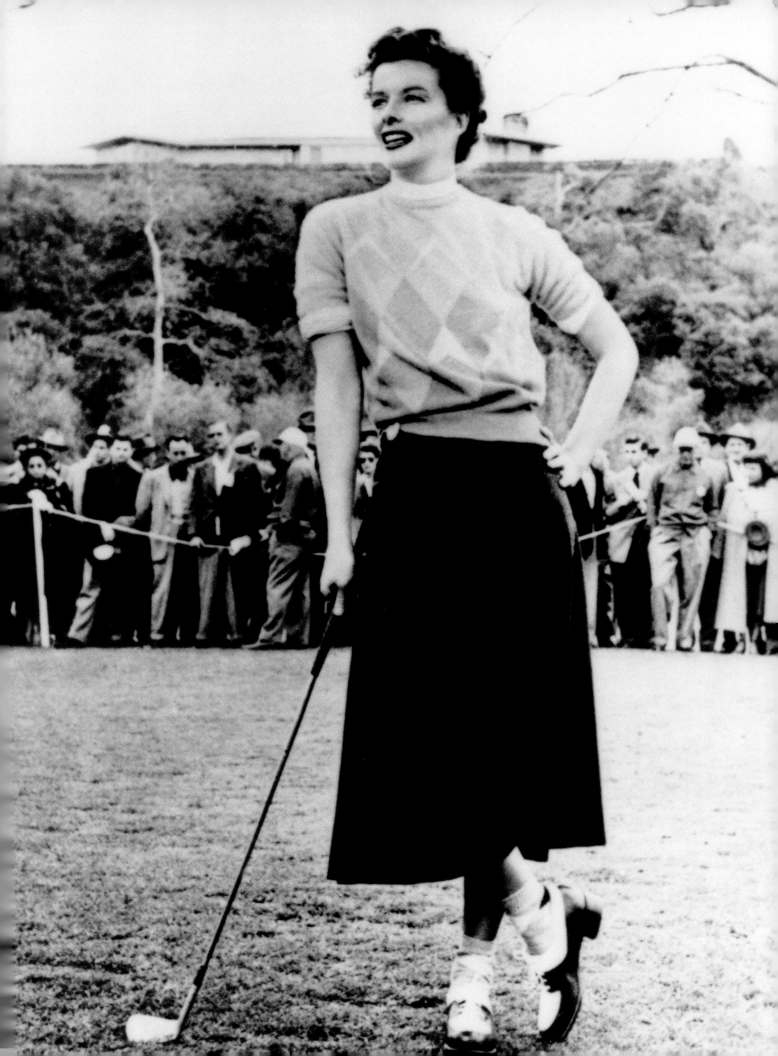

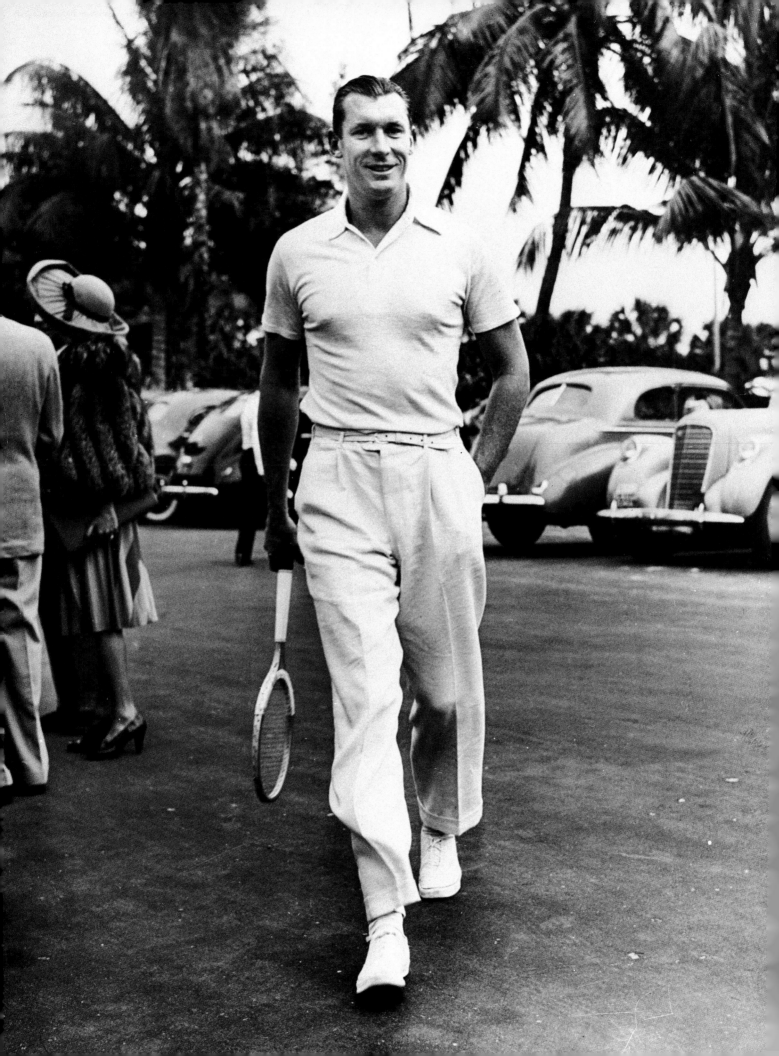

ABOVE:

Courtside Cool: Laurence Fellows illustration for Esquire, *1934.*

OPPOSITE:

Known for his consummate skill on the polo field, Winston F.C. Guest was also an accomplished tennis player. Guest is shown en route *to a match at Palm Beach's Everglades Club, 1938.*

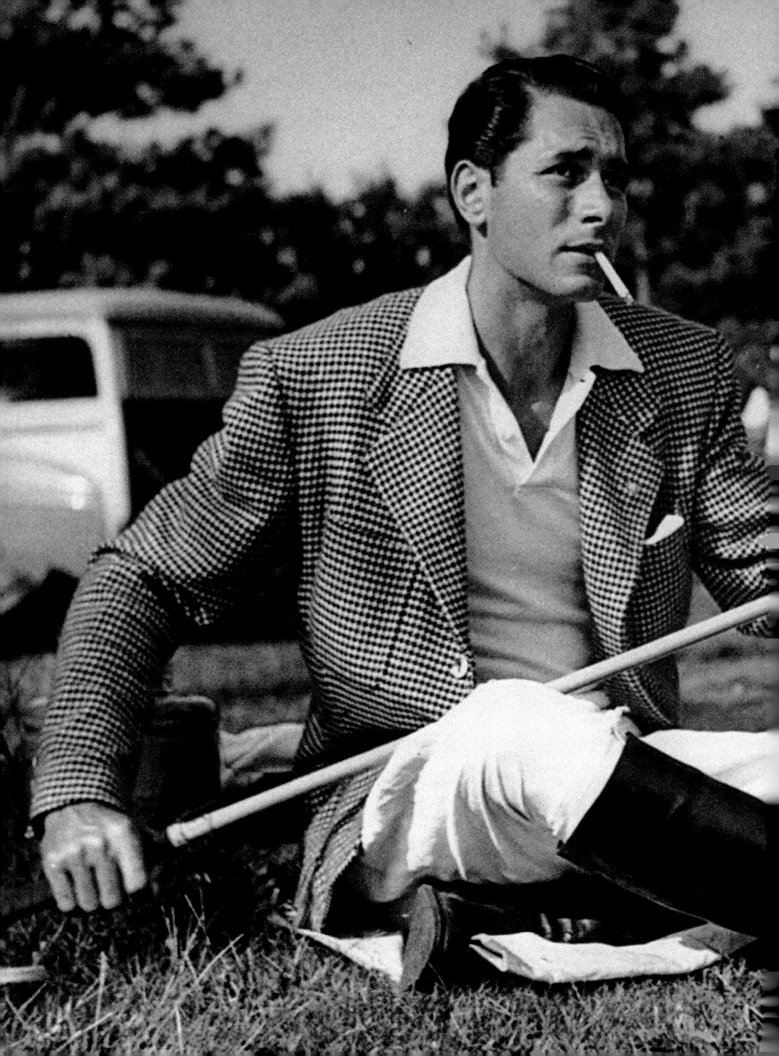

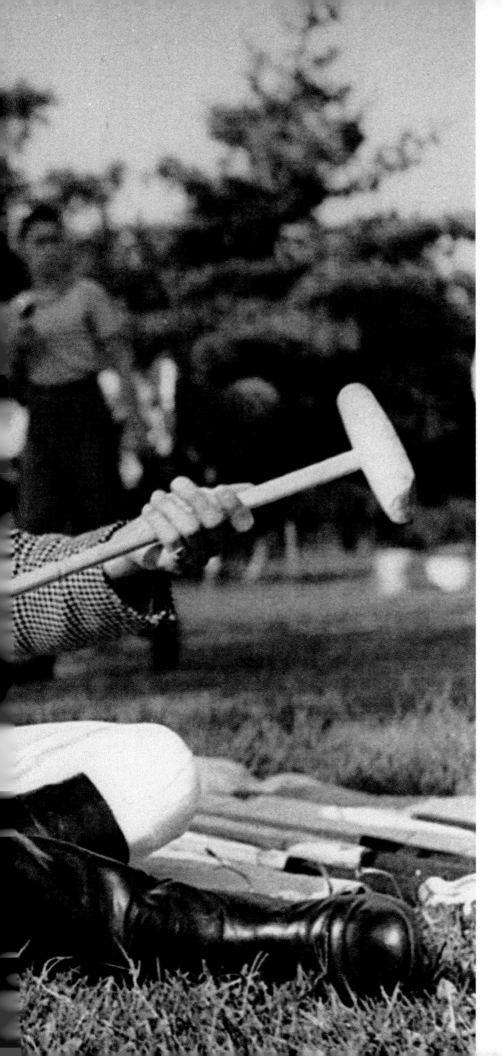

61

International 8-goal polo player Peter Perkins takes a break at the US versus Mexico polo match, 1946.

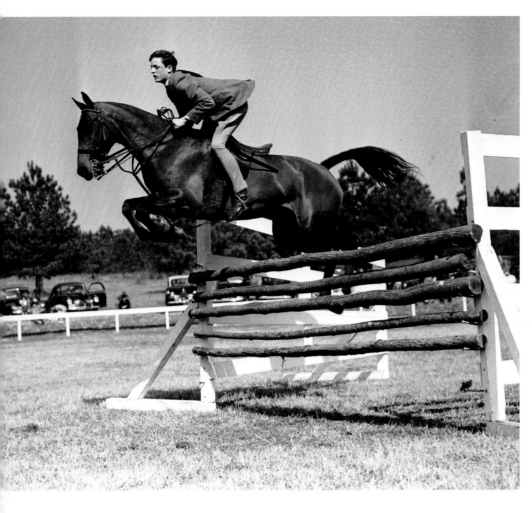

ABOVE:

William F. Buckley Jr. as a young man, show-jumping his horse "Pickles" in Camden, South Carolina, 1941.

RIGHT:

The young Jacqueline Bouvier holds the reins of her horse "Danseuse" at the East Hampton Horse Show in which she competed, 1941.

FOLLOWING PAGE LEFT:

In the 1930s, Brooks Brothers' provided a series of "little books" which included the Racing Schedule and a list of Yachts for the western part of Long Island Sound during the summer of 1930. They also graciously suggested appropriate apparel to wear while yachting for those who were new to the game.

FOLLOWING PAGE RIGHT:

The Duke and Duchess of Windsor: style-setters nonpareil *in the summer-weight, sorbet-colored clothes they wore in resorts by the sea. Miami, 1941.*

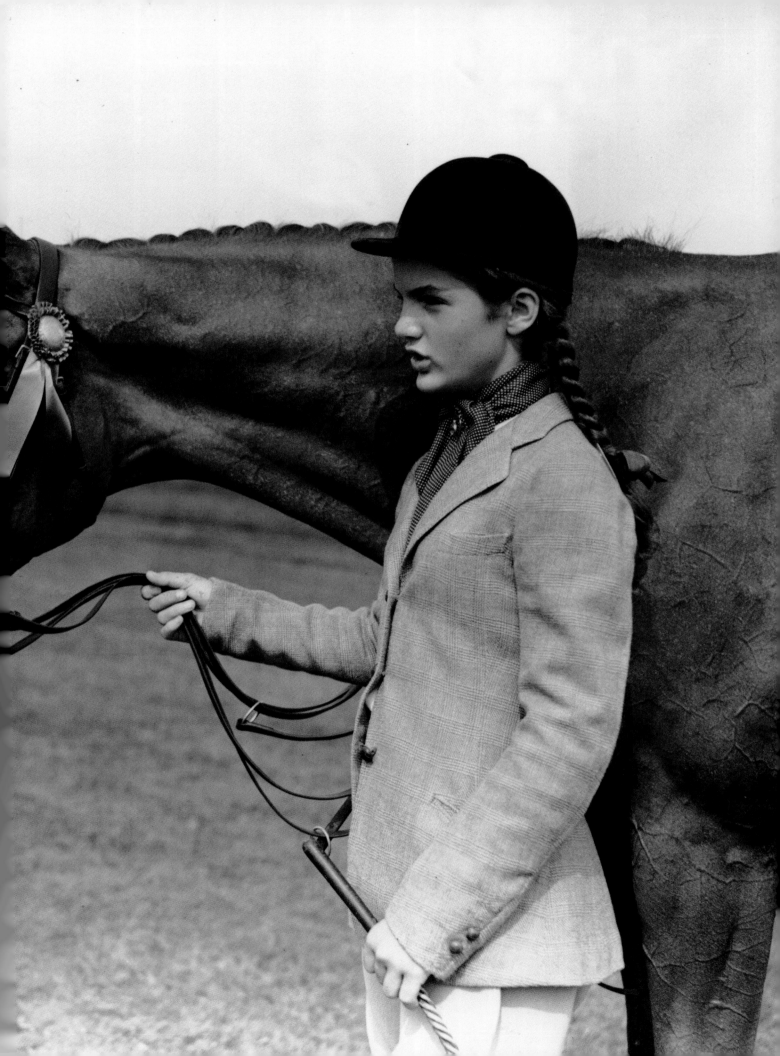

AMERICAN (NEW YORK) CRUISING CLUB OF AMERICA BAYSIDE COLUMBIA (NEW YORK)

EASTERN HARLEM

HEMPSTEAD HARBOUR HORSE SHOE HARBOR

HUGUENOT INDIAN HARBOR

KNICKERBOCKER LARCHMONT

MANHASSET BAY NEW ROCHELLE

NEW YORK NEW YORK ATHLETIC CLUB

PORT WASHINGTON RIVERSIDE (CONN.) SEAWANHAKA CORINTHIAN STAMFORD

LIST OF YACHTS

and

Racing Schedule 1930

Long Island Sound
{ Western Part }

With Notes on the

INTERNATIONAL YACHT RACES

BROOKS BROTHERS
Madison Avenue, cor. 44th Street
NEW YORK

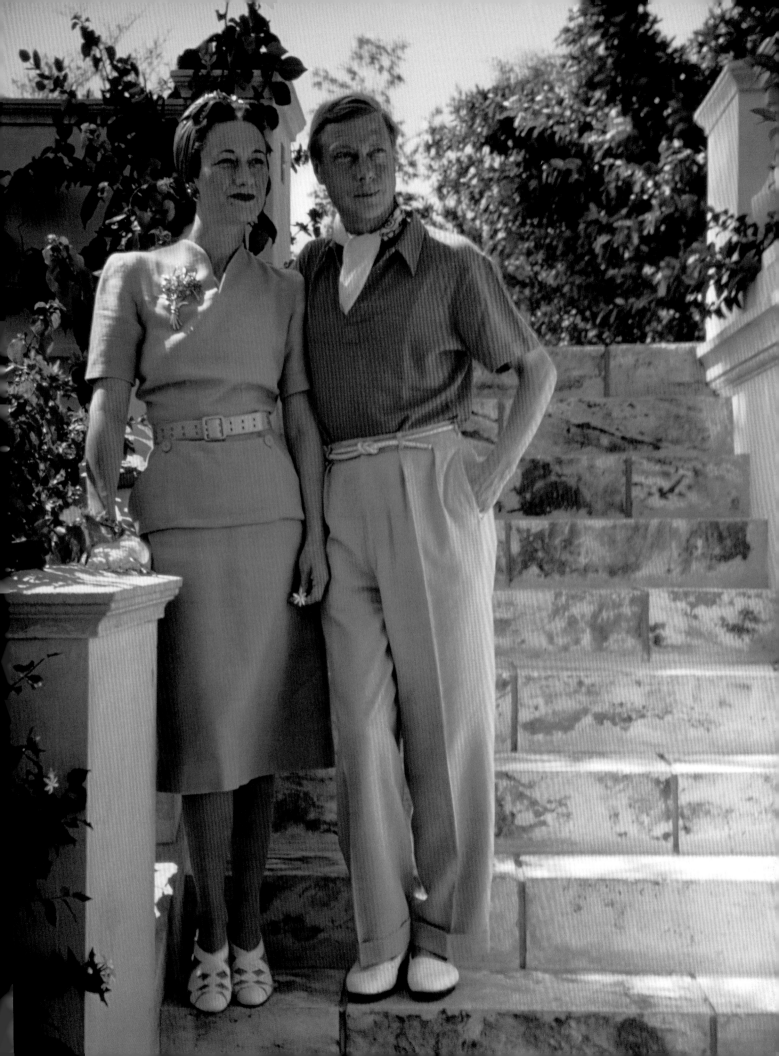

PURVEYORS
TO THE PRIVILEGED

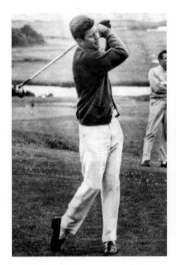
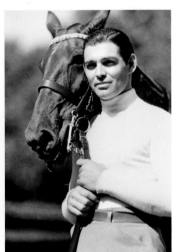

B y the early 1930s, the trend toward more casual, athletic-inspired menswear—cultivated by the students at Princeton, Yale, and Harvard—had taken root, and it was widely acknowledged that this definitive new way of dressing stemmed from the Ivy schools. But in order to disseminate the style and grow it nationally, it took the efforts of some highly innovative men's clothiers who adapted, created, and marketed new forms of sportswear that reflected this modern, informal All-American approach to style.

Brooks Brothers, not so much a clothier as an American institution—whose history includes making suits for almost every U.S.

OPPOSITE:

In the 1920s, Brooks Brothers started a repp tie trend in the U.S. based on the British regimental or club ties. To "Americanize" the neckwear, Brooks reversed the direction of the stripes, and by the 1950s the Brooks repp tie was considered an important element of the Ivy League look.

ABOVE LEFT:

President John F. Kennedy sporting yellow pants and Weejuns penny loafers on a Palm Beach golf course. His vibrant golf attire tacitly gave thousands of American male golfers the green light to wear outrageous colors on the links—a trend that will never go out of style.

ABOVE RIGHT:

Clark Gable in simple, equestrian good looks: white jersey and britches with his horse in the film Hold Your Man, *1933.*

president from Abraham Lincoln to Barack Obama—was far and away the most prominent and resourceful retailer in the creation of Ivy style. Brooks literally came up with the goods: researching, inventing, and often anticipating the desires of its customer. For example, the clothier introduced Americans to the button-down shirt, unquestionably the most iconic item in the annals of Ivy League style. As the story goes, around the turn of the 20th century, John Brooks, a grandson of the founder, watched a polo match in England where the players wore shirts with soft collars that were buttoned down to prevent their "wings" from flapping as the men galloped down the field. It didn't take long for him to return to the U.S. and initiate the manufacture of an adaptation of that button-down shirt, not for polo or any other sport, but for a sportier streetwear look.[1]

In its understated way, Brooks' introduction of the soft-collared button-down shirt created a sea change in the shirt world. Until then, almost all men's shirts had been sold separately from their stiff, abrasive linen collars and cuffs. The button-down shirt provided an ease and comfort to which men quickly became accustomed and from which they never turned back. As columnist Heywood Broun presciently observed in 1923: "The whole issue of the soft collar is much broader than a mere matter of fashion and taste. It is an inevitable symbol…once he (man) has found stimulation in one act of rebellion, he is likely to go further."

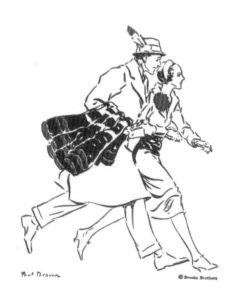

Paul Brown. © Brooks Brothers

Brooks offered the novelty of a spectrum of colors in its new shirts, and men found themselves considering the heretofore-unlikely choices of pink, yellow, blue, and green. The store also pioneered many of what we consider to be staples of American Ivy League sportswear. During the 1920s, Brooks continued to modernize menswear, adding a new natural, soft-shouldered suit with three buttons (the company's much vaunted "#1 Sack Suit") and "odd" jackets, like blazers and pants which were designed to complement but not match each other, for a more offhand look.[2] They were also responsible for importing the favorite Ivy staple, madras, from India—utilizing the cool, guaranteed-to-bleed plaided fabric in summer leisurewear that encompassed everything from bathrobes to ties to swim trunks.

ESTABLISHED 1818

Brooks Brothers
CLOTHING
Men's Furnishings, Hats & Shoes

MADISON AVE. COR. FORTY-FOURTH ST.· NEW YORK
NEWBURY COR. BERKELEY STREET · BOSTON
NUMBER ONE WALL STREET · NEW YORK

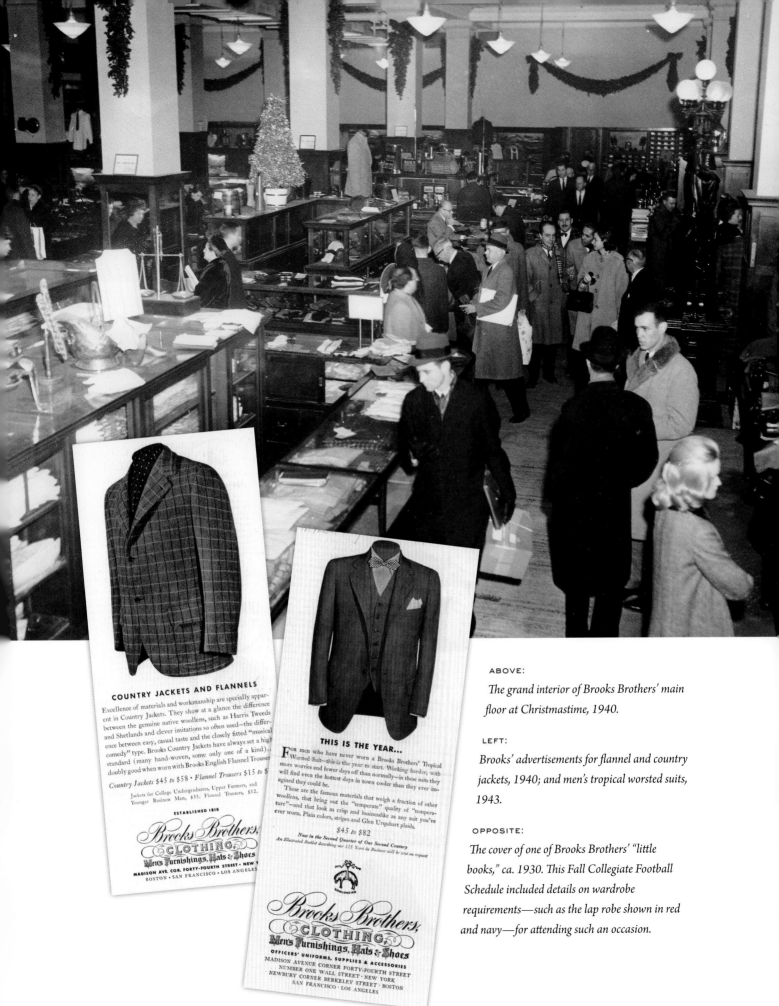

COUNTRY JACKETS AND FLANNELS

Excellence of materials and workmanship are specially apparent in Country Jackets. They show at a glance the difference between the genuine native woollens, such as Harris Tweeds and Shetlands and clever imitations so often used—the difference between easy, casual taste and the closely fitted "musical comedy" type. Brooks Country Jackets have always set a high standard (many hand-woven, some only one of a kind)...doubly good when worn with Brooks English Flannel Trousers

Country Jackets $45 to $58 • Flannel Trousers $15 to $

Jackets for College Undergraduates, Upper Formers, and Younger Business Men, $35. Flannel Trousers, $12.

ESTABLISHED 1818

Brooks Brothers
CLOTHING
Men's Furnishings, Hats & Shoes

MADISON AVE. COR. FORTY-FOURTH STREET · NEW YORK
BOSTON · SAN FRANCISCO · LOS ANGELES

THIS IS THE YEAR...

FOR men who have never worn a Brooks Brothers' Tropical Worsted Suit—this is the year to start. Working harder, with more worries and fewer days off than normally—in these suits they will find even the hottest days in town cooler than they ever imagined they could be.

These are the famous materials that weigh a fraction of other woollens, that bring out the "temperate" quality of "temperature"—and that look as crisp and businesslike as any suit you've ever worn. Plain colors, stripes and Glen Urquhart plaids.

$45 to $82

Now in the Second Quarter of Our Second Century
An Illustrated Booklet describing our 125 Years in Business will be sent on request

Brooks Brothers
CLOTHING
Men's Furnishings, Hats & Shoes
OFFICERS' UNIFORMS, SUPPLIES & ACCESSORIES

MADISON AVENUE CORNER FORTY-FOURTH STREET
NUMBER ONE WALL STREET · NEW YORK
NEWBURY CORNER BERKELEY STREET · BOSTON
SAN FRANCISCO · LOS ANGELES

ABOVE:

The grand interior of Brooks Brothers' main floor at Christmastime, 1940.

LEFT:

Brooks' advertisements for flannel and country jackets, 1940; and men's tropical worsted suits, 1943.

OPPOSITE:

The cover of one of Brooks Brothers' "little books," ca. 1930. This Fall Collegiate Football Schedule included details on wardrobe requirements—such as the lap robe shown in red and navy—for attending such an occasion.

Brooks debuted the classic double-breasted polo coat with mother-of-pearl buttons—another find from the gentlemen's sport—launching it in creamy white, followed by grey, and, finally, the traditional camel. In the 1930s Brooks also pioneered suits made of seersucker, a crinkly cool fabric indigenous to India, which, given its combination of a smooth and bumpy weave, keeps air circulating around the skin on a sultry day. Blue and white or brown and white striped seersucker remain a summer Ivy staple, particularly in the South—sometimes served with a twist.

The "Brooks Brothers suit" has always stood as a model of fine-tailoring, propriety, and power and never more so than at the start of the Eisenhower era in 1953, when the post-World War II explosion in employment allowed a much broader range of college-educated men to apply for jobs. It didn't take them long to learn that "working in corporate America demanded a knowledge of certain codes, many of which were embedded in the corporate uniform."[3] America had become more and more politically conservative, and Ivy-League clothes—with their inherently understated quality and ability to blend in—were the perfect expression of the new "buttoned-down" philosophy. Ivy college graduates, well-schooled in conformity, went to work uncomplainingly in their narrow-lapeled, sack suits with skinny ties, while older alums, inspired by the slimmer, more youthful-seeming style, also joined the growing band of sack-suited men. Although initially invented by Brooks Brothers in 1915—and J. Press around the same time—the plain, clean-lined suit (natural-shouldered, two or three buttons, no darts, little or no nip at the waist) became the "business model" for a burgeoning corporate America. The suit was so popular that when *The Man in the Gray Flannel Suit,* a novel by Sloan Wilson about a discontented businessman's search for purpose in a corporate world, was published, the title became a metaphor for the 1950s conformist American businessman.

There were plenty of gray flannel suits in the rapidly-growing advertising world of the late 1950s and early '60s—although they were perhaps worn with a little more creativity on Madison Avenue than they were on Wall Street; or so we would imagine watching dapper Don Draper and the cast of *Mad Men.* The widely acclaimed AMC television series debuted in 2007 to much acclaim, not the least of which was due to the show's fashion influence, particularly the male leads' Ivy style suits, portrayed as "sharp enough to cut through any boardroom tension."[4] Draper, the complex character played by actor John Hamm, is often a monochromatic study in black and shades of gray—from smoke to

Preppy is in the details: Brooks Brothers' iconic "Classic All Cotton Original Polo Oxford Cloth Button-Down Dress shirt" in blue no. 3. Brooks introduced the shirt to the U.S. in the early 1900s; they single-handedly persuaded American men to forever dispense with their starched shirt collars.

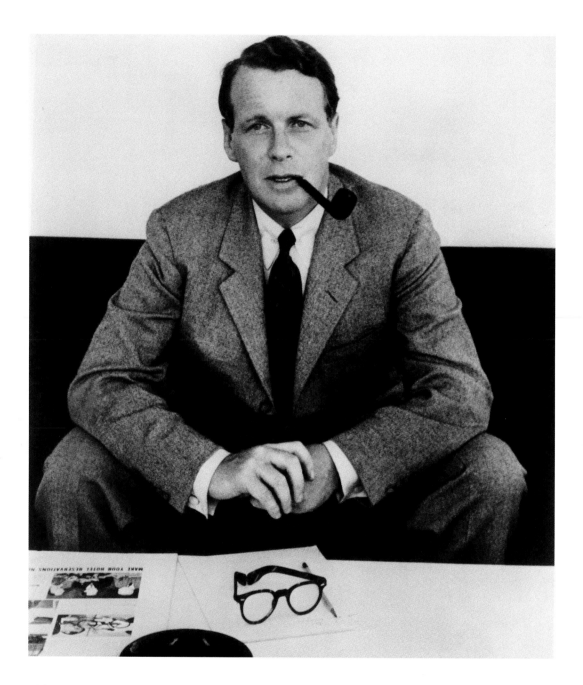

ABOVE:

David Ogilvy, 1954. The tweedy, pipe-smoking, prototypical Mad Man and founder and president of the advertising agency Hewitt, Ogilvy, Benson & Mather was principally known for creating the intriguing man with an aristocratic eye patch as the icon for C.F Hathaway Company, the shirt manufacturer for men and boys in Maine.

OPPOSITE:

Impeccably dressed Gregory Peck gathering information on the advertising industry for his new movie The Man In The Grey Flannel Suit, *1955.*

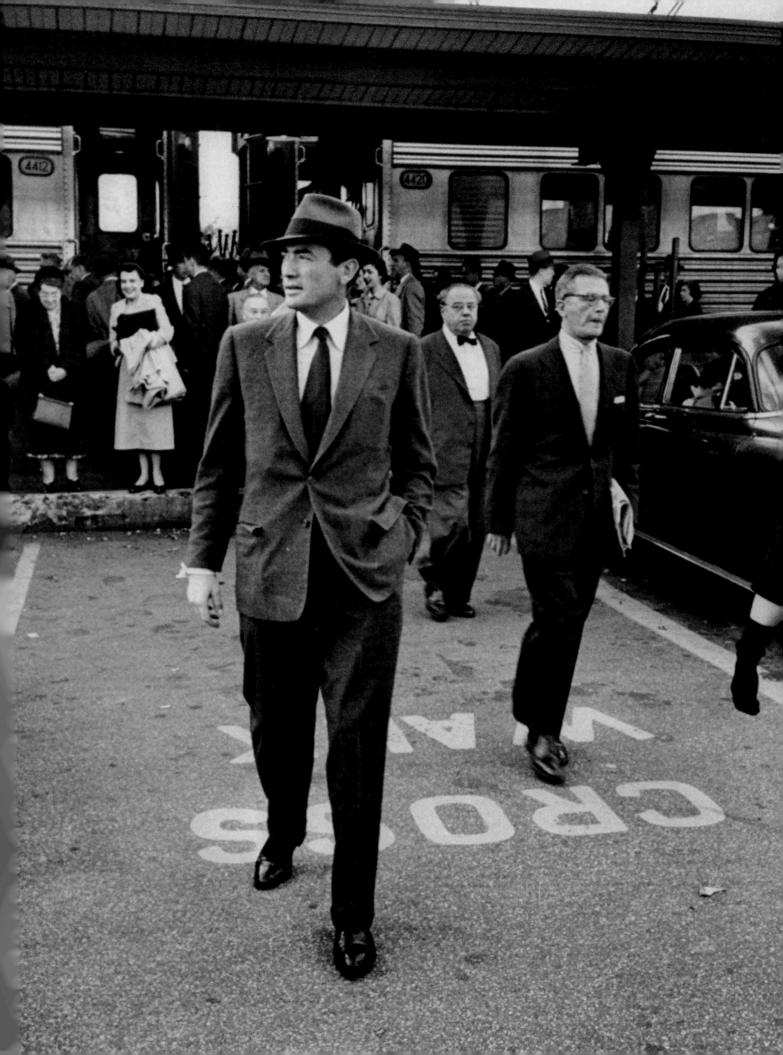

silver—almost always punctuating his suits with crisp white shirts and narrow ties with a half-Windsor knot, not to mention tie bars, collar pins, and pocket squares in abundance, as well as the requisite martinis and misogynistic remarks. The costumes for the show were made by Brooks Brothers to the specifications of the show's costume designer, Janie Bryant. The impact of the *Mad Men* series on male fashion has been extraordinary, sending menswear in a new, sleeker, simpler Ivy League direction that has had particular resonance with young American men in their '20s and '30s who had never witnessed this style.

Of course, Ivy League fashion in the 1950s was much more than the grey flannel suit. Gorgeous Hollywood leading men like Cary Grant, Jimmy Stewart, Gary Cooper, and Clark Gable, who were celebrated for their debonair dressing, found a fit in the understated Ivy. And out-of-sync though it seems, in the late 1940s, jazz great Miles Davis began wearing Brooks Brothers sack suits while performing—a quantum leap from the flashy zoot suits of the earlier part of the decade. A few years later, in 1954, Davis became a true Ivy aficionado when he was introduced to Charlie Davidson, master tailor at the Andover Shop in Cambridge, steps away from Harvard Yard. With an eye as keen as his

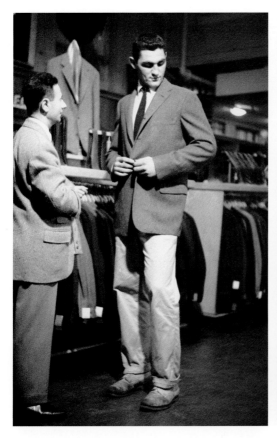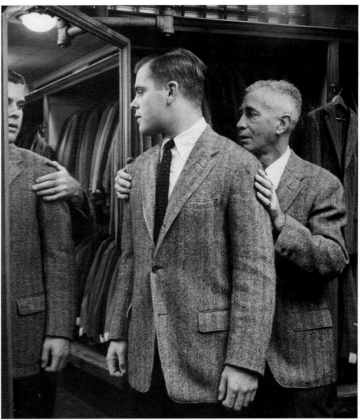

ear, Davis "got [the appeal of Ivy] [as] Davidson dressed him in jackets of English tweed or madras with narrow lapels and natural shoulders, woolen or chino trousers, broadcloth shirts with button-down collars, thin knit or rep ties, and Bass Weejun loafers. It was a look that redefined cool and shook those who thought they were in the know."[5] As a style icon, he influenced a number of other jazz artists—among them his pals Bill Evans, Stan Getz, Chet Baker, and others—who followed in Davis's footsteps and got hip to the new clean-lined cool of Ivy League.

ABOVE:

J. Press, in New Haven, has been purveyor and tailor to Yale students since the beginning of the 20th century. Left: Yale football tackle, Philip Tarasovic, trying on a sport coat. Right: James M. Brown III, another Yalie, is educated by a Press salesman in the subtleties of "the odd jacket"—in this case, a herringbone tweed sport coat, also worn by the Press salesman.

OPPOSITE:

Study in contrast: The mix of nubby tweed sport coats and smooth tartan twill-weave vests was considered the height of Ivy League cool at Yale in 1950.

As the much-vaunted Andover Shop was clothier to Harvard, J. Press was outfitter to Yale. Founded by Jacobi Press in New Haven in 1902, Press—another pioneer purveyor of traditional and collegiate menswear—started the business by taking their show on the road, literally; they went "door to door at Yale dormitories and then travel[ed] to all the prep schools by train."[6] They carried with them beautifully-made samples of traditional "young gentlemen's clothing" from which students could order a proper collegiate wardrobe. (Until the mid '60s, traditional men's dressing, i.e., jackets and ties, were largely required for both

the classroom and dining hall at men's colleges. And even today, while colleges have long since dropped dress requirements, a number of prep schools continue the tradition of requiring jackets and ties—or alternatively turtlenecks in winter—for classes and dinner.) After Press established a strong following among college boys and preps, they opened a shop of their own next to Yale in New Haven, followed by later stores in Cambridge, New York, and Washington D.C.

Unlike Brooks Brothers, which for years has attempted to adapt—however slightly—to shifts in menswear, J. Press singularly prides itself on remaining a traditional constant in the menswear business. J. Press's strength, according to Denis Black, the longtime manager of the Cambridge store, is their strict adherence to doing what they have always done well and a loyalty to their customers, who don't want change, but rather a timeless look. Black explains, "the suit sold at J. Press today is tailored with a plain-front, cuffed pants, and a natural shoulder, three-button jacket, just as it always has been."[7] In other words, Press has sold this ultra-traditional take on the Ivy League look to their customers for over forty years—without changing a stitch.

Press's success and longevity certainly gives credence to the comment of social critic John Sedgwick who observed, "fashion has no place in the Ivy League wardrobe. The Ivy Leaguer is really buying an ethic in his clothing choices…a Puritanical anti-fashion conviction that classic garments should continue in the contemporary wardrobe like a college's well-established and unquestioned curriculum."[8] This philosophy was never better demonstrated as when Yale alumnus and former president George H.W. Bush was delivering a speech at his alma mater and was interrupted by hecklers shouting that he "was just another out-of-touch Brooks Brother Republican."[9] The president, annoyed, paused and—with superb timing—opened his suit coat to reveal its unmistakable J. Press label.

When the youthful Senator John F. Kennedy of Massachusetts became President of the United States in 1960, he brought a whiff of Ivy with him to the White House—not only in his personal style, but also

Ivy-Leaguer John Fitzgerald Kennedy as a 28-year-old, 1946. The first-time Congressional candidate from Massachusetts and heroic Navy veteran of World War II dons the same ensemble he sported while studying at Harvard: white shirt, repp tie, and grey flannels—a look he and his fellow Harvard advisors popularized 14 years later in 1960 when he became President of the United States.

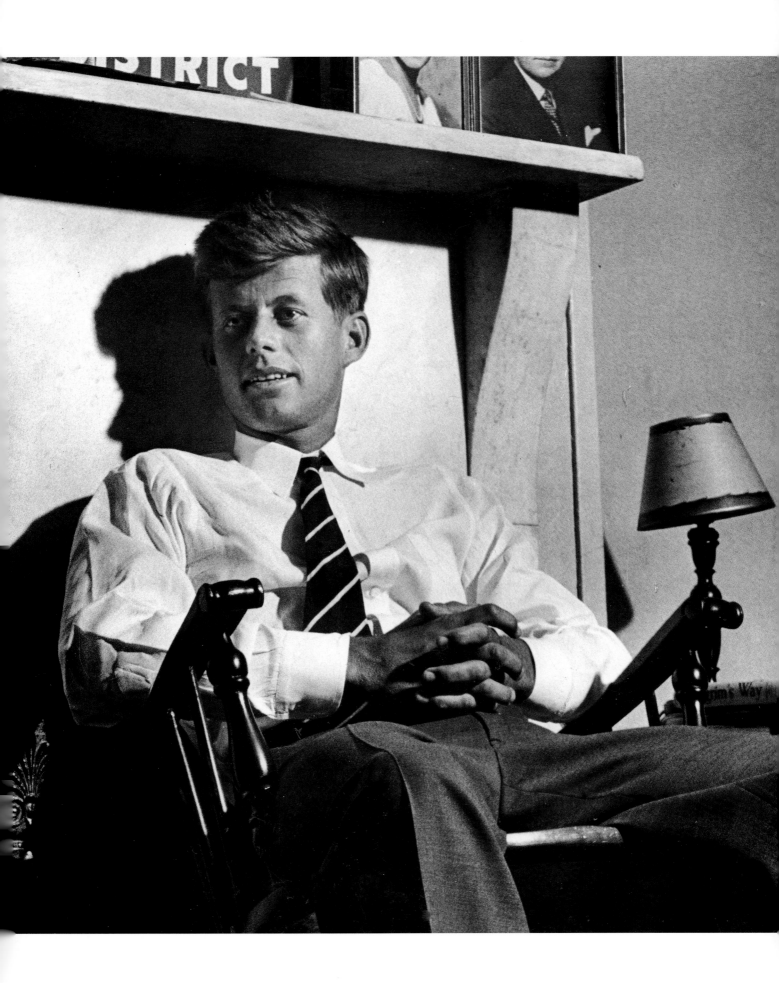

with his Harvard-educated coterie of advisors, almost all of whom wore classic American, natural-shouldered suits, horn-rimmed glasses and repp ties. In addition, JFK, his pals, and his large and exuberantly-athletic family often spent the weekends in the Kennedy compound at Hyannisport where they were photographed playing rowdy games of touch football or sailing, often in khakis, Sperry Topsiders, polo shirts, and oxford button-downs with the tails hanging out. Tanned, the breeze ruffling their hair, the Kennedy clan exuded the fun-loving, youthful air of perennial college students. The ease and carelessness with which they wore their clothes was as attractive as the clothes themselves. The president, who was also a golfer, took to wearing bright yellow pants on the links—if not initiating, at least showing his approval of bright colors at the country club.

78

At the same time, President Kennedy's wife, Jacqueline, became the women's style setter for the nation, and while she was sometimes dressed by European designers, her own casual style emphasized pearls, simply cut shifts, sweaters tied around the shoulders, casual Capris, and Jack Rogers sandals—the picture of the bred-in-the-bone preppy Farmington and Vassar girl she had been.

RIGHT:

In the early 1960s, Chipp did a brisk business in preppy madras jackets and "fun" pants for men, sometimes bi-paneled or even 4-paneled pants in primary colors; but the sine qua non *was the special sailing-inspired pant with one red leg and the other green, cleverly evoking the nautical terms "port" (left) and "starboard" (right).*

OPPOSITE:

Thomas J Watson Jr., American business executive, president (and later Chairman) of IBM, 1955. A student when he first met Sidney Winston, founder of Chipp, Watson remained a loyal customer of the tailor for the rest of his life, delighting in the colorful sport coat linings that were the shop's stock-in-trade.

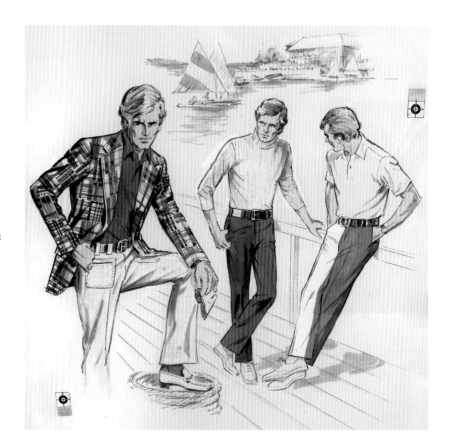

One of President Kennedy's favorite clothiers was Chipp, another innovative Ivy purveyor, founded in 1947 by longtime J. Press alum Sidney Winston, who opened shop in New Haven, then moved to 44th Street, just off Madison Avenue in the heart of the traditional men's clothing district. Winston, a born salesman, had often been dispatched by Press to do trunk shows at all the prep schools; and, as he was not much older than his customers, he was able to develop lasting relationships with a number of them, some of whom remained loyal to him for life. Men like IBM's longtime chairman Thomas Watson, Jr., former Secretary of State Cyrus Vance, and auto magnate Henry Ford II were among his early, youthful clientele.

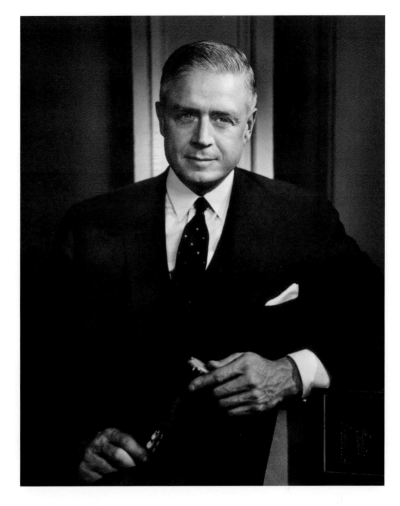

Sidney's son, Paul Winston, now the proprietor of Chipp 2/Winston Tailors, started working for his father at Chipp in the early '60s when Ivy was at the height of its popularity. Offering fine custom and traditional ready-to-wear, Chipp also became renowned for its color and wit—bold jacket linings and humorous ties—and for inventing that most rambunctious Ivy staple, patchwork madras pants, so vividly immortalized by Tom Wolfe as "go to-hell pants" in *Mauve Gloves & Madmen, Clutter & Vine*:

> . . . [Boston men] had on their own tribal colors. The jackets were mostly navy blazers, and the ties were mostly striped ties or ties with little jacquard emblems on them, but the pants had a go-to-hell air: checks and plaids of the loudest possible sort, madras plaids, yellow-on-orange windowpane checks, crazy quilt plaids, giant houndstooth checks, or else they were a solid airmail red or taxi yellow or some other implausible go-to-hell color. They finished that off with loafers and white crew socks or no socks at all. The pants were their note of Haitian abandon . . . at the same time the jackets and ties showed they had not forgotten for a moment where the power came from.[10]

What Chipp did not become renowned for (because they were asked not to divulge the information) was that they were making suits for President John F. Kennedy when he was in office, as well as for his brother, then-Attorney General Robert F. Kennedy, and brothers-in-laws Steve Smith, Sargent Shriver, and Peter Lawford. Winston recalls accompanying his father to fittings at the Carlyle Hotel, where the Kennedys always stayed in New York. Although he was a young student at the time, he remembers that Kennedy always treated him with great respect and at the end of each session the President would turn to him and say, "Now, Paul, I want you to personally select something for me." Winston also recounts his dealings with Robert F. Kennedy, who, when running for the office of U.S. Senator from New York, was besieged by enthusiastic young women reaching out to touch him on the campaign trail. As a result, Kennedy's suits were often in tatters after only a few days, which kept Chipp busy tailoring new ones. His most poignant story recounts a visit Bobby Kennedy made to

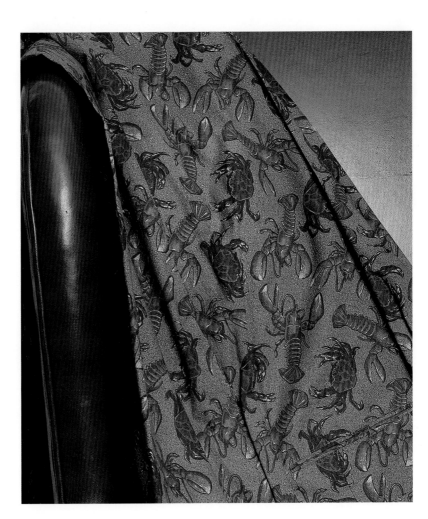

RIGHT:

Fish and Chipp's: lobster embroidered "go-to-hell" pants from Chipp. Founder Sidney Winston is often credited with originating the embroidered "critter" pants.

OPPOSITE:

A stack of Chipp's elegant tie silks in foulards, stripes, and all manner of menswear patterns. The silks will be turned into ties and used for jacket linings.

him after President Kennedy's assassination: bearing the suit his brother had worn at his presidential inauguration, he asked Winston to remake it for him, which he did—remarking sadly that there was a great deal of fabric left over.[11]

The original Chipp closed its doors in the 1980s, but Paul Winston and Chipp 2/ Winston Tailors continue to offer their loyal clientele the superb quality fabrics and custom tailoring to which they are accustomed. One of the most interesting aspects of Chipp 2's business has always been that their conservative clients take great joy in choosing vivid, patterned silk linings for their jackets. It is heartening to think that these statesmen and captains of industry, who inspire others with the confidence and leadership conveyed with their conservative suits, still retain some Ivy League humor and appreciate the value of keeping a little color and whimsy close to the vest.

Ivy League style, though it was bred and cultivated in the United States, was not limited to Americans. In the mid-1960s, around the same time as John F. Kennedy's presidency, a group of well-to-do young Japanese men and teenagers based in Tokyo, became obsessed with American Ivy League clothing. Their inspiration was a man named Kensuke Ishizu, the designer of a menswear label, Van Jacket, and the publisher of an elite men's fashion magazine.[12] In 1965, Ishizu had commissioned a book entitled *Take Ivy* (the title was inspired by "Take Five," the Dave Brubeck jazz classic): a collection of photographs of American students on their respective Ivy League campuses, walking to class, playing sports, studying in the library, eating in the dining halls, or just hanging with friends. The male students (all but two of the Ivy colleges were all-male at the time the photographs were taken) are wearing casual khakis, madras Bermudas, crew neck sweaters, college-logo'd sweatshirts and button-down shirts that constituted the wardrobe of many students in the early '60s. To an American at the time, the students would have looked typically collegiate, but to the Japanese, the look was remarkable—the Ivy Leaguers appeared to be an exotic tribe, and their informal clothing and college culture were curious and fascinating. Thus, *Take Ivy*—with its candid photographs by Teriyoshi Hayashida and wide-eyed captions—reads more like a sociological guide than a fashion odyssey. When it was initially published, the book created a cult following among style-conscious young men in Tokyo, igniting the spark of an ever growing Japanese national passion for the Ivy look.

82

In the summer of 1964, a group of young Japanese men (and a few women) referred to as the "Miyuki-zoku" started hanging out in Tokyo's Ginza shopping district, dressed in classic American Ivy. Prep popularity continues to soar in Japan today. J. Press, owned by fashion giant Kashiyama, sells "six times more American made Ivy clothing in Japan in department stores than it does at its four U.S. J. Press stores."[13]

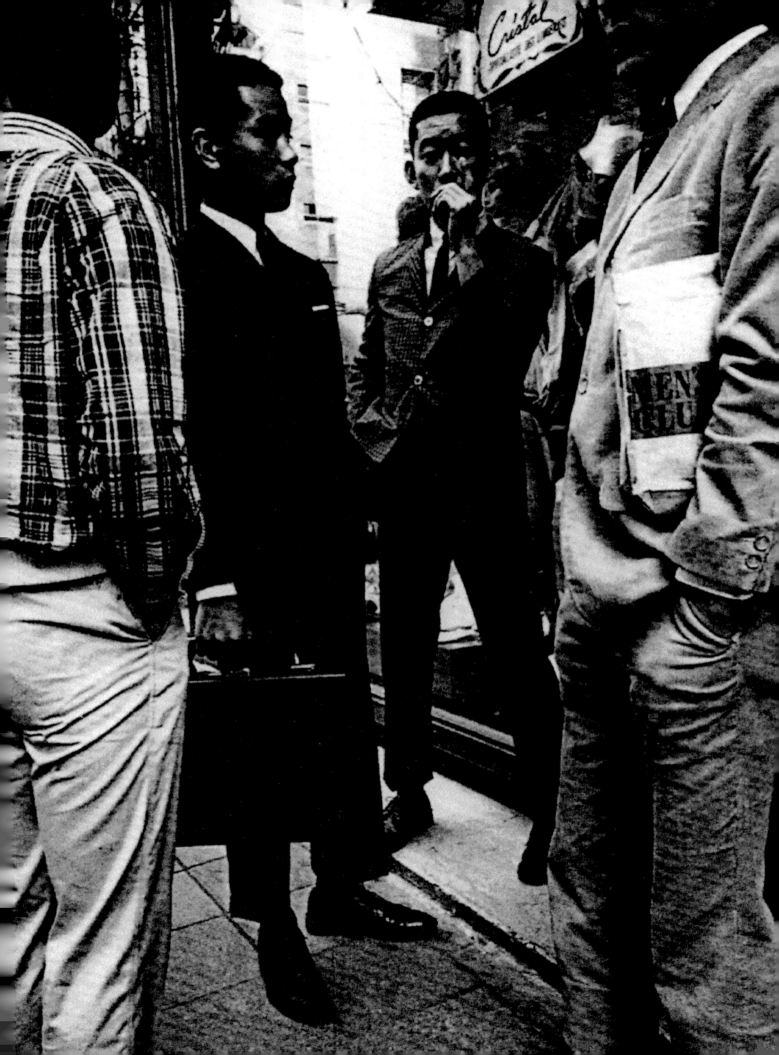

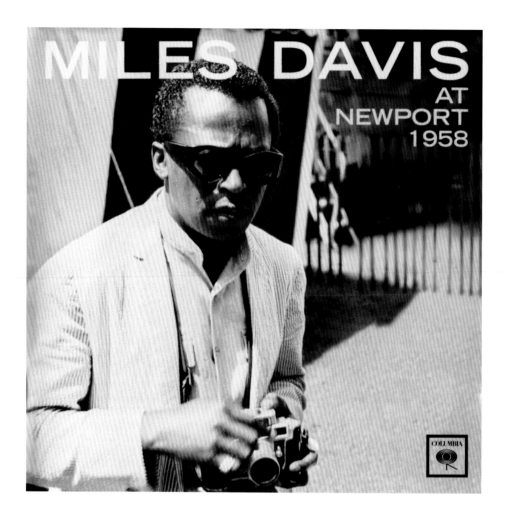

ABOVE:

Cooler than just about anyone, jazzman Miles Davis, who had always been something of a style icon, got hip to preppy in the 1950s and demonstrated his fondness for the style by showing up at the 1955 Newport Jazz Festival where he performed his musical magic in an unwiltable seersucker suit.

OPPOSITE:

Artist and scene-maker Andy Warhol never forgot his conservative advertising agency roots where he was influenced by the button-down shirts his colleagues wore. No matter how un-buttoned the scene, Warhol stayed true to his Brooks Brothers b-d's all through his life— amidst his wardrobe of black turtlenecks, of course.

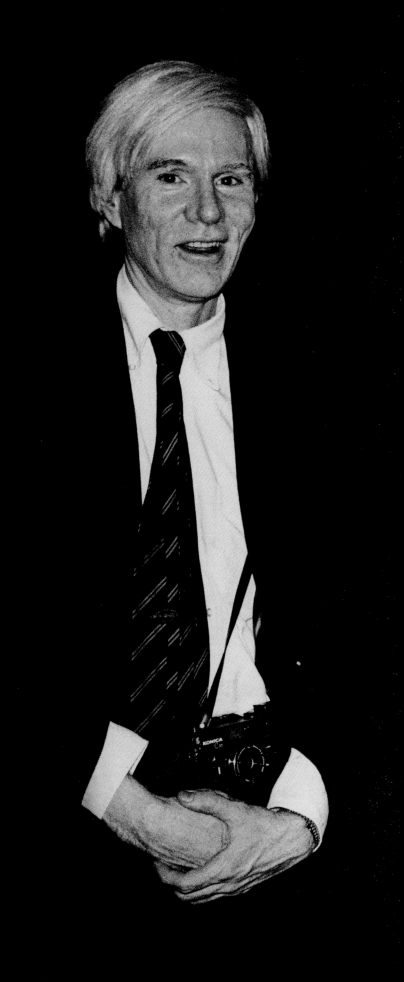

BORROWING
FROM THE BOYS

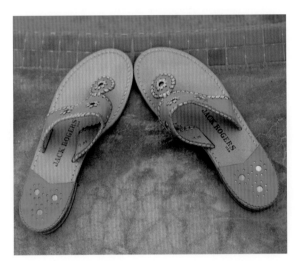

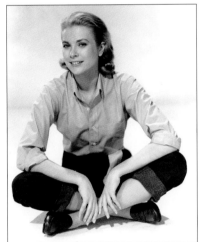

S ince the Ivy League look came to dominate men's college campuses, it was only
natural that women would want in on it, too. As early as 1910, when Brooks
Brothers introduced their sporty-classic polo coat for
men, young women marched straight to the Madison Avenue
men's emporium to purchase the coats for themselves—in the
boys' department, since Brooks, in those days, catered strictly to
men.[1] In the following decades, the handsome, double-breasted
coat, buttoned on "the "wrong side," just like the boys', was
one of the early examples of Ivy League style that was deemed
acceptable for both men and women.

 In the early part of the twentieth century, borrowing from
the boys wasn't an entirely new concept: women sometimes
wore men's Ivy elements like boyfriends' letter sweaters or

OPPOSITE:

*The tartan plaid often associated with schoolgirl
uniforms graduates to college, 1946. Unlined blazer
in Dress Stewart tartan over a sweater, long Bermuda
shorts, knee socks, and bias-cut tartan shoes-to-match.*

ABOVE LEFT:

*The classic Jack Rogers flat-heeled sandal, whipstitched
with contrasting leather in turquoise and gold (also
available in pink and green and every color combination
a preppy girl could conjure).*

ABOVE RIGHT:

*Grace and Poise: Ms. Kelly in pink button-down shirt
and skinny pants, 1954.*

regimental-striped school scarves. But when female students at Eastern single-sex colleges began to test the idea of wearing pants, the administrations responded with a resounding "no": as far as the authorities were concerned, a student wearing pants was both flaunting propriety and risking the loss of her feminine appeal. Wearing pants was even said to have evidenced "bad manners."

The Skidmore College Handbook from 1924 included a section entitled simply "Dress," which painstakingly detailed what types of attire would and wouldn't be tolerated on and off campus.

> Hats must be worn on Broadway [the main street of Saratoga Springs, New York, where Skidmore is located]. Sneakers, athletic sweaters, riding habits, and knickers are not to be worn in the business section of the city. Students... may wear sneakers and athletic sweaters when on a bike. Knicker costumes and riding breeches may be worn on long hikes and for skating and bicycling, if of suitable fit and appearance... Riding habits may be worn only for riding and coats should come well below the knees.

While many of the elite "Seven Sisters" colleges (Wellesley, Smith, Mt. Holyoke, Vassar, Radcliffe, Bryn Mawr and Barnard), may have frowned upon their students wearing trousers or "athletic" clothes as day wear, some students chose to wear pants for comfort's sake, while studying in their dorms. "The relaxed attitude toward clothing had solidified into a distinctly recognizable student style by the 1930's. You could lead a person blindfolded into a girls' dormitory anywhere and, as soon as you removed the bandage, she could tell by a glance at the first six girls she met whether she was in a co-educational or women's college," noted the president of the student government at a single-sex school. "The fluffy ruffles that are admired in the classrooms at Northwestern and Michigan would seem ridiculous at Vassar and Smith. They think we're sloppy. We think they're overdressed."[2] As there were no men present during the week at women's colleges, there was no pressure to compete with other women in terms of clothing or dates, which allowed female students to focus more intently on their studies. Not only did they appreciate the ease and informality of the clothes, women also began to suspect that if they dressed more like men, they might be taken more seriously on an intellectual level.

OPPOSITE TOP:
Playing tennis in long skirts might have hampered their footwork but not the spirits of the all-women Skidmore College's tennis team, ca.1914.

OPPOSITE BOTTOM:
Girls at Miss Porter's School pose for their class photograph in boys' Brooks Brothers polo coats (note the right-to-left buttons), early 1920s. Brooks Brothers introduced the polo coat to America around 1910, and by the 1920s, it was a must-have across eastern campuses.

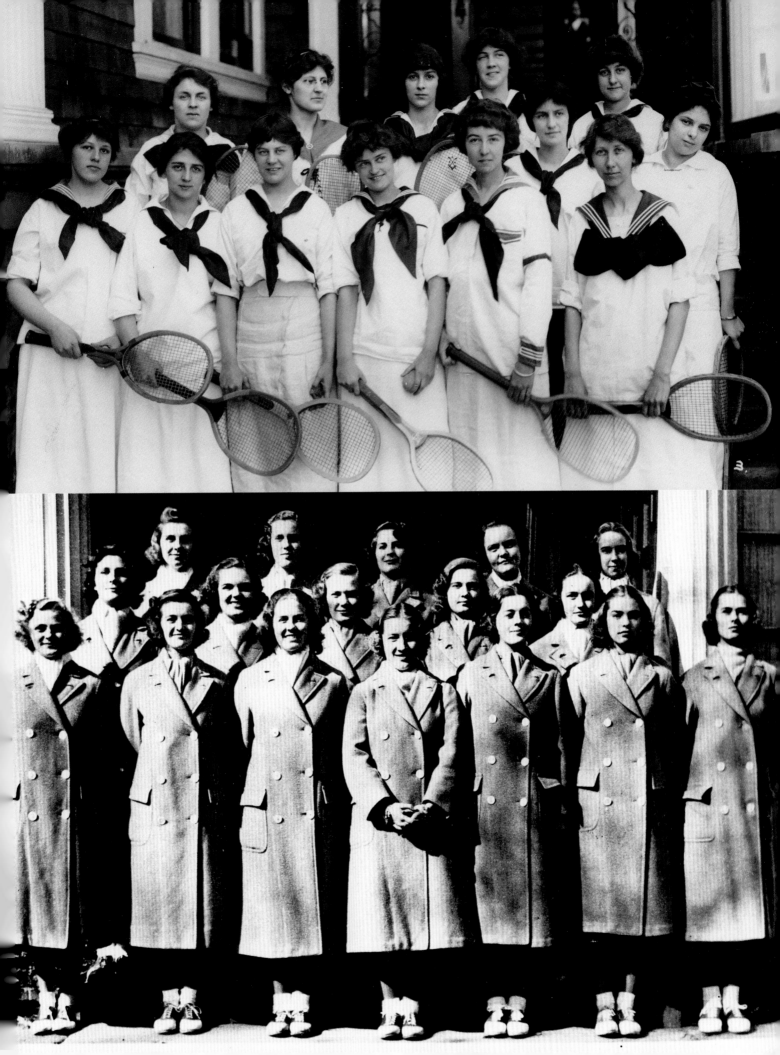

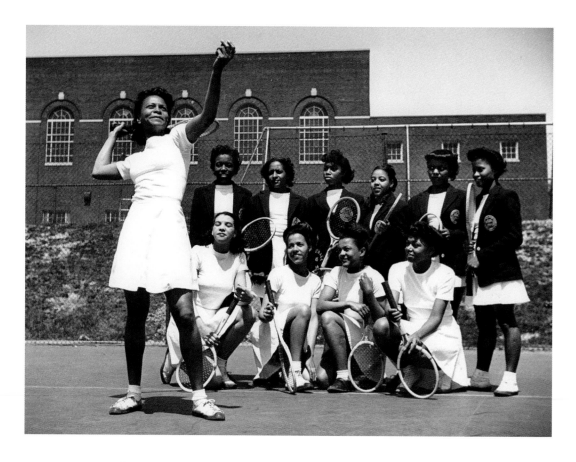

As it turned out, Brooks Brothers rose to the rescue: in 1949 the store launched a pink button-down shirt, made especially for women. *Vogue* magazine saw fit to commemorate the event by putting the pink button-down shirt in its August 1949 issue, creating an overnight sensation in the fashion industry causing women to mob the store.

During the same post-World War II period of time, an unusual blip on the screen of women's single-sex college history took place. Young World War II veterans—beneficiaries of the G.I. Bill that promised to pick up the cost of a soldier's education—were enrolled at a number of women's single-sex colleges to complete their education. There were many interesting repercussions from the "temporary co-education" (Vassar did not go coeducational officially until 1969); however, in terms of fashion influence, the presence of men produced interesting results. Freshly back from the front, the men brought with them a can-do attitude and their government-issue khakis. The sturdy trousers that had served them so well as a military uniform then became a uniform of a different sort: everyday go-to trousers for collegians who found they could pair comfortable, slightly rumpled, casual khakis with everything from a beaten up old sweater to a sport coat and tie.

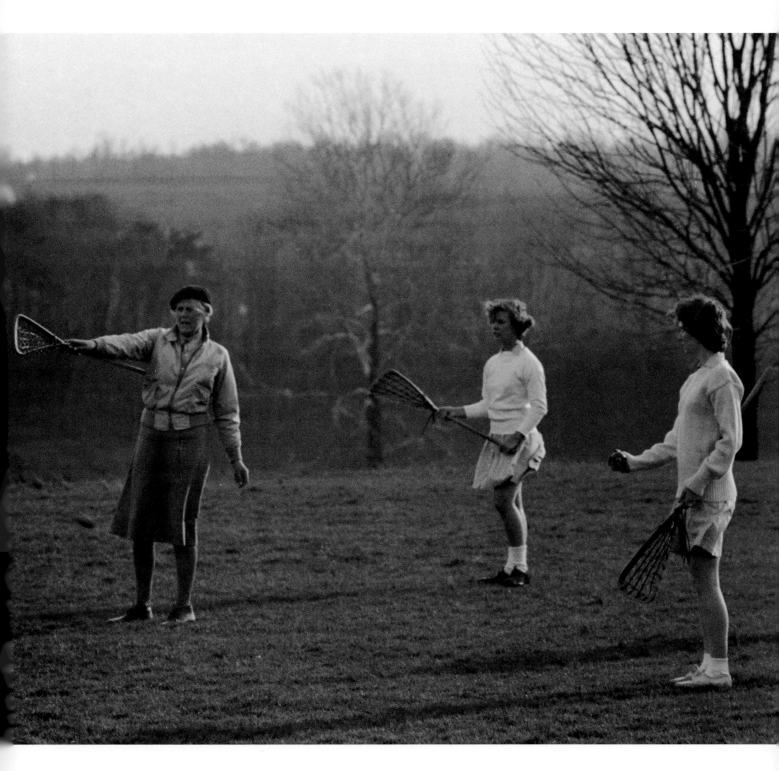

ABOVE:

*Sweet Briar College lacrosse practice, 1951. "What is considered healthy psychological development in a man—
aggressiveness, independence, ambition, courage, competitiveness—was viewed as unhealthy in a woman. Yet it is
precisely those qualities that are found in every athlete, male or female. Whatever it is that works for little boys also
works for little girls" (excerpt from the* Time *magazine's article "Comes The Revolution," June 26, 1978).*

OPPOSITE:

Howard University's women's tennis team practices their serves, 1949.

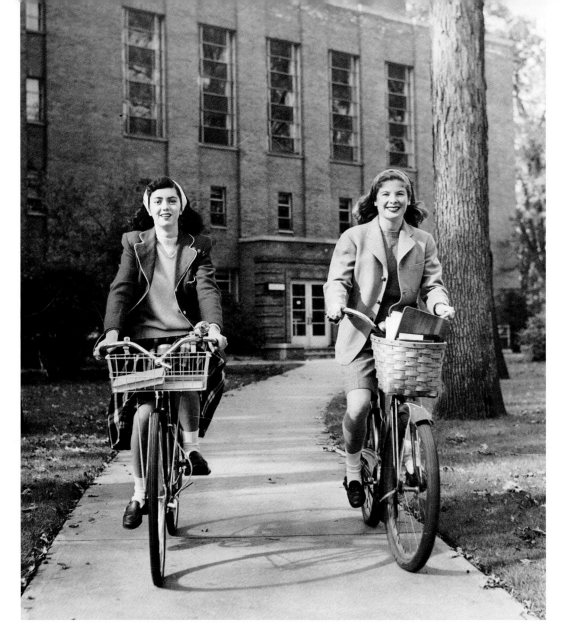

92

ABOVE:

Skidmore girls pedal to class in blazers, Shetland sweaters, Bermudas, and skirts, 1948.

RIGHT:

When the G.I. Bill was passed after World War II, so many veterans took advantage of the opportunity that the single–sex women's colleges like Skidmore opened their doors to men, shown here, ca.1946. As a result, the girls picked up some fashion items from their male classmates, like Bermudas and khakis. The co-ed experience lasted only for a short time, but it pre-figured the ultimate move to co-education in colleges that really took over around 1969.

OPPOSITE:

Yale-Vassar Bicycle Race, 1952. A fun relay race from New Haven (where Yale is located) to Poughkeepsie (Vassar's home) spanning 175 miles was an informal social event meant to bring the two single-sex colleges together. An annual event for some years, it was followed by a plunge in the lake and a beer and picnic lunch afterward. Naturally, the boys did all the biking while the girls cheered them on.

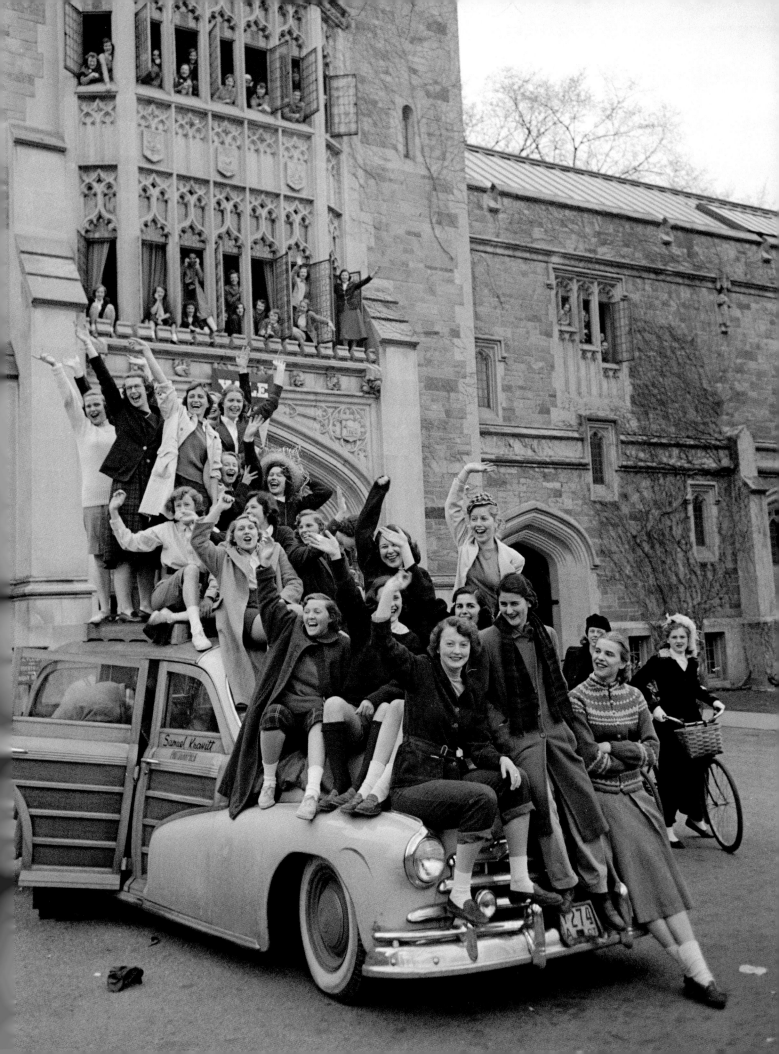

One giant step for women: in 1949 the much-beloved, borrowed-from the-boys, button-down shirt that women had been buying from Brooks Brothers in the Boys department, is finally made available in women's sizes by the men's specialty store. While this hardly sounds buzz-worthy today, Vogue *magazine featured it* (above); Life *magazine put it on its cover* (opposite). *The store was besieged with women clamoring for their emblem of the Ivy League.*

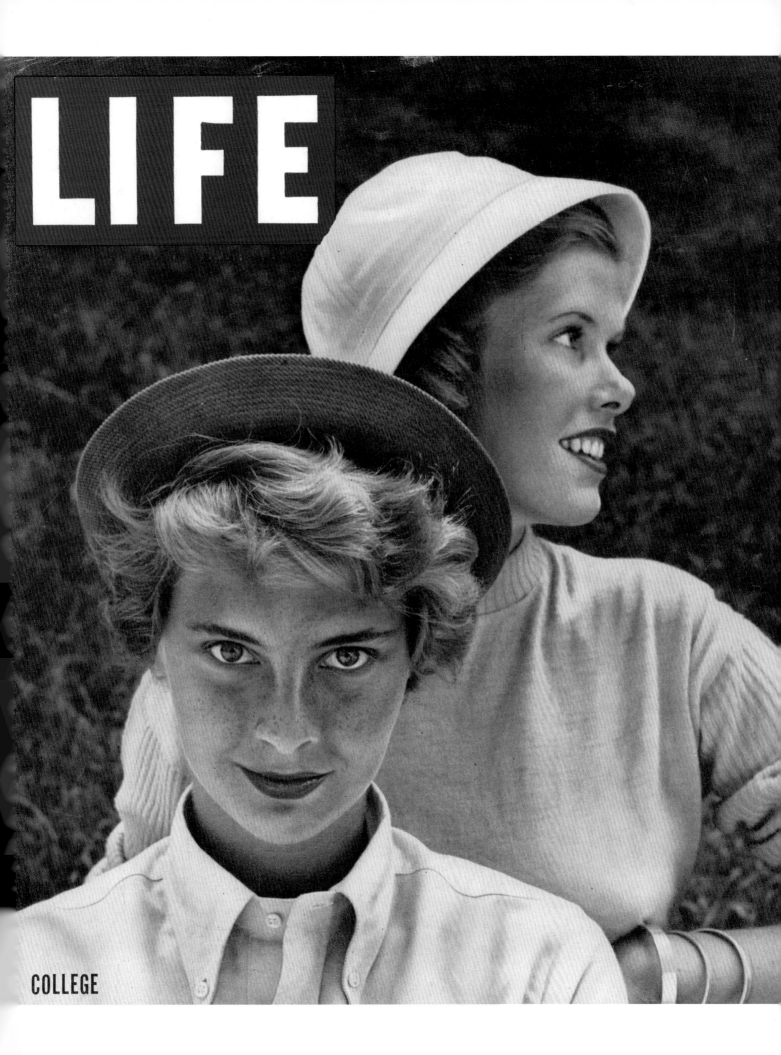

LIFE

COLLEGE

Within a short period of time, women at Vassar, Sarah Lawrence, Skidmore, and Smith were sporting khaki pants or shorts, along with a number of items from the men's Ivy roster, such as Bermuda shorts and blazers in wool flannel or tartan, Shetland sweaters, saddle shoes, Weejuns and Sperry Topsider boat shoes. In 1954, Brooks finally equipped a small section of one of its men's floors with women's fitting rooms so female shoppers might have privacy to try on merchandise before buying. Ivy was gaining new ground for women.

Soon other women's designers and manufacturers jumped on the Ivy-League bandwagon and began producing refined, feminine Ivy classics: McMullen, the Glens Falls, New York manufacturer credited for originating the classic shirtwaist dress; and later, John Meyer of Norwich and Villager, who became the go-to sources for women seeking crisp, collegiate looks. These clothes often mixed menswear details, like an Ivy-League buckle on the back of a pair of Bermuda shorts, with feminine flourishes; Oxford cloth shirts were softened with rounded Peter Pan collars; McMullen's Bermuda-collared blouses, done in delicate Liberty prints, were paired with mini-cable cardigans with knitted buttons and color-matched linen pants or skirts; fuzzy Shetland crewnecks from Drumohr or soft pastel cardigans were trimmed with grosgrain ribbon down the front; ladylike cashmere sweater sets from Pringle and plaid skirts from Pendleton were legion, as were pleated tartan skirts or kilts with knee socks and loafers; Fair Isle sweaters, with their intricate yokes, were knitted in heathery Scottish hues; and then there were simple linen shifts monogrammed just below the neckline, trim A-line skirts in linen or hopsacking, horn-toggled duffel coats, little black dresses and Louis-heeled pumps; not to mention the authentic Indian, guaranteed-to-bleed cotton madras plaid—the Iviest icon of them all—which became a women's warm-season staple, in the form of shirtwaist dresses, blouses, wrap skirts and Bermuda shorts.

OPPOSITE CLOCKWISE FROM TOP LEFT: *Enjoying the game in a belted pea jacket and polo cap, 1950; college student Carolyn Rice from Oregon State in tweed pants and crew over a turtleneck sweater, 1957; Briarcliff girls pack into the Volkswagen Beetle convertible—a nifty economical car ubiquitous on college campuses in the 1960s.*

For resort and summer there were, happily, Lilly Pulitzer's sunny, signature dresses, Capri pants, and bathing suits in riotous patterns of hot pink, parrot green, orange, yellow, and all the blues of the sea. Socialite-designer Lilly had started out by making simple sleeveless shifts for herself and her friends in Palm Beach. The friends happened to include former Farmington schoolmate, Jacqueline Bouvier Kennedy who, as the wife of President John F. Kennedy, was *the* style arbiter of America. When Mrs. Kennedy was photographed for *Life* magazine in her Lilly shift, that image launched

thousands of Lillys; the simple, lace-seamed body-skimming dresses became must-haves at every resort. Lilly added pants, tunics, swimsuits, even shirts, Bermuda shorts and blazers for men in her tropical prints—probably the first instance of women's preppy clothes influencing men's. Though she retired from the scene in the 1980s, when the company was reconfigured under new ownership in the '90s, the new owners brought back Lilly as a consultant. Her lighthearted Lilly clothes live on as sunny, sartorial perennials, season after season, worn by grandmother and granddaughter alike, with more offshoots blossoming each year.

Women's collegiate looks were also defined by a multitude of details: the right jewelry, the proper bags, the perfect shoes—a treasure chest of must-have accessories that telegraphed not only who a girl was, but also where she had traveled. In the '50s and '60s the "it" jewelry included creamy pearls (preferably inherited from her great-grandmother), delicate gold circle pins or solid gold discs monogrammed with three initials, gold disc earrings monogrammed to match, and colorful exotic scarab and gold charm bracelets—particularly if they sported charms from your various European holidays. The must-have bags were comprised of trim wooden-handled "Bermuda" bags with linen slip-covers that could be changed on a whim and beautifully woven Nantucket bags—baskets, really—trimmed with scrimshaw carved into nautical motifs (if you hadn't gotten it in Nantucket, you didn't have the right one). Little triangular cotton scarves that you tied in back (a look Jackie Kennedy perfected in her trips to Capri) and neat headbands —in grosgrain, velvet, or madras in the spring—topped off the accessory list. Girls borrowed Weejuns, saddle shoes, and bucks from the boys, but they also wore Capezio ballet slippers (very Audrey Hepburn) or delectable, collectible Pappagallos, slip-ons that were shaped like Belgian loafers, but piped and bowed in contrasting colors like pink and green, or red and navy. And then there were Jack Rogers' sexy little Navajo sandals to show off one's perfectly pedicured feet.

Lee Smith, author of *The Bubba Stories*, 1991, provides us with a perfect Kodachrome snapshot of the early '60s southern, to-the-manner-born preppy, entering college, as observed by an outsider:

ABOVE:

For many years Glamour *magazine's August college issue (the biggest issue of the year) featured 10 young women as* Glamour's *Best-Dressed College Girls, one of whom was Mary Patricia Cogan of Sweet Briar College, here on the magazine's August 1967 cover.*

OPPOSITE:

Ali MacGraw and Richard Benjamin in Goodbye Columbus—*a story of young, upwardly mobile love in the Westchester suburbs, 1969.*

ABOVE:

The bike and baggage-laden station wagon, the well-groomed mother, the fresh-faced tartan-skirted daughter: 1961 portrait of a Skidmore freshman on her first day.

OPPOSITE:

Anne Ford (left) and Marcia Meehan (right) in sophisticated prep with a soupcon of St. Tropez at The Meadow Club in Southampton, ca. 1961. Anne mixes American prep classics with sandals from Capri; Marcia wears espadrilles from the south of France and carries her Nantucket bag.

Dixie Claiborne came from Memphis where she was to make her debut that Christmas at The Swan Ball. She had long perfect blond hair, innumerable cashmere sweater sets and real pearls. She had a lot of friends already, other girls who had gone to St. Cecilia's with her (at first, it seemed to me that a good two-thirds of all the girls at school had gone to St. Something-or-other). They had a happy ease in the world and a strangely uniform appearance that I immediately began to copy— spending my whole semester's money, saved up from my job at the jeweler's, on several A-line skirts, McMullen blouses and a pair of red Pappagallo shoes.[3]

The author, Ms. Smith, hits all the marks of the southern preppy: pearls and perfect blond hair, the right clothes, the friends from St. Cecilia's or Saint Something-or-other with their familiarity and their similar appearance—all packaged in McMullen blouses, A- line skirts, and Papagallos. But far more than the pearls and sweater sets, it's that "happy ease in the world," the nonchalant, slightly careless quality Dixie wears lightly, along with her pearls, that has always been at the heart of preppy appeal.

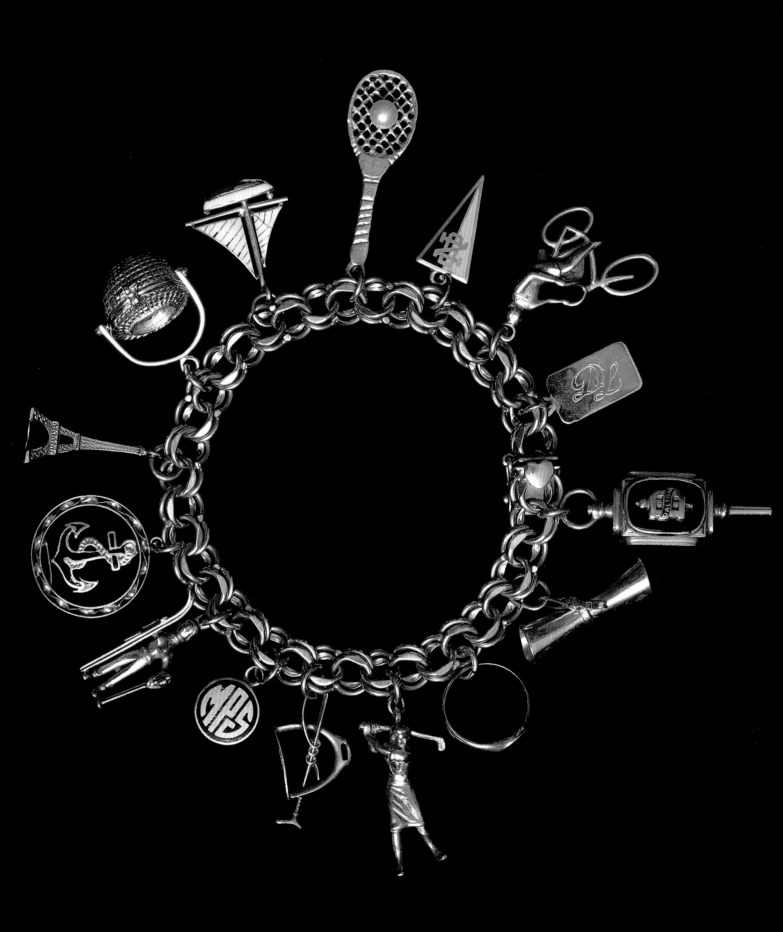

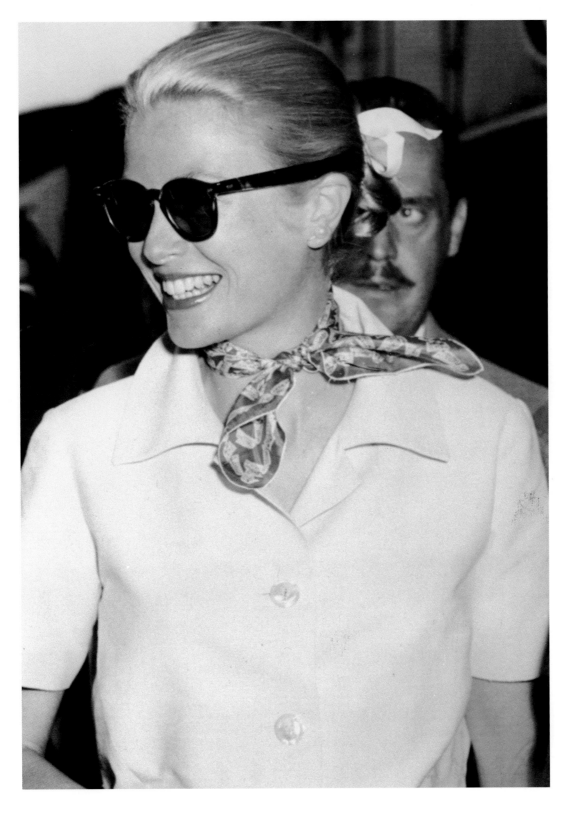

ABOVE:

Grace Kelly adds a French touch to her American sportswear look with a pleated Hermes neck scarf, 1956.

OPPOSITE:

Deanna Littell's Charm School: a chunky gold charm bracelet is festooned with carefully-collected charms.[4]

ABOVE:

Slim Aarons captures Mr. and Mrs. Donald Leas at the entrance to the Flagler Museum, Palm Beach, 1964. Mr. Leas is the paradigm of a Palm Beach gentleman in his straw-hat, blue blazer, and Lilly Pulitzer pants—perfectly complementing his wife's mimosa-colored, ankle-grazing Lilly dress.

RIGHT:

Lilly Pulitzer striped shift, 1968.

OPPOSITE:

Lilly Pulitzer and her Lilly-clad daughters in matching sun-drenched dresses that seem to be spilling with daisies, 1968.

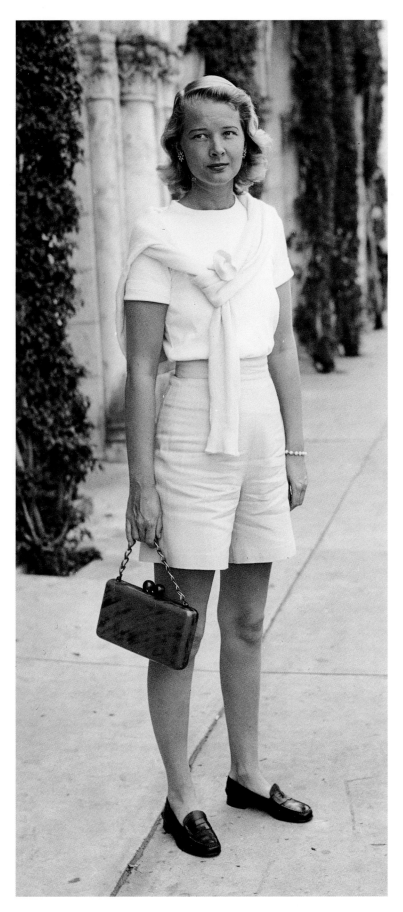

LEFT:

C.Z. Guest on Palm Beach's Worth
Avenue in the classic American good
looks she wore like a second skin—
cashmere sweater tied over a short-sleeved
crewneck, linen Bermudas, and loafers.

BELOW:

Jacqueline Kennedy and her daughter
Caroline stroll on a pier in Amalfi,
1962. Jackie sports a neat headscarf,
Capris, and Jack Rogers sandals. The
sandals, based on the classic sandal seen
on the streets of Capri, were allegedly
first spotted on Mrs. Kennedy as she was
leaving St. Edwards Church in Palm
Beach after Sunday Mass in March 1961.

107

OPPOSITE:

Dina Merrill, sleek and chic in a neat and
proper diamond-patterned red and navy
dress, her sweater tied nonchalantly over
the shoulders.

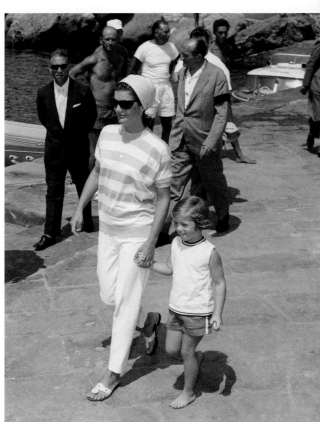

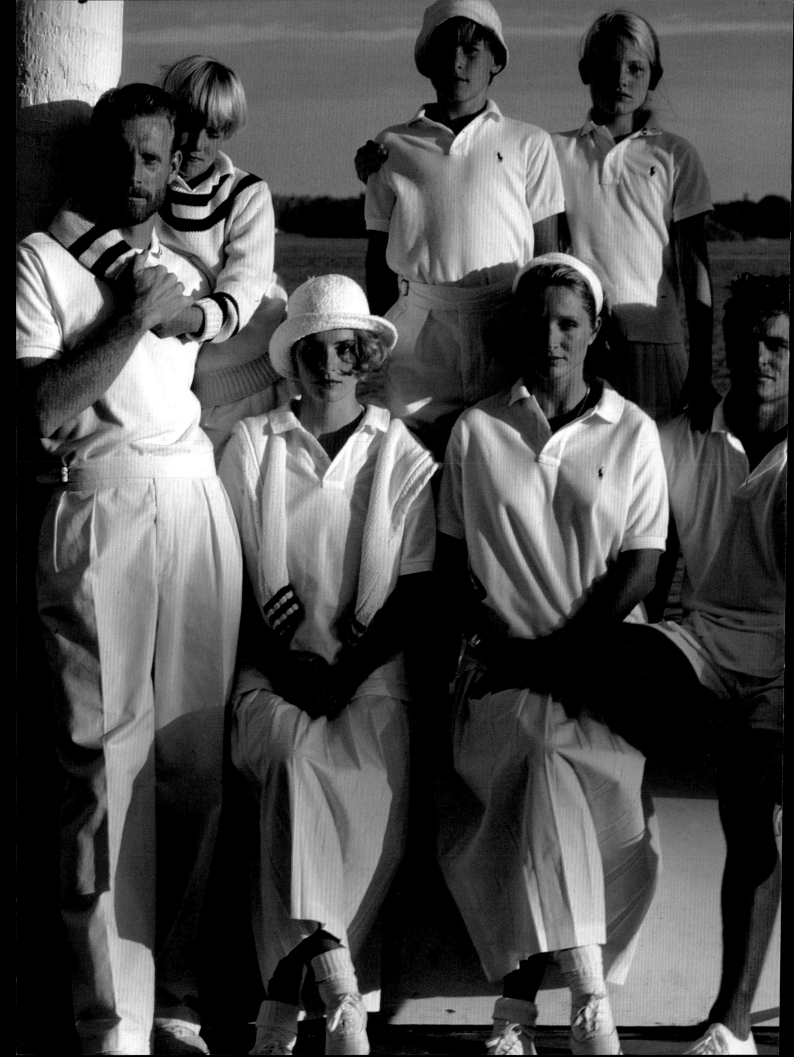

ASPIRATIONAL PREPPY

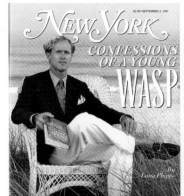

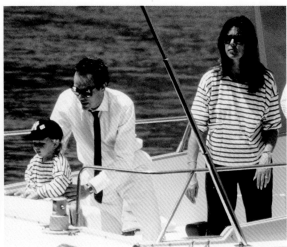

The Ivy style legacy of the Kennedys had almost disappeared (except within the portals of suburban country clubs) by 1968, a year which, not incidentally, saw both Senator Robert F. Kennedy's and Martin Luther King's assassinations, not to mention a surge of anti-war demonstrations and campus unrest. Ivy League college admissions had finally opened up, bringing in a more diverse student body than previously, and students were jolted into a new social consciousness, trading their tweeds and button-downs for tee shirts and jeans, which were devoid of class distinctions. A counter-culture hippie style with its long hair, beads, and bell-bottoms sprung up, usurping the clean-cut conservatism of Ivy.

Despite its virtual disappearance in the late 1960s, the endangered Ivy style, instead of dying on the vine, simply went

OPPOSITE:

High net worth: impeccably-mannered, classic tennis whites with just a trace of navy blue striping. Polo Ralph Lauren men and Ralph Lauren women, Spring 1985.

ABOVE LEFT:

Lang Phipps on the cover of New York *magazine for the much buzzed-about article he penned, "Confessions of a Young WASP." Photographed in Paul Stewart clothing at the Meadow Club in Southampton, 1991.*

ABOVE RIGHT:

Princess Caroline and son Andrea, Monte Carlo, 1985.

underground, and by the late 70s, began developing new offshoots, largely through the nurturing of designer Ralph Lauren. Lauren, who had learned everything he needed to know about Ivy as a young salesman at Brooks Brothers, left the store to embark on a new career, designing and selling a line of fashion-forward ties. A movie buff, Lauren had always hewed toward the sartorial elegance of silver screen leading men like Cary Grant and Gary Cooper; and sensing a need for the nonchalant, Ivy influenced clothes he had always admired, he started a menswear company specializing in fine men's clothing and sportswear based on the Ivy model and aptly named the company Polo, after the world's most elegant sport. Lauren was smart from the start, designing not just Ivy clothes the way they had been, but the way he imagined they might have been; his fabrics were more luxurious, his colors lusher, his sweater cables thicker. Besides designing aspirational clothing, Lauren conjured up the idea of selling an entire aspirational lifestyle: beautiful clothes with a backdrop of idealized houses, perfect wives and children, and perfect dogs. In quick succession, Lauren developed clothes for women, children, and, yes, even a few

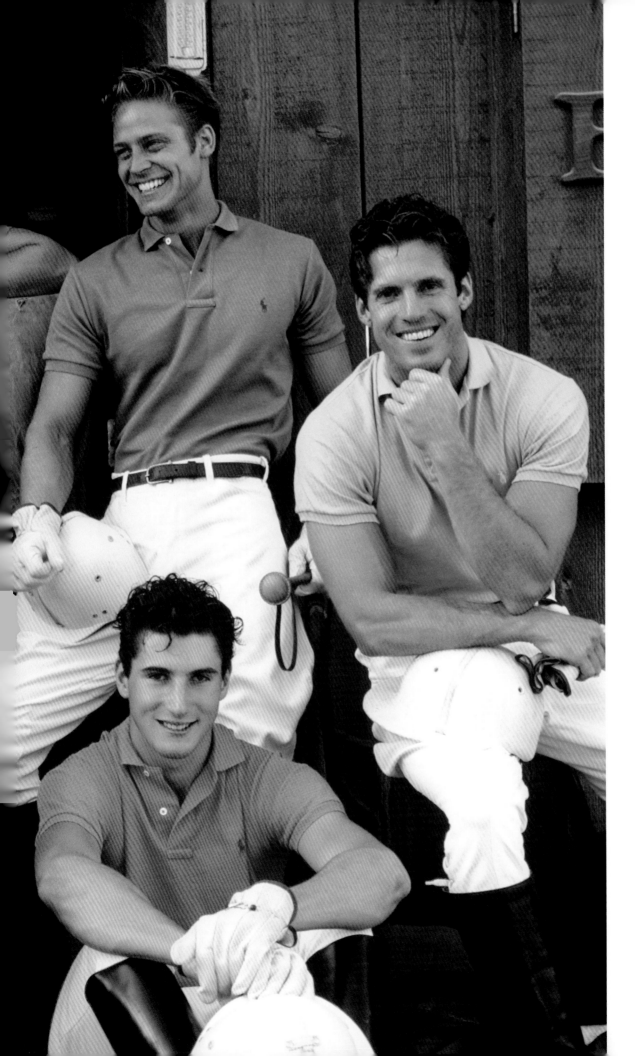

113

*The Ultimate Polo
Team: this 1981
Gentlemen's
Quarterly fashion story
photographed by Bruce
Weber transforms
models into polo
players each wearing a
different colored Polo
Ralph Lauren polo
shirt—the icon of the
brand. The shirt—now
made in almost every
color imaginable—can
be customized with
various color options
for the pony logo.*

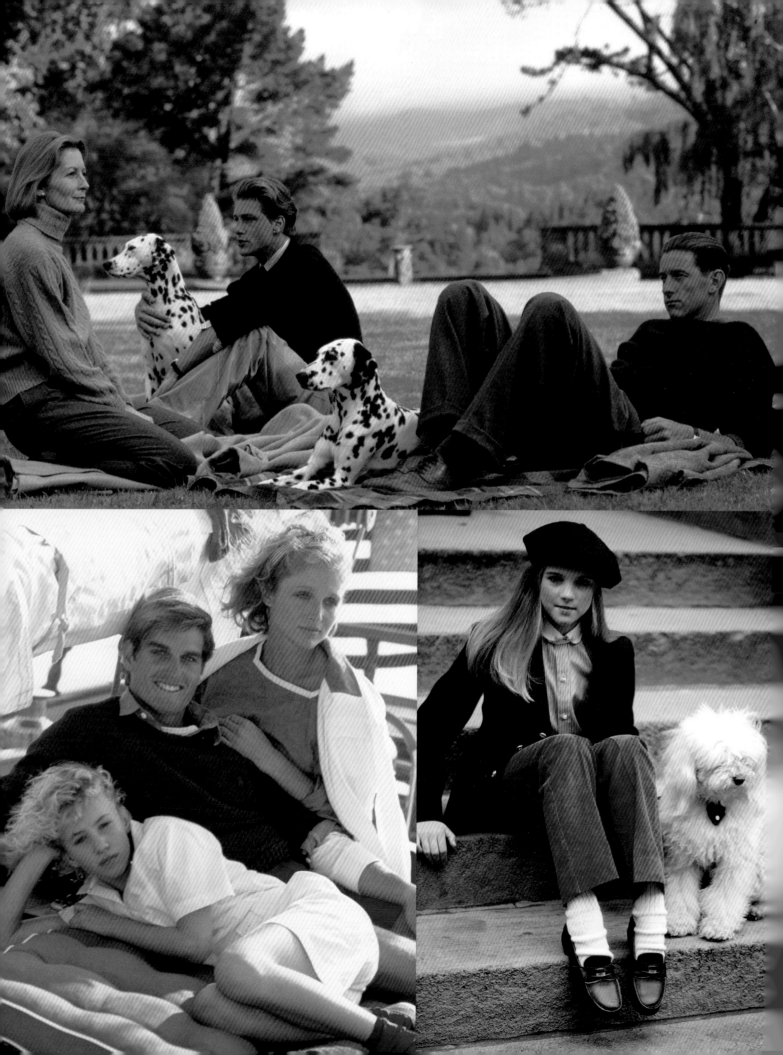

items for dogs; he continued with shoes, sheets, home furnishings, silver, crystal, china, paint, rugs, wallpaper, and more. Suddenly everyone wanted everything-Ralph. It has been said by many in retrospect that had it not been for Ralph's vision and timing, Ivy League style might never have made a comeback.

Fortunately for Ralph, with the election of conservative Republican Ronald Reagan in 1980, America's then sluggish economy started to improve and within a few years, was soaring, bearing with it a new generation of "yuppies" (young urban professionals) with pockets full of money and a strong desire to spend; Ralph's Ivy-League look, with its new iteration and preppy label, became a bolder, more vivid version of its former self. Colors were pumped up to higher volume, tweeds were patterned with purple overchecks, multi-layering was in, and perhaps most importantly, logos and designer names took precedence over retailers'—a fact later immortalized by television journalists demanding to know *who* celebrities are wearing (not *what*).

Preppy fashion began to proliferate at a rapid rate. This did not daunt newcomer Tommy Hilfiger, from upstate New York, who, in 1984, decided to try to break into the exclusive ranks of American preppy designers with a red, white, and blue bang. The 34-year-old Hilfiger launched a company with an audacious advertising campaign, predicting that his name would soon rival that of the big three American designers of the time: Ralph Lauren, Calvin Klein, and Perry Ellis. People in the fashion industry were shocked, but Hilfiger garnered great publicity; his cheerful collections of clothes, initially logo-splashed and colorful, were easy to like and moderately-priced, causing his popularity to soar.

Also among the group of young designers who were part of the new preppy cohort were Alexander Julian, Alan Flusser, Jeffrey Banks, and Sal Cesarani. Alexander Julian grew up in his father's preppier-than-thou Chapel Hill, North Carolina collegiate store (Julian's), and went on to found his own shop, Alexander's Ambition (now Julian's). A talented colorist, Julian often devised not only hues for his fabrics, but the fabrics, themselves, and developed and licensed several eponymous menswear lines. Alan Flusser, who also started out in the '80s, is widely known for his understated elegance, but especially for the overstated clothes he designed for the Michael Douglas character, Gordon Gekko, in the 1985 movie *Wall Street*. Gekko's suits sported excessively wide bead-striped jackets, peak lapels, and roll back cuffs, typifying the brash

OPPOSITE:

Ralph Lauren masters the art of living. His relaxed preppy classics appear even more desirable when surrounded by the comforts of family and dogs.

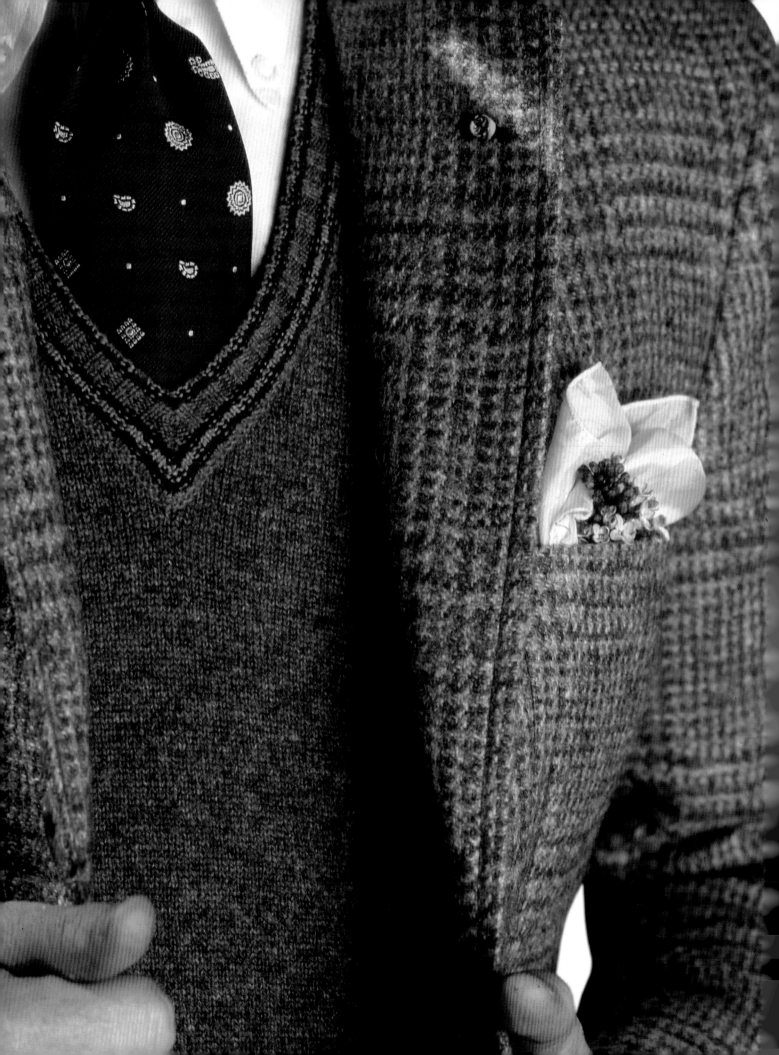

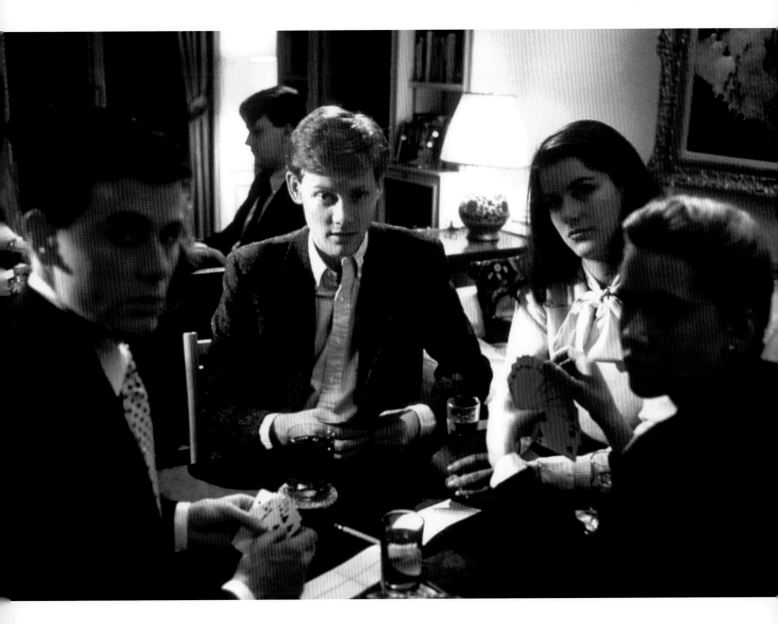

ABOVE:

Metropolitan, *1990: Whit Stillman's prep-centric movie is a thoughtful and nostalgic sort of elegy for the upper classes.*

OPPOSITE:

Alexander Julian jacket, V-neck sweater, foulard tie, and shirt, 1978. Julian took the basic raw materials (tweed, cotton, tartans, cashmere, foulard) that he grew up with at his family's shop, Julian's College Shop, in Chapel Hill, North Carolina and redesigned them with an eye for art.

FOLLOWING PAGE LEFT:

Menswear designer Alan Flusser's sharp focus on Ivy details: back-buckled high-rise pants, braces, and a third button on the back of an otherwise already buttoned-down collar, keeping the collar from rising in back.

FOLLOWING PAGE RIGHT:

Michael Douglas in Wall Street, *1987, wherein Greed was Good and power suits were better—especially when designed by master tailor Alan Flusser.*

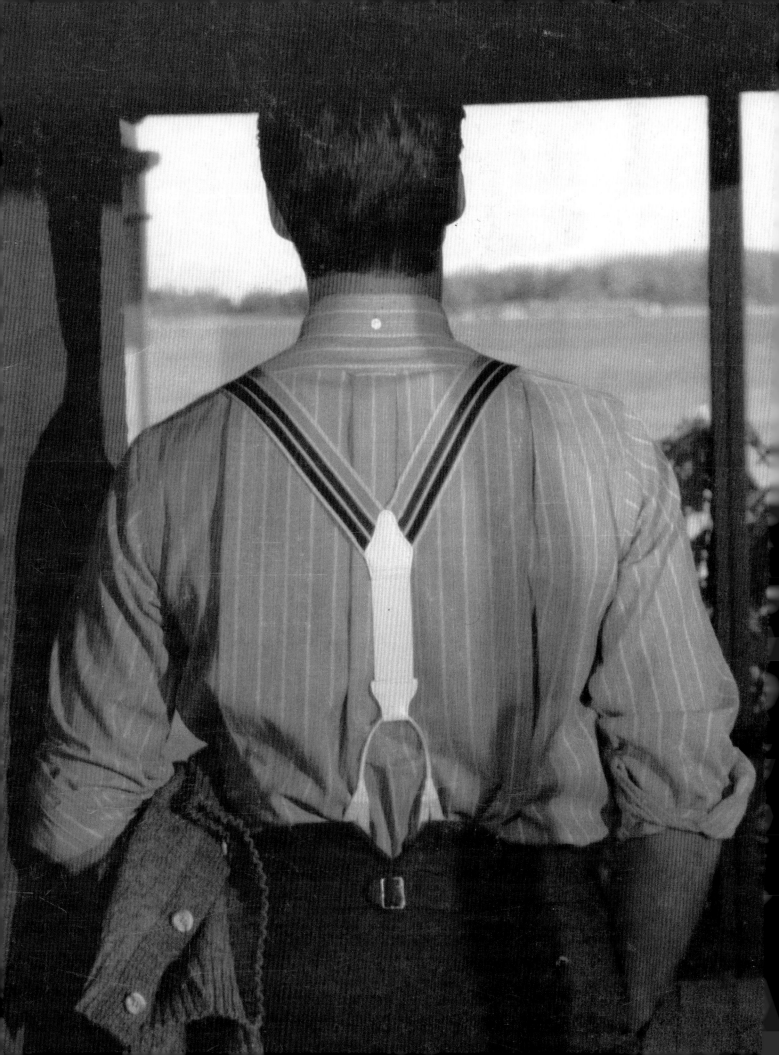

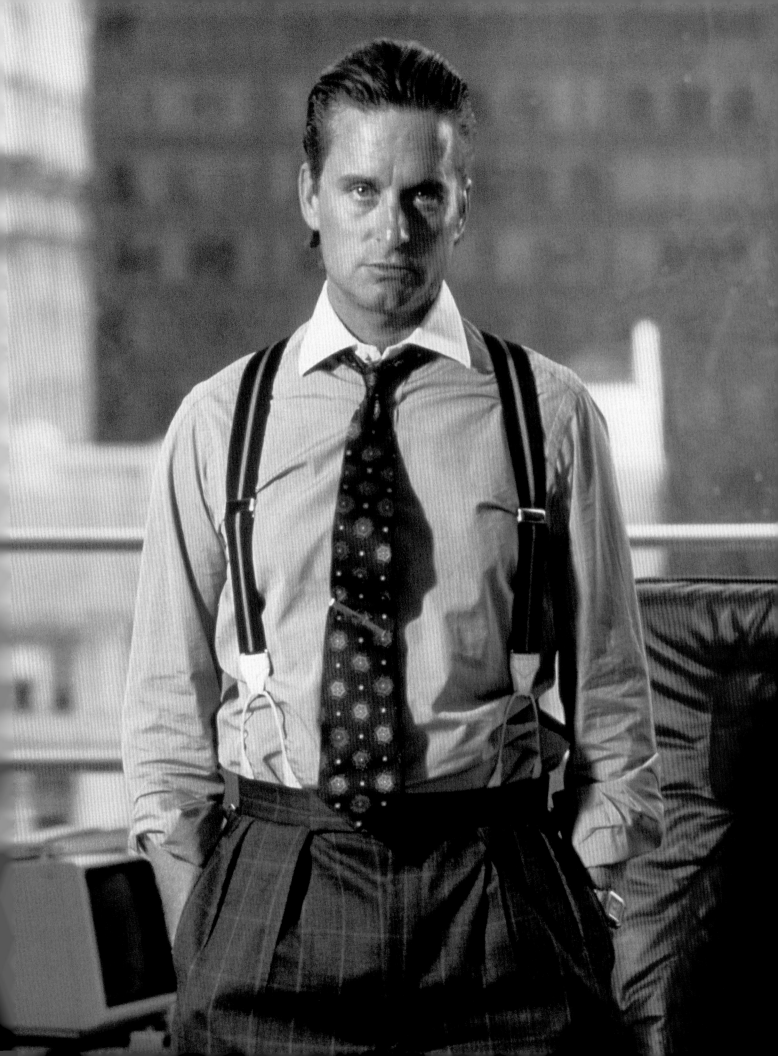

investment banker's credo, "Greed is Good," an oft-repeated phrase of the era.

One of Ralph Lauren's alums, designer Jeffrey Banks, also established his own label, a collection of suavely casual menswear, as well as a line of crayola-colored "spectator sportswear"—a new category of athletic-inspired clothes for Merona Sport which would revolutionize what people wore on weekends.

Weekend dress proved most important to the ever increasing facets of preppy style. The entrepreneurial McLaughlin brothers, Jay and Kevin, with their savings from renovating brownstones in Brooklyn, started an eponymous shop in 1977 in the heart of preppydom—Third Avenue, Upper East Side, Manhattan. Their modus operandi was ingeniously simple: the block between 74th and 75th Streets also housed two of the most popular restaurants on the Upper East Side: JG Melon's and Jim McMullen's. The McLaughlins figured—rightly—that their customer could easily spend an entire Saturday afternoon eating, drinking, and shopping without ever crossing the street. In their first year of business they had to hire a doorman to manage the heavy traffic within the store.[1]

At first the McLaughlins bought from the small stable of stalwart men's designers—like Bert Pulitzer, Sal Cesarani, Barry Bricken, and Gant—but ultimately decided to create their own designs. They also branched into the women's area, as they quickly realized that

120

Jeffrey Banks plays with color and proportion: pumped-up madras plaids, oversized bold-checked button-down shirts, and a matched madras jacket and shirt in khaki and pink, 1982.

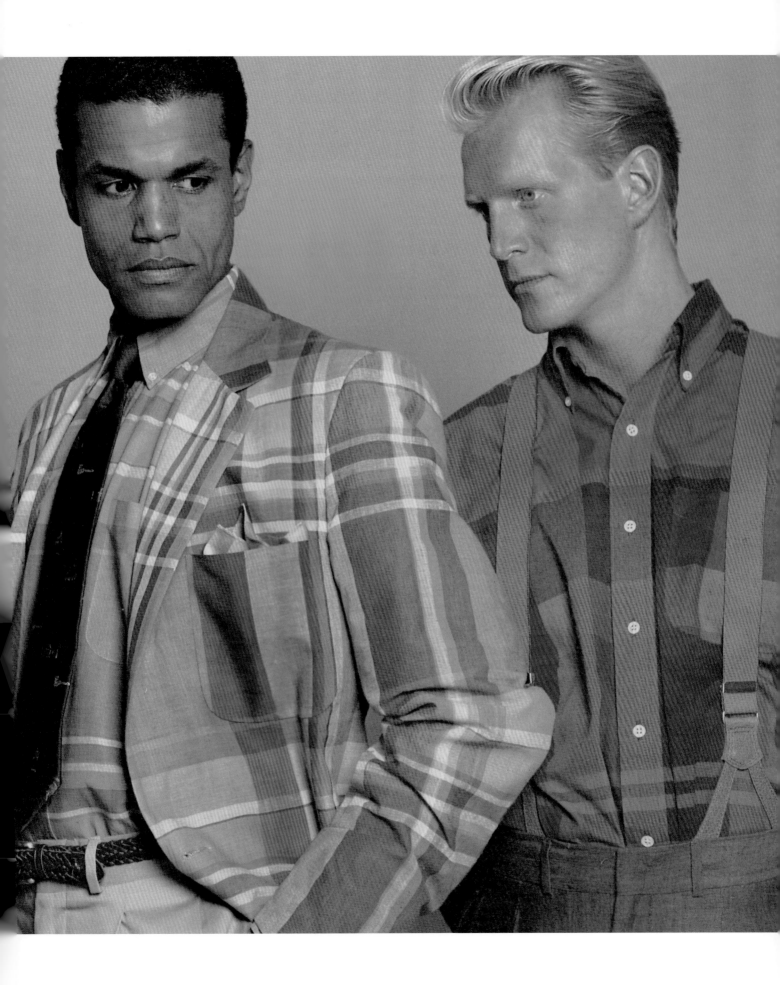

Jeffrey Banks' standout red and black Prince of Wales plaid jacket, white shirt, and black and white repp-striped tie, 1990 (right); and his horse-blanket-scaled tartan jackets for the holidays over brushed shetland sweaters and wide-wale corduroy pants, 1982 (opposite).

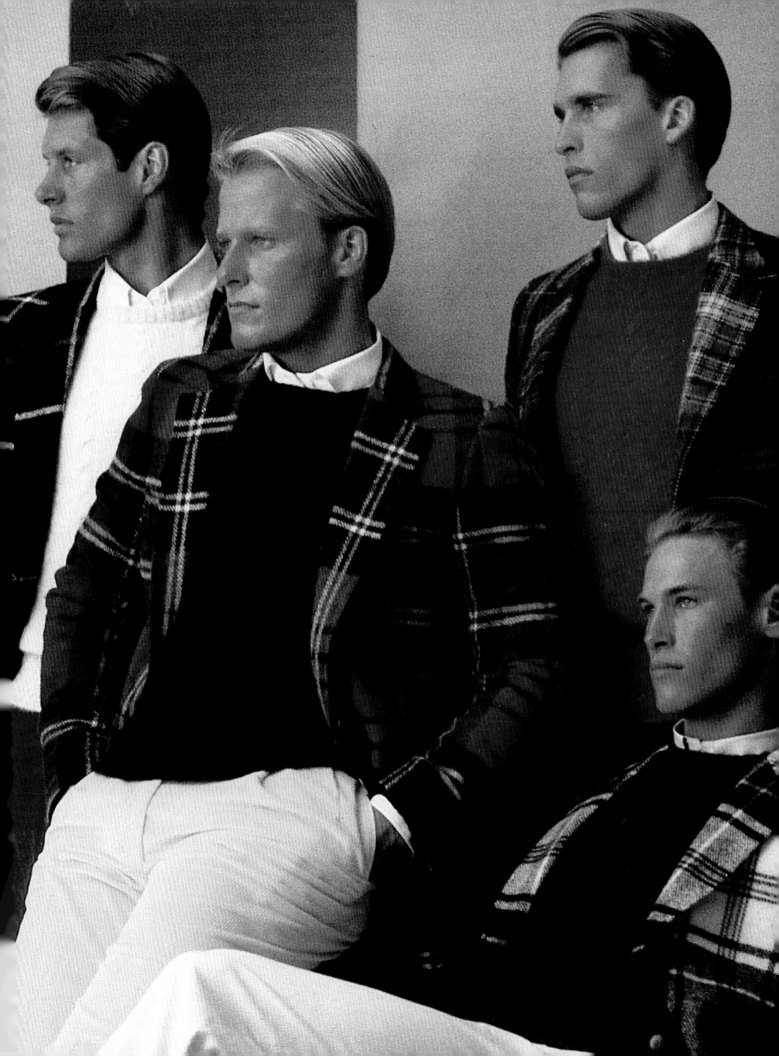

shopping was becoming a coed sport. McLaughlin's sophisticated preppy clothes were loaded with the fine details from preppy vernacular: handmade socks with martini glasses or sailing motifs; handsome needlepoint belts; thin horizontally ribbed corduroy pants; women's cardigans with beautifully scarf-patterned silk fronts; classy quilted jackets; slender Capri pants in an array of melons, pinks, and greens; slim dresses and skirts, handmade in rainbows of ribbon; and a chic wardrobe of bags, big and small—from paisley totes to a tiny little bamboo clutches.

McLaughlin's enterprise has paid off. In the intervening years, they have created a chain of forty-six J. Mclaughlin shops, mostly on the East Coast, each uniquely designed to fit into the historical architecture of its locale.

By 1980, writer Lisa Birnbach and colleagues had published the seminal send-up: *The Official Preppy Handbook,* their "loving, but irreverent" guide to the art (and craft) of preppiness. It is a blueprint, really, for the uninitiated, detailing and demystifying the mind-set and minutia of the preppy demographic: where they live, where they go to school, where they summer, what brands they wear, how they decorate their homes, the preppiest dogs, and the preppiest drinks. Focusing

Shep Miller, outside his shop on Job's Lane in Southampton (right), *is said to have originated the trend of using vibrant "women's colors" to punch up men's sportswear. For over forty years, beginning in the late 1940s, Miller applied his talents to the making and marketing of what was sometimes called "formal beachwear"—bright-colored linen, silk, and madras jackets, flannel, fine corduroys, silk shirts and monogrammed velvet slippers. Miller focused on elegant design, superb fabrics, irresistible color, and individual style—qualities he emphasized to Kevin McLaughlin to whom he was an unofficial mentor. J. McLaughlin's Southampton store sits proudly on Job's Lane, the site of the old Shep Miller shop* (above).

OPPOSITE:

J. McLaughlin's crisp, button-down shirts in graphic gingham checks.

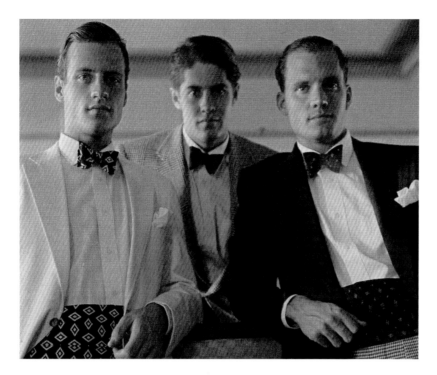

Sal Cesarani's soigné dinner jackets worn with silk foulard ties, matching cummerbunds, and a debonair slouch.

The perfect match: bold madras plaid jackets over matching madras shirts, white pants, and sockless loafers designed by former Ralph Lauren associate Sal Cesarani.

In the 1983 movie Trading Places—*starring Dan Aykroyd as preppy Wall Streeter Louis Winthorpe and Eddie Murphy as Billy Ray— the tennis club is full of prettily preppy girls, one of whom* (wearing headband on right) *is famous 1980s Ralph Lauren model Clothilde.*

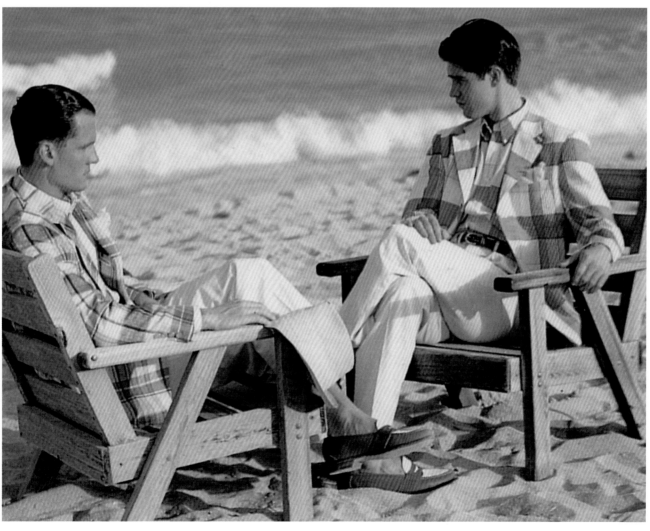

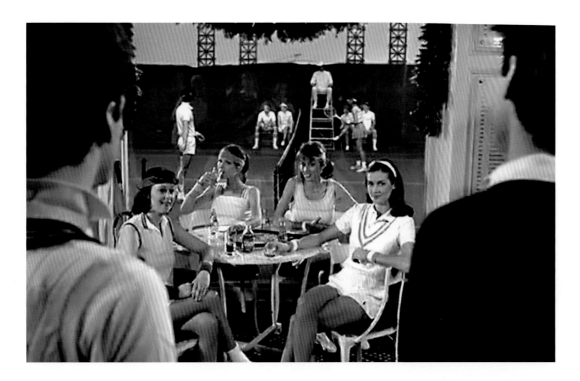

tongue-in-cheekily not just on *what* to wear, but more importantly on *how* to wear,
Birnbach, for example, writes about the need to appear casual at all costs in pitch-perfect
preppy tone: "Socks are frequently not worn on sporting occasions or on social occasions,
for that matter. This provides a year-round beachside look that is so desirable that comfort
may be thrown aside."[2]

To the astonishment of the publishing world, *The Official Preppy Handbook* was
reprinted forty-one times, a stunning phenomenon in publishing and a strong indicator
of the number of "prep-arians" at the gate, clamoring for the key to that "exclusive" club.
It was rumored that some dyed in-the-wool preppies were not all that thrilled with the
handbook, concerned that their realm of "exclusivity" might be at risk if all their secrets
were revealed. Birnbach admits, "There was a little bit of discomfort with the "code"
being shared."[3] As it turned out, they had nothing to worry about.

The ensuing "prep rally" that took place during most of the 1980s was certainly
partially attributable to the power of *The Official Preppy Handbook,* through whose
pages thousands learned for the first time about the habiliments and habits of the
WASP cohort. Ironic or not, the book made preppy seem neat, attractive, and, suddenly,
attainable. And you didn't need to be named Muffy or Biff or have spent a grueling four
years at one of the proper prep schools. Now you could just go to a store, put down your
money, and be a preppy—or *look* just like one.

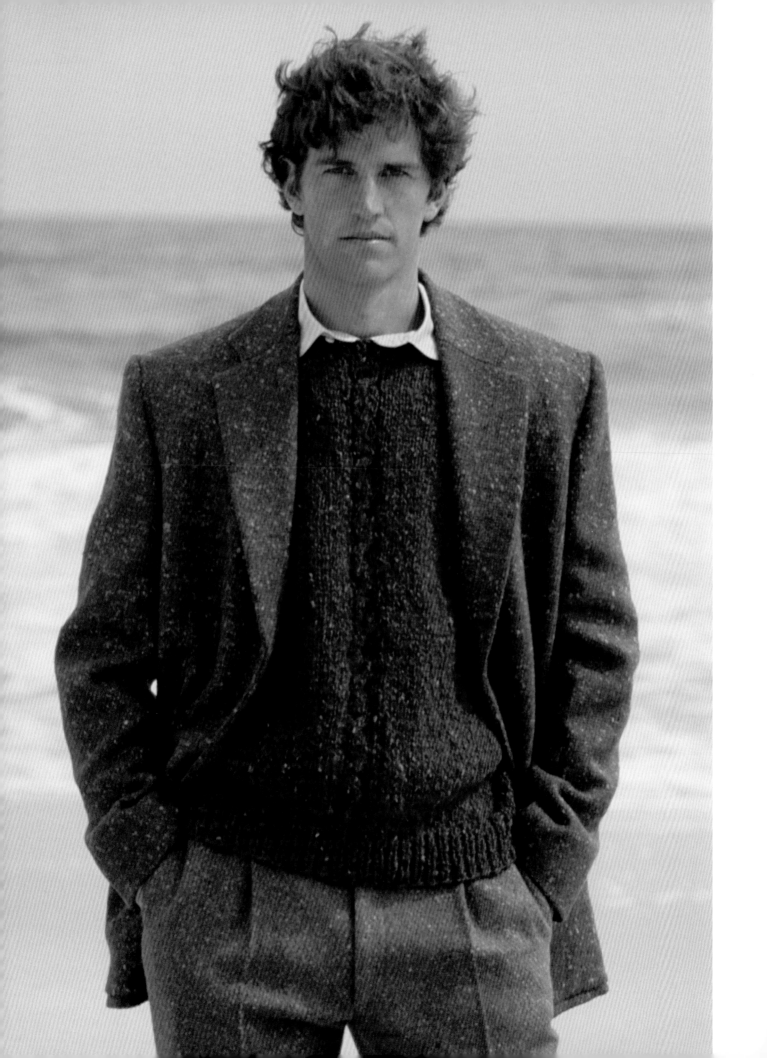

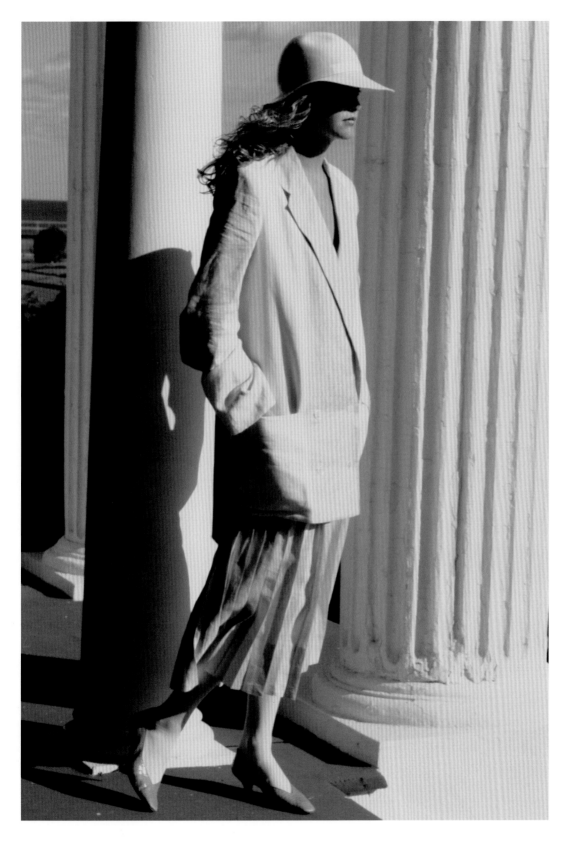

Above, *Perry Ellis' elegantly simple summer dressing—an oversized, cabana-striped linen blazer and matching skirt, and, opposite, his relaxed Donegal tweed sportcoat and signature single-cabled sweater, 1982. A born prep, in 1968 Ellis was the designer for John Meyer of Norwich, the coveted preppy women's line.*

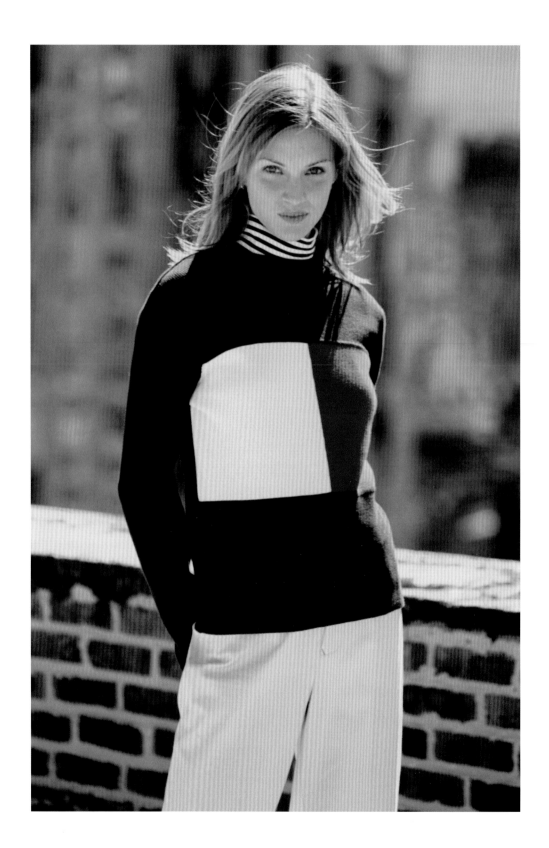

RIGHT:

*Tommy Hilfiger's
semaphore sweater
signals a classic All-
American image with
striped turtleneck and
khaki pants, 197?.*

OPPOSITE:

*The witty and erudite
writer, commentator,
founder, and editor of
the* National Review
*William F. Buckley, Jr.
steers a conservative
course on his yacht on
Long Island Sound.*

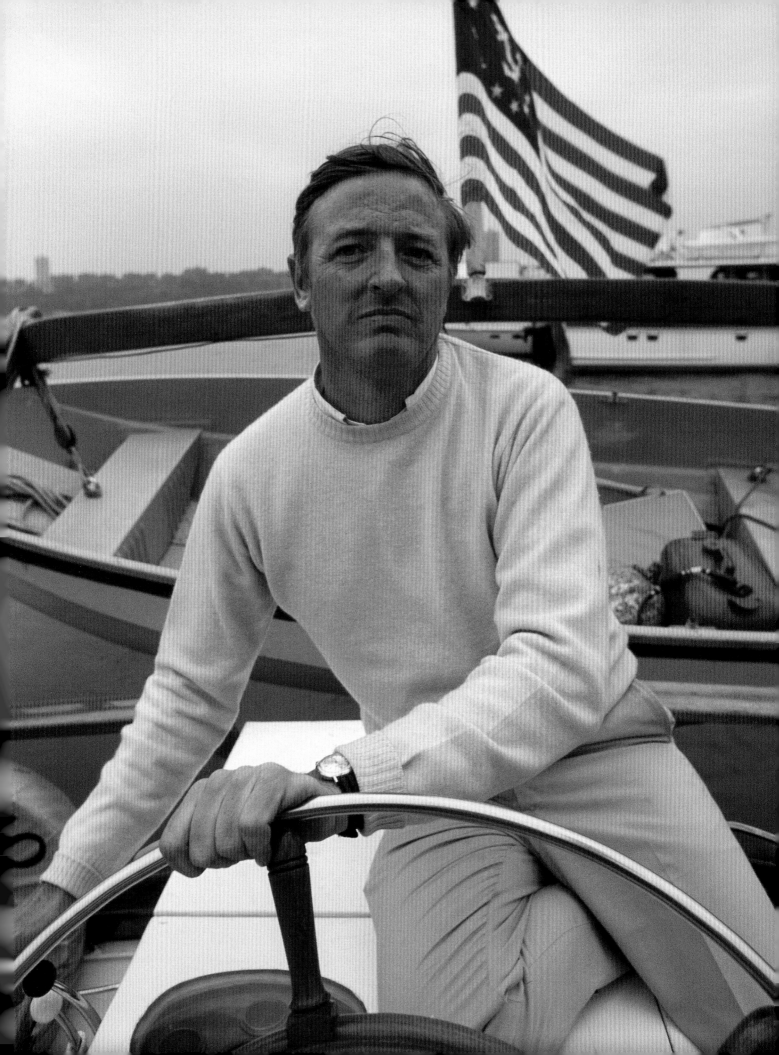

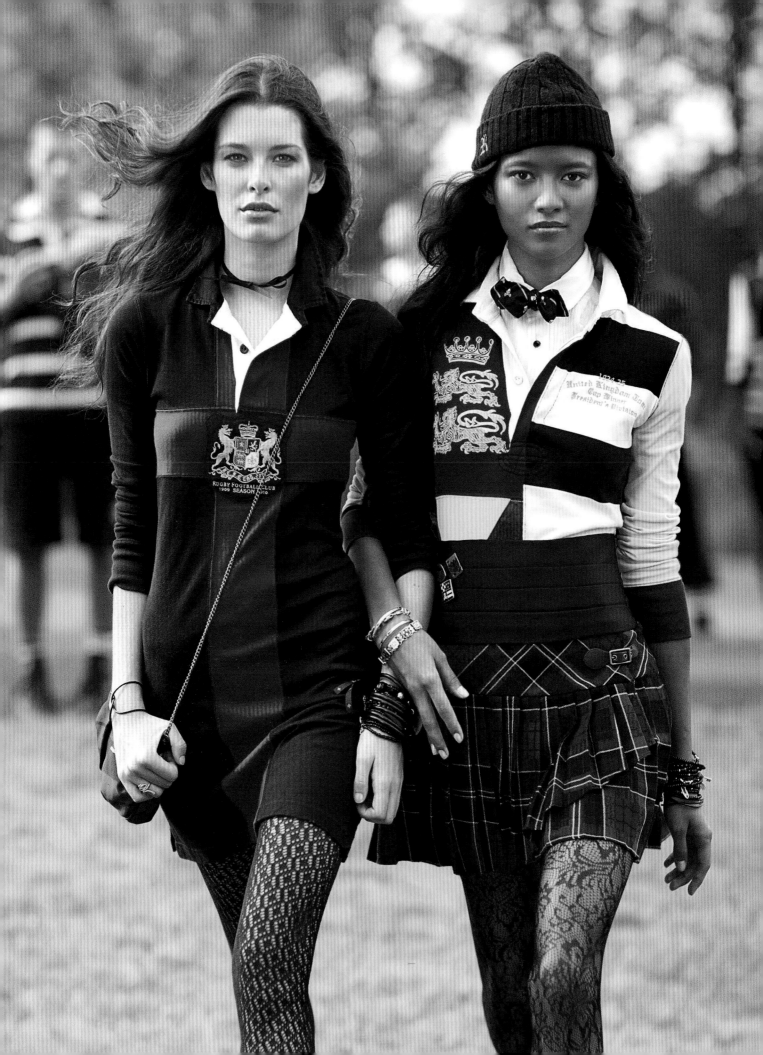

EVOLVED IVY

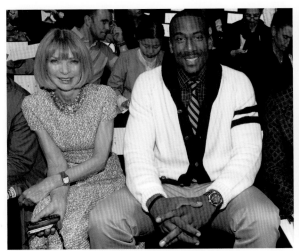
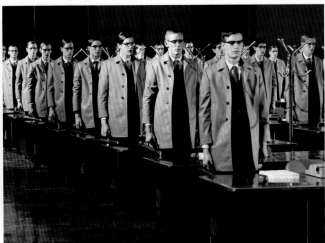

After the politically conservative Reagan years, fashion went minimal, faded to black or fell under the influence of grunge and hip-hop. Dressing down was cool, hoodies were hot, and preppy was relegated to the back of the closet, except during holidays, when a Lilly shift or a pair of Nantucket reds might be dusted off for fun. "Casual Fridays"—a concept that allowed men to go to the office on the last day of the work-week in relaxed pants and shirts (no jacket) and women to dress in a similarly informal manner—emerged as a welcome trend to many, with the exception of the fashion industry, as it swept tailored clothing out of the picture. The trend evolved further into everyday "Office Casual" attire and continued as long as the economy was soaring. But as of fall 2008's recession, the

classic business suit started to make a comeback: men and women, newly unemployed, had to "dress-to-impress" for job interviews. In women's clothing, expensive designer-label shoes and bags ruled the day, and the word "bling," referring to flashy, ostentatious looking jewelry and accessories, became part of the vocabulary—thanks to celebrities and rock stars flaunting mega-watt gems, sequined dresses, and lots of skin. For women in the 2000s, the theme became "more is more."

At the onset of the second decade of the twenty-first century, there has been a strong resurgence of preppy style, which some believe is a reaction to the economy and others characterize as an "anti-bling" statement. Simon Doonan, Barney's ambassador-at-large thinks the new prep rally resulted from the dominance of trashy pop culture in our reality-show world. Doonan considers the new iteration of preppy fascinating in its nuances: "You can wear prep ironically, you know, like a Brooklyn hipster will wear a button-down oxford but it will have frayed cuffs and maybe tears in it. Or fit like it belonged to their littlest brother in a shrunken, preppy prep school kind of look. Or you can have the people in the Hamptons or Palm Beach who never relinquished their prep and wear it without any iota of irony–you know, fully embrace it. So between those two extremes there are a million ways to engage with prep."[1]

Engaging with prep has indeed become a gigantic business, for companies big and small, who are now focusing on appealing to a younger, hipper, more upscale preppy clientele. At the giant end of the spectrum is J. Crew, whose founder, Arthur Cinader once claimed that he started the company after he was inspired by the successes of "The Official Preppy Handbook" and Polo Ralph Lauren in 1983. The plan was to create uncomplicated preppy style—a price-conscious alternative for a growing contingent of yuppies. Starting only with a mail order catalog, the company used classy editorial-looking models and photos, resembling the pages in fashion magazines, to establish his brand. Highly successful at the outset, the company ran into problems in the late '90s and under new ownership, ultimately hired the dynamic Millard "Mickey" Drexler as C.E.O, who had been best known for growing jeans retailer Gap into a giant denim lifestyle line. Since assuming the reins at J. Crew in 1999, Drexler, who is known to travel around the office corridors on a bicycle, has turned J. Crew into a preppy behemoth, converting what had been a mail-order business into a retailer with slews of locations plus a gigantic online presence.

Most importantly, J. Crew has developed a reputation for "preppy with a twist," tweaking their clothes with a sexiness, shape, and style that has not been seen in the

135

Jazz Age Lawn Party: boaters, braces and blues on a summer afternoon, Governor's Island, New York.

ABOVE:

Michelle Obama Princeton 1985, Harvard Law,1988, knows how to dress in a relaxed, but First-Lady-like-way, often mixing formal and casual. She wears a pale sequined J. Crew cardigan over an ivory top and a sharply tailored, textured skirt.

OPPOSITE:

Malia and Sasha Obama at their father's inaugural ceremonies, January 2009. President Barack Obama's daughters wore coats from J.Crew's Crewcuts collection: Malia in periwinkle blue and Sasha in an orange-pink combo.

RIGHT:

"Innocents Abroad," the theme of the sensational A&F Quarterly, 1999: he wears a weathered A&F sweatshirt and a long-sleeved Henley shirt with utility pants; she wears cardigan sweater embroidered with delicate flowers over a camisole.

OPPOSITE:

The mix of contrasting elements are the yin and yang of prep: cargo shorts, rumpled shirt and tie, grounded by a tweed blazer, 2000.

classic, somewhat androgynous preppy culture. According to the company's Creative Director and President Jenna Lyons, J. Crew is all about classic things mixed a certain way . . . polo shirt, khakis, blazers, white shirts—but the secret is in the way they are presented. Lyons is responsible for making the look modern, more feminine, a little more embellished, and more "Euro" than the usual prep, but also approachable and affordable. Her edited looks are the essence of evolved preppy. On the J. Crew men's side, Frank Muytjens has focused on a cleaned-up preppy look, leaning toward authentic Ivy League, but mixing high and low and trying to make it look effortless. In a nod to iconic American brands, J. Crew, in addition to its own designs, also curates some stalwart "heritage" brands like Russell Moccasins, Red Wing, and Alden shoes—classic items the store feels are too perfect to be improved upon.

Abercrombie & Fitch, one of the great heritage brands, started out as a prestigious American sporting goods retailer, known and respected for outfitting professional sportsmen (and sportswomen) since 1892. The landmark store enjoyed almost a hundred years as *the* purveyor of clothing and gear to explorers and adventurers such as Teddy Roosevelt, Robert Peary, Ernest Shackelton, and Amelia Earhart—as well

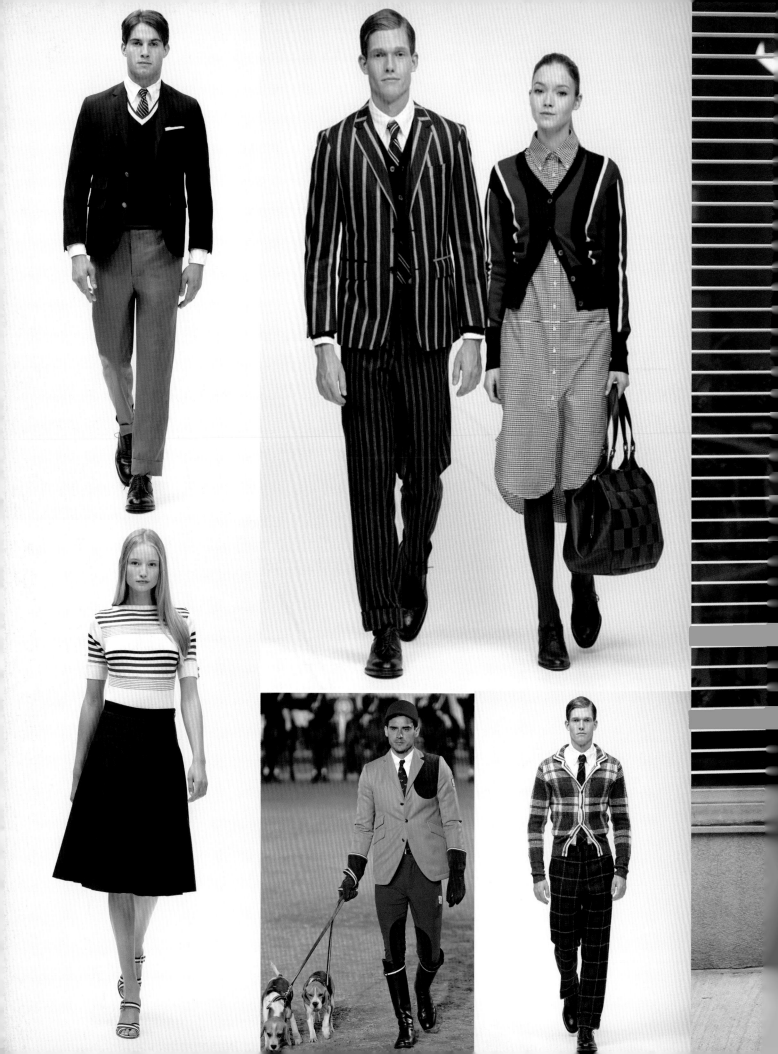

as Hollywood luminaries Greta Garbo, Clark Gable, and legions of others. One of the reasons for Abercrombie & Fitch's initial success in the early part of the twentieth century was the store's development of a clever marketing tool: in 1909 they produced a 456-page store catalogue which they mailed to 50,000 names worldwide, at the then-enormous cost of $1 per book—a move that nearly bankrupted the company. The catalogue was brilliant; it featured not only outdoor clothing and camping gear, but also articles, advice columns, and tips for sailing, camping, or setting out to explore Antarctica, equipped, of course, with Abercrombie and Fitch goods. Thus, the catalogue set a personality, tone, and standard of excellence for the store, creating an exclusive culture that was beloved for decades. But by the early 1970s, market and social changes had rendered A&F somewhat of a retail dinosaur.

In 1988, Limited Brands bought the company and installed Michael Jeffries, a brilliant, detail-obsessed retail executive, who has radically revolutionized the Abercrombie & Fitch image. Under Jeffries' direction, A&F has become a preppy lifestyle brand, marketed to an idealized, upscale, American collegiate audience with a fondness for the great outdoors. Jeffries hired attractive sales staff and managers to create excitement and underline the brand's "cool factor." In a move that echoed that of the A&F founders, in 1997, he launched a "magalog" (a hybrid magazine/catalogue) called the *A&F Quarterly*, available free to its customers, or sold to those 18 and over at newsstands. The *Quarterly*, shot by legendary photographer Bruce Weber, was an instant hit with its hip articles and sexy, provocative models and clothes, but it didn't score points with parents and religious groups who threatened to boycott Abercrombie & Fitch stores everywhere if the magalog didn't tone down its racy presentations and controversial articles. A&F halted publication of the book in 2003, but by summer of 2010, the magalog was revived, full of gorgeous photographs and convention-flouting content. Abercrombie & Fitch seems to have a real handle on its young customer: what could be more appealing than inviting controversy?

Designer Thom Browne has engaged prep in an eccentric way. His conservative but quirky take on menswear has received both cheers and jeers from his audiences but is universally recognized as having supplied a much-needed injection of fresh and original ideas into the men's clothing business. A fan of late '50s, early '60s Ivy League suits, Browne used to wash his vintage suits then shrink them in the dryer in order to get the look he desired. Now he designs his own ultra-slim, oddly-proportioned suits,

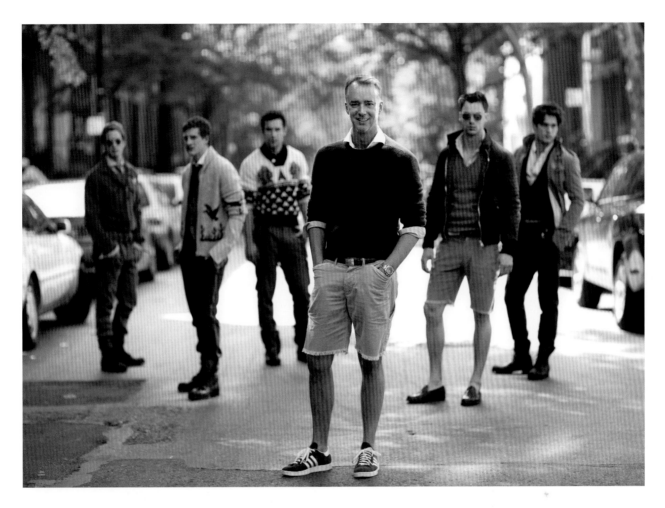

A study in the unstudied: designer Michael Bastian describes his namesake collection as being "a little broken down and familiar" as he mixes relaxed, "cuffs-rolled-up" sportswear pieces with sharp tailoring to create an Ivy look that is both nonchalant and easy to live in, Fall 2009.

Black Fleece by Brooks Brothers has the all quality and spirit you'd expect from the traditional brand, made modern with new spareness and proportions designed by Thom Browne. The huntsman in tailored and technical jacket and jodhpurs is Thom Browne for Moncler Gamme Bleu, 2011.

The talented Thom Browne in the shorter, slightly shrunken proportions he has pioneered.

which are sometimes composed of a 27" jacket (the norm is 30-31" and up), sleeves stopping mid-wrist, a hem stopping short of covering a man's backside, and flat-front pants that could be labeled "high water" or "floods" as they end above the ankle. His stock-in-trade is a three-button suit with narrow lapels that roll to the center button and trousers without belt loops. The look is '60s sleek, yet geeky at the same time, but his work has earned Browne serious fashion accolades, including the prestigious

CFDA Menswear Designer of the Year Award in 2006. Browne's clothing hedges between the radical and the traditional but has developed enough of a following that no less than the most established of American men's clothiers, Brooks Brothers, has partnered with him to create Black Fleece. The small specialty collection successfully combines Browne's distinctive proportions with Brooks' solidly traditional point of view; in this case, that means the pants actually do meet the tops of a man's shoes. He has also recently launched a slim-lined collection for women which has a vaguely aristocratic, intellectual appeal and a feminine fit.

Heritage is a word that is bandied about with some abandon in the current prep climate. Much heralded "heritage" brands like Woolrich Woolen Mills, L.L. Bean, Pendleton, and Gant have helped form the basis of American preppy style and contributed to its longevity—in some cases for over a hundred years—organically growing their products into virtual American icons. Gant, the shirtmaker founded in 1949, is said to have invented the so-called "locker loop" on the back of button-down oxford shirts, has opened a new campus store right next to Yale in New Haven, where their shirt factories had long been located. Along with vintage memorabilia, they are selling the notion of their authenticity and their longtime association with Yale, where their shirts were sold in the Yale Co-op fifty years ago. In addition to fortifying their authentic image, Gant has also joined forces with menswear designer Michael Bastian, former men's fashion director at Bergdorf Goodman, whose athletic American aesthetic

*Rachel McAdams bundled up in
a military-inspired Smythe coat, a
paisley scarf, and booted in classic
L.L. Bean, 2009.*

meshes perfectly with that of the shirtmaker. Bastian has used a lacrosse stick as his motif, with the hopes of creating a logo for Gant that is as identifiable as Ralph Lauren's polo–player. He's designed a relaxed but sophisticated collection of men's sportswear and a brand new mini-collection for Gant Women. No, the women aren't wearing smaller versions of Gant men; Bastian has given them a soft, sensual look, more geared to the Gant guy's girlfriend than to his little sister. The partnership is perfect: Bastian brings buzz to the shirtmaker, and Gant brings an expanded audience to Bastian.

In 2006, Michael Bastian launched his own label because he "was not able to find classic American things you think are out there but really aren't." His namesake collection is filled with sleek menswear which he describes as "a little broken down and familiar"—a quality he achieves by "starting with something perfectly designed and executed, then knocking the edge off."[2] Bastian is celebrated for the "unstudied" nature of his clothes, which often pair razor-sharp tailoring with relaxed "cuffs-rolled-up" sportswear, a conceit which has been at the core of preppy since its inception.

Like so many of his countrymen, Japanese designer, Daiki Suzuki, known for his innovative Engineered Garments, has always had an enormous respect for American ivy style. Recently, he has mined the century-old heritage brand Woolrich Woolen Mills, distilling its essence, then making it spare and modern. Using Hudson Bay stripes and hunting plaids, the designer created surprisingly tailored looks in stark '70s colors. North Carolina-born Mark McNairy, who has honed his craft designing for both traditionalist J. Press and Engineered Garments, assumed the reins as creative director of Woolrich in 2010 and decided to experiment with proportion and shape. For the moment, he is eschewing buffalo checks and nudging the revered label into '50s and '60s-inspired looks that include camouflage, military, and ivy, lending some worldliness to the woodsiness. McNairy has also launched a new company: Mark McNairy New Amsterdam (as in the name the Dutch settlers gave to New York), a small collection of clothes and accessories in the Anglo-American tradition—skinny cargo pants, blazers, button-down shirts, and ties. McNairy's style is gathered from a hodgepodge of Ivy style, workwear, and U.S. military inspirations; he has also applied his aesthetic to footwear including smartly-tweaked versions of brogues, boots, loafers, and bucks.

Heritage brand L.L. Bean, anticipating its centennial next year, is mining its archives as well, having installed former Polo Ralph Lauren associate Alex Carleton to helm a designer collection offering leaner, more modern versions of some of the all-time

LEFT:

Preppy soars to new heights: Tommy Hilfiger's sexy and wildly successful "reboot" of the Duck classic on a sky-high heel with suede uppers that lace up to over the knee.

OPPOSITE:

"The Hilfigers," the fictional and dysfunctional family stars in Tommy Hilfiger's spring 2011 advertising campaign at the "El country club de la clubius" where sports and sporting clothes take over. Shown, Noah in a seersucker suit and madras tie with Chloe, the preternaturally sophisticated youngest of the clan, in a blue button-down shirt, vanilla shorts, loafers, and striped duffel.

*Jack Wills Nordic
sweaters, Winter 2010.
Britain's popular prep
purveyor specializes in
the "hedonistic university
life-style" with layers of
preppy clothes: rugby
shirts, tweeds, tartans,
sweaters, denim, and
sweats—all cheerful, age-
appropriate, and slyly,
but not overtly sexy.*

Bean classics with a focus on quality and fit (which at L.L. Bean is somewhere between your dad's baggy khakis and a contemporary European cut). The good old Downeaster ruggedness is there—but it has developed a tad of sophistication.

Tommy Hilfiger certainly has learned how to appeal to his customer. A die-hard music-lover, Tommy's business (founded in the early '80s) really started to rock when he plugged into the music world to market his label. His brilliant marketing initiative in 1994 started with popular rap artists such as Snoop Dogg, who wore Hilfiger's baggy jeans and logo'd jerseys while performing, and even included Hilfiger's name in his lyrics. Tommy suddenly developed street cred and gained a whole new audience. Clothing and shoe manufacturers, hoping to pick up on the urban youth trends, sent people into inner-city neighborhoods to determine what the kids thought were cool. Hilfiger also kept the music rocking (and the cash registers ringing) by establishing alliances with artists like Britney Spears, Lenny Kravitz, and The Who, and even sponsoring The Rolling Stones' "No Security" Tour.

By the time the urban kids moved on, Hilfiger, ever-inventive, developed a fast-growing European business, largely by returning to his preppy roots. He believes, "the future of preppy is evolution—retaining its heritage, but twisting and shaping it to make it new for new audiences."[3] His widely-acclaimed advertising campaign for fall

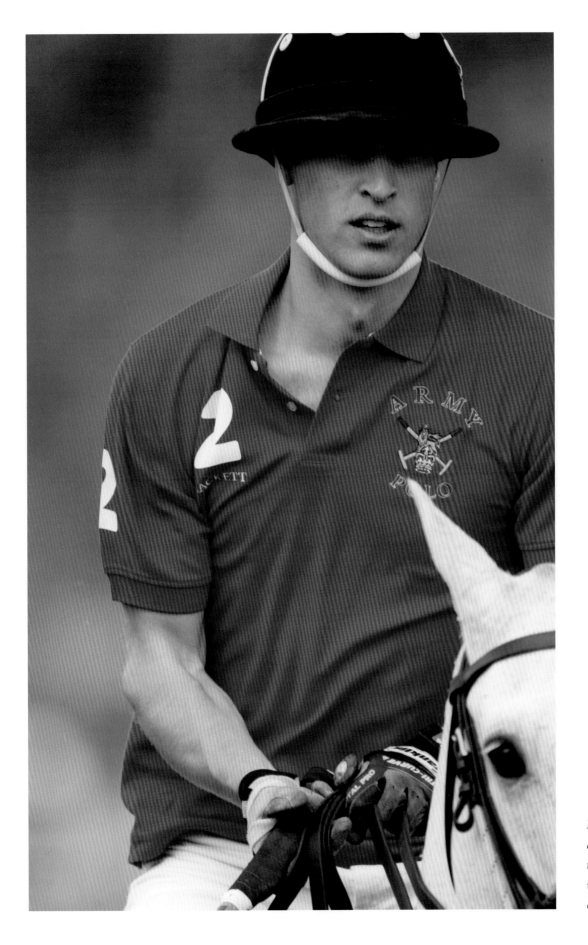

Prince William plays on a Hackett-sponsored polo team in scarlet polo shirt with the Hackett logo emblazoned, 2007.

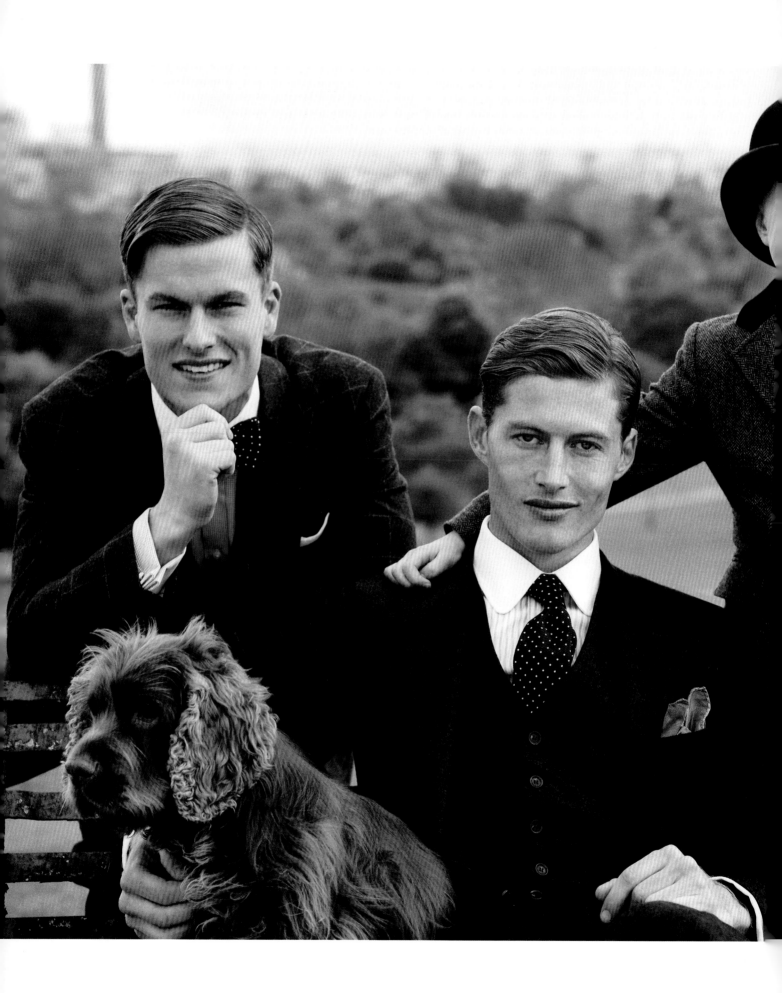

2010 is a case in point. An imaginary family called "The Hilfigers," attractive, dysfunctional, multi-generational and multi- racial, all dressed in slightly subverted preppy clothes, celebrate the holidays by tailgating with their vintage Wagoneer woody. The youngest child, wearing outsized sunglasses, gets behind the wheel and drives off, and the family, laughing, follows in hot pursuit. It is Hilfiger's take on preppy: inclusive, full of style, family, spirit, color, adventure, and fun.

Across the pond in England, where preps and their Brit counterparts "Sloane Rangers"[3] own a certain kind of style: Jack Wills, a small chain of British shops founded by Peter Williams and Robert Shaw cater to what they call the "hedonistic university lifestyle," i.e., the preppy demographic. A relative newcomer to the scene, having opened its doors in 1999, Wills has been thriving in England, where they've opened shop mainly in university towns and affluent neighborhoods, appealing to customers within cantering distance—including Prince William, Kate Middleton, and Prince Harry. Recently, Jack Wills has hopped the pond and opened shops in Prep towns such as Nantucket, Martha's Vineyard, and in college-bountiful-Boston.

Extolling the virtues of what they call the "fabulously British" look for young men and women, Jack Wills stores are hardly distinguishable from those of Abercrombie and Fitch, with an emphasis

Brit-prep: Hackett's dapper Sloan Ranger-style dressing, from the country that invented tweed and... bowlers. And one of Jeremy Hackett's beloved Sussex spaniels, whose initials are engraved on his master's cufflinks.

Scott Sternberg, guru of geek prep, used to dress in head-to-toe Ralph Lauren. His Band of Outsiders collection, launched in 2004, is filled with shrunken and quirky twists on preppy. Because women like his menswear so much, he also initiated a women's line aptly named "Boy."

on bright rugby shirts, tweeds, sweats, and denim, layering. The crew of "cool kid" salespeople are all clothed from head to toe in the company's goods. The feeling is one of clean, age-appropriate stuff—innocently, not overtly sexy. And of course, there's the hint of at least a little old-fashioned elitist British charm. Unlike many of their competitors, Wills chooses not to spend money on expensive advertising or catalogues, but rather they dispatch their trained emissaries, called "*seasonnaire*s," to different ski resorts in the Swiss Alps or the beaches of Nantucket in the summer to hand out flyers and free logo-branded merchandise, play beer-pong, and invite kids to join them at Wills-sponsored parties which often take place at the local Jack Wills shop. It's a personalized form of public relations that seems to have a similar effect as the social media networks, without quite the same volume. Wills gets high marks for linking up with the Harvard and Yale polo teams in the U.S. and collaborating with various varsity teams at Oxford and Cambridge. In the end, they are following the Ivy trail back to where it began—on the green athletic fields of the best universities in the world.

Another emporium of Brit-prep is the genteel Hackett: the purveyor of stylish men's clothes and accessories, founded in 1983 by Jeremy Hackett and Ashley Lloyd-Jennings. Both men had been salesmen on Savile Row and spent weekends combing the Portobello antiques market to find the classic clothes that had presumably been given away by British gentlemen who had moved on to "swinging '60s" style. Starting out

as a used clothing store, Hackett gradually moved into designs of their own, featuring sumptuous tweeds and beautifully tailored city suits, as well as lots of military and sport-inspired clothes, like the polo shirt Prince William wears when he plays for the Hackett-sponsored British Army team. Now in over 60 free-standing shops worldwide, the true-Brit brand is totally reflective of the witty and dapper Mr. Hackett himself, who looks to be straight out of central casting, complete with Sussex spaniels whose names are engraved on his personalized cuff links. The secret of his success, he maintains, is to walk a fine line between heritage and nostalgia.

One of the most-watched newcomers to prepdom is Scott Sternberg, helmsman of Band of Outsiders, who started his career as a talent agent for Creative Artists Associates in Hollywood and, after seven years, decided to apply his own considerable talents to starting a fashion label. BOA began in 2004 and by 2009 had already racked up a CFDA award for "Best Menswear Designer" for Sternberg's edgy prep collection for men—known for its "indie-cool" vibe, featuring shrunken proportions and hand-sewn seams. He's since added two separate labels: Boy—a menswear-inspired line for women; and most recently, Girl—a lower-priced collection with softer, more feminine touches that's garnered raves for its sexy-in-a modest-way appeal. Cultivating his "outsider" image, Sternberg insists on living in Los Angeles, citing his need to be out of the fashion vortex in order to create. As he confessed to *The Wall Street Journal*, "If I was in New York, in this mix influenced, by the same things all these people are influenced by, the edge would be gone."[4] Judging by his talent so far, Sternberg, whose idiosyncratic collections have been popular in the U.S. and stratospheric in Japan, will be continuing his upwards trajectory. He has recently launched a line of fitted polo shirts, fittingly entitled: "This is not a polo shirt."

Nearly a century after the Ivy Leaguers of the 1920s created the paradigm for preppy style, its sustainability seems secure. While both global and social changes have broadened the collegiate environment to include students of all races, ethnicities, and genders, those leafy Ivy campuses still breed the penchant for school spirit, peer pressure, and the casual, athletic looks that stamped the original Ivy Leaguer. As preppy progresses from generation to generation, ever widening its field, those of us who have been *stamped* by it will always "have it" in some way: a nostalgic nod to our youthful student years, or simply an appreciation of the unstudied, seeming classic style— American to its core.

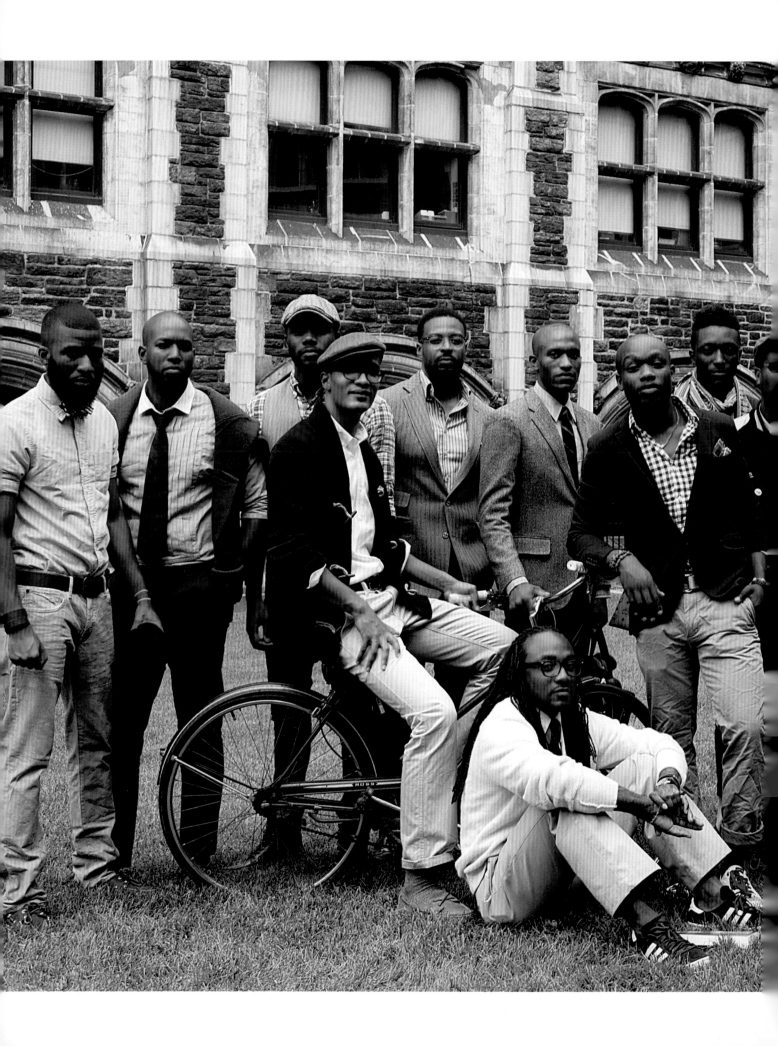

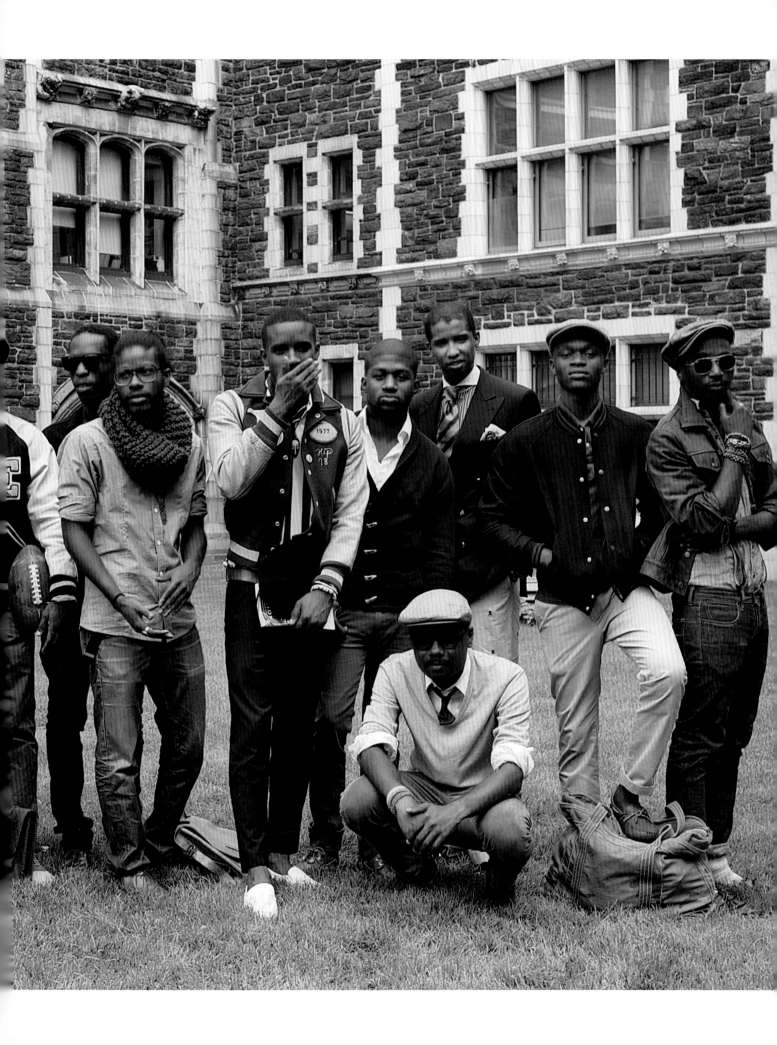

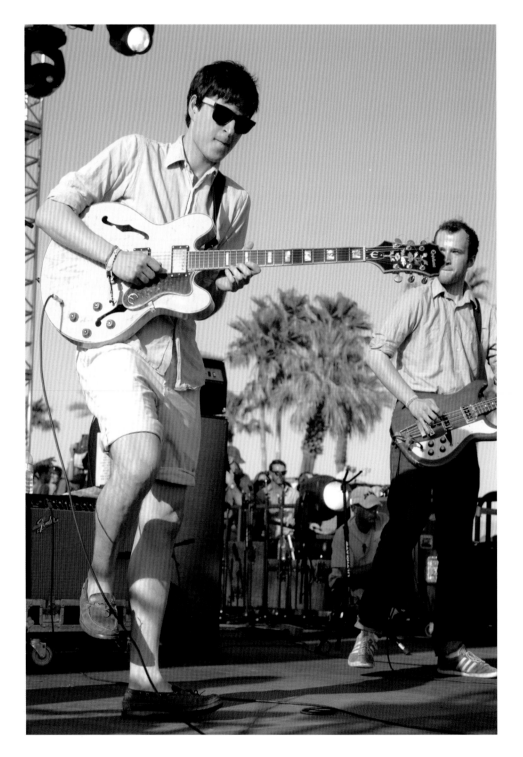

PREVIOUS PAGES:

Black Ivy: Joshua Kissi and Travis Crumbs of the style blog "Street Etiquette" decided to do their own take on Ivy, this time celebrating the inclusion of larger numbers of minority students on campuses today.

ABOVE:

Vampire Weekend, famous for their music and their Ivy League (Columbia) roots and style.

OPPOSITE:

Leighton Meester and Chuck Bass in Gossip Girl, *the television series about privileged Manhattan preppies.*

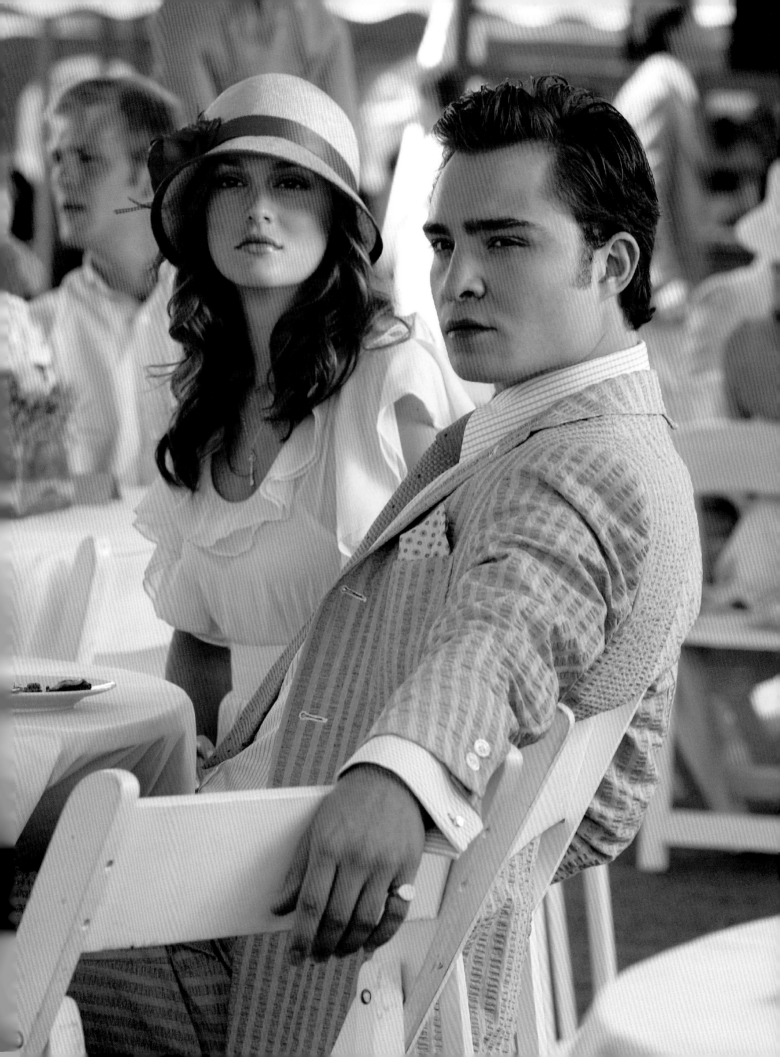

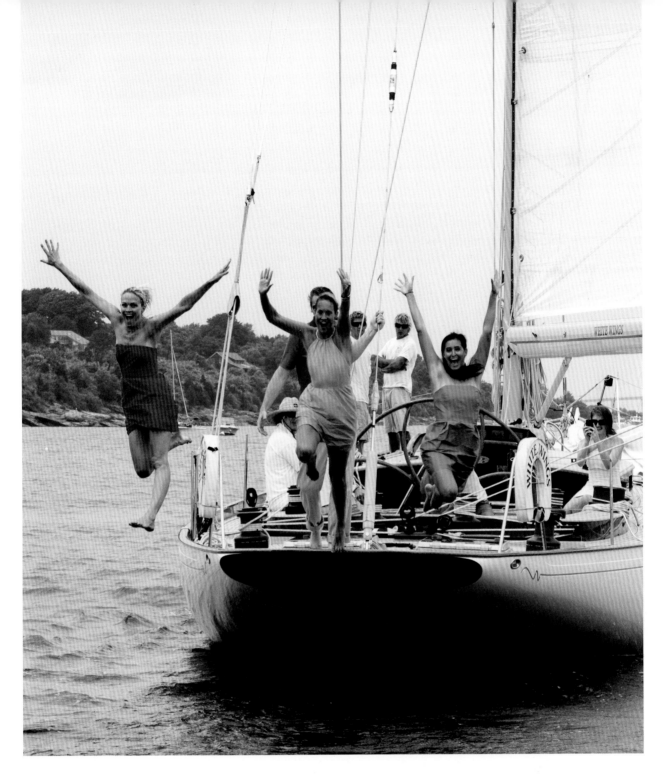

ABOVE:

Women overboard! Camilla Bradley and friends hit the water in a flotilla of CK Bradley's fun, floaty summer dresses, summer 2010.

OPPOSITE:

Murray's Toggery on Nantucket (official creator of the fabled fade-able Nantucket Reds) opened its doors in 1945. At the time, Nantucket Reds were just cotton canvas pants, hardy enough to weather the rigors of sailing. If they faded, it was because you wore them a lot and the sun and salt water did their work. As the faded pants became a sign of sailing cred, a clever manufacturer decided that, like jeans, Nantucket Reds could be distressed to look as though they were salt-worn .

NOTES

162

INTRODUCTION

1 Deirdre Clemente, "Caps, Canes, and Coonskins: Princeton and the Evolution of Collegiate Clothing, 1900-1930." *The Journal of American Culture*, 2008. High Beam Research.

2. Chris Hogan, "The Roots of American Preppy." September 9, 2010. http://offthecuffdc.com/roots-american-preppy-redux.

3. Noah Feldman, "The Triumphant Decline of the Wasp," *The New York Times*, June 27, 2010.

THE "GOOD BREEDING" GROUNDS

1 F. Scott Fitzgerald, "Winter Dreams," Metropolitan magazine, 1922.

2. The term Ivy League is used to reference a selective group of institutions comprised of eight of the oldest, most prestigious northeastern colleges and universities in America, including Harvard, Yale, Princeton, Dartmouth, Columbia, Cornell, Brown and the University of Pennsylvania. While the term "Ivy League" literally refers to the intercollegiate athletic conference in which the schools participate, it has also long stood for academic excellence, high selectivity of admissions and social prestige.

3. Clemente, "Caps, Canes and Coonskins: Princeton and the Evolution of Collegiate Clothing, 1900-1930," *The Journal of American Culture*. 2008.

4. Ibid.

5. F. Scott Fitzgerald, *This Side of Paradise*. (New York: Scribner and Sons, 1925).

6. Clemente.

7. Richard Martin and Harold Koda, *Jocks and Nerds, Men's Style in the Twentieth Century*. (New York: Rizzoli International Publications, Inc., 1989).

8. Clemente.

LEGACY OF THE SPORTSMAN AND THE LEISURE CLASS

1. Suzy Menkes, *Windsor Style*. (Topsfield: Salem House Publishers, 1988).

2. Martin and Koda, *Jocks and Nerds, Men's Style in the Twentieth Century*. (New York: Rizzoli International Publications, Inc., 1989). 116.

PURVEYORS TO THE PRIVILEGED

1. John William Cooke, *Brooks Brothers Generations of Style*. (New York: Brooks Brothers, Inc., 2003).

2. Ibid., 51.

3. Ibid., 82.

4. "How Mad Men Became a Style Guide," August 1, 2008. http://www.guardian.co.uk/culture/tvandradioblog/2008/aug/01/youdonthavetowatchmadmen

5. John Szwed, So What: The Life of Miles Davis. (New York: Simon &Schuster Paperbacks, 2002). 200.

6. Christian Chensvold, "The J. Press Interview," July 13, 2009. http://www.ivy-style.com/tradition-and-change-the-j-press-interview.html.

7. Ibid.

8. Martin and Koda, *Jocks and Nerds, Men's Style in the Twentieth Century*. (New York: Rizzoli International Publications, Inc., 1989). 137.

9. Chris Hogan, "J. Press: As Classic as You Can Get," July 22, 2008. http://offthecuffdc.com/j-press-as-classic-as-you-can-get.

10. Tom Wolfe, *Mauve Gloves and Madmen, Clutter & Vine*. (New York: Farrar, Straus, Giroux).

11. Paul Winston, interview by authors. December, 2010.

12. W. David Marks, "The Man who Brought Ivy to Japan," August, 2010. http://www.ivy-style.com/the-man-who-brought-ivy-to-japan.html.

13. David Colman, "The All-American Back From Japan," *The New York Times*, June 17, 2009.

BORROWING FROM THE BOYS

1. John William Cooke, *Brooks Brothers Generations of Style*. (New York: Brooks Brothers, Inc., 2003). 83.

2. Lynn Peril, *College Girls*. (New York: W.W. Norton & Sons, 2006). 123.

3. Lee Smith, "The Bubba Stories," *New Stories from the South*. (Algonquin Books: Workman Publishing, 1992).

4. In the 1950s and 1960s charm bracelets provided a personal profile of a preppy girl's life: her trips to Paris and Sun Valley and Nantucket, her love of sports, especially sailing, but also riding and tennis and skiing, her school pennant, her monogrammed signet ring, her faithful wheels, and her hard-earned diploma. Along with preppy fashion, charm braclets are enjoying another round in the 2010s.

ASPIRATIONAL PREPPY

1. Kevin McLaughlin, interview by authors, January 2011.

2. Lisa Birnbaum, The Official Preppy Handbook. (New York: Workman Publishing Co., 1980). 213.

3. Lisa Birnbach, quoted by Christian Chensvold, "The Lisa Birnbach Interview," April 29, 2010. http://www.ivy-style. com/preppy-evangelist-the-lisa-birnbach-interview.html

EVOLVED IVY

1. Simon Doonan, Linda Wertheimer interview, "Did Sleaze Bring Preppy Back?" National Public Radio, September 10, 2010.

2. Michael Bastian, interview by authors, January 2011.

3. Tommy Hilfiger, telephone interview by Jeffrey Banks, February 2011.

4. Sloane Rangers: the preppies across the pond are stereotypically well-bred young English women and men from the Upper Class who share distinctive similarities. The term comes from the posh neighborhood in London near Sloane Square where many of the "Sloanies" live. They are portrayed as conventional, conservative, and insular, (Princess Diana was considered the prototypical "Sloanie"), but as with their American preppy counter-parts, their profile has expanded to include a wider range of interests.

5. Ray A. Smith, "Can an Outsider Cash In?" March 27, 2010. http://online.wsj.com/ article/SB10001424052748703734504575 125742268568652.html.

PHOTO CREDITS

Pages ii: courtesy of Ralph Lauren; iii, 78, 80–81, 102, 122, 162–163, 165: Thom Gilbert; iv–v, 46 top: courtesy of The Breakers Palm Beach; vi: Christopher Leidy; 2, 14, 22, 24–25, 108, 110,112–114, 120–121, 123, 138–139: Bruce Weber; 3 left, 45 right, 64, 66, 68–70, 89 bottom, 140 left, top, and bottom right: courtesy of Brooks Brothers; 3 right, 104, 105 bottom: photo by Betty Kuhner, courtesy Lily Pulitzer; 5: courtesy of Groton School; 8 left: the debonairextraordinaire; 8–9: Oliver Fluck; 10–11, 29 right, 45 left, 65, 72, 97 top, 103, 131: Corbis; 12, 56, 137: AP Photo; 13, 106: Courtesy of the Rumbough Family; 15, 17–19, 30 bottom, 31 middle left, 32, 35–36, 38, 41 bottom, 42–43, 47, 51–52, 54–55, 57–58, 60–63, 73–75, 77, 79, 86, 91, 93, 101, 107, 109, 133, 136: © Getty Images; 16: Photo by Mary Randolph Carter, courtesy of Ralph Lauren; 20, 87 right, 127: Photofest; 21 top, 148–149: photos by Craig McDean © Tommy Hilfiger; 21 bottom, 67, 99, 117, 119: Everett Collection; 26: First View; 27, 134: © Scott Schuman; 28, 40: Illustrations by Joseph Christian Leyendecker © 1998 by the National Museum of American Illustration™; 29 left, 33, 37: © Princeton University; 31 bottom left, 44, 53: Library of Congress; 31 bottom right: courtesy of Yale Sports; 46 bottom: Courtesy of Eric Woodward; 49: Photograph by Jacques Henri Lartigue © Ministère de la Culture – France / AAJHL; 50: Lacoste, Rights Reserved; 85: Timothy Greenfield-Sanders; 87 left: Courtesy of Jack Rogers USA; 89, 92, 100: courtesy of Skidmore College; 90: The Smithsonian; 94: John Rawlings, *Vogue*, 1949 © Condé Nast Publications; 95: photo by Phillipe Halisman, courtesy of Brooks Brothers; 98: Santo Forlano, *Glamour*, 1967 © Condé Nast Publications; 105 top: Slim Aarons © Getty Images; 109: Photo by Ted Hardin, courtesy of New York Magazine;116, 118: Courtesy of Alexander Julian; 124: Photo by Curtis Hemmert, courtesy of J. McLaughlin; 125 top: Photo by Patricia van Essche, courtesy of J. McLaughlin;125 bottom: Courtesy of Shep Miller; 126: Courtesy of Sal Cesarani; 128–129: Erica Lennard; 130: David Turner, *WWD*, 1996 © Condé Nast Publications; 132: Arnaldo Anaya, courtesy Ralph Lauren; 133 right, 141: Courtesy of Thom Browne; 140 bottom center: Courtesy of Moncler; 143: Michael Falco; 144: Lee Clower; 145: Mordechai Rubinstein; 146: Splash News;150: Courtesy of Jack Wills; 152–153: Photo by Garda Tang, Courtesy of Hackett; 156–157: "The Black Ivy" by Street Etiquette photo courtesy of Fred E. Castleberry; 160: Photo by Fred.E Castleberry; 169: Photo by Fred.E Castleberry, courtesy of Kiel James Patrick; endpapers, front (left center): courtesy of Sperry Top-Sider.

ONLINE PREP

BLOGS

While researching our book, we have come across some outstanding blogs that specialize in the often-arcane world of preppy. All of them are informative and well written, and most seem to have that mix of knowledge, quirkiness, taste and irony that one might associate with preppy. These are our faves.

A Continuous Lean
www.acontinuouslean.com

Black Watch
42ndblackwatch1881.wordpress.com

Confessions of a Preppy Princess
preppyprincess.wordpress.com

Dandyism.net
www.dandyism.net

Deanna Littell's Charm School
www.deannalittellscharmschool.com

Esquire
www.esquire.com/blogs

Garden & Gun
gardenandgun.com

GQ: Look Sharp, Live Smart
www.gq.com

Ivy Style
www.ivy-style.com

Manner of Man Magazine
mannerofman.blogspot.com

Meet the Hilfigers
usa.tommy.com

Mister Mort
mistermort.typepad.com

New York Social Diary
www.newyorksocialdiary.com

Of Rogues and Gentlemen
blog.brooksbrothers.com

Off the Cuff
offthecuffdc.com

Sartorially Inclined
sartoriallyinclined.blogspot.com

T Magazine Blog
tmagazine.blogs.nytimes.com

The Ivy League Look
theivyleaguelook.blogspot.com

The Rake
therakeonline.com

The Selvedge Yard
theselvedgeyard.wordpress.com

The Trad
thetrad.blogspot.com

Unabashedly Prep
www.unabashedlyprep.com

Valet: Style
www.valetmag.com/style

Wasp 101
wasp101.blogspot.com

PREPPY STORES

The Alan Flusser Custom Shop
www.alanflussercustom.com

Alden of New England
www.aldenshoe.com

Alexander Julian
www.alexanderjulian.com

Band of Outsiders
www.bandofoutsiders.com

Barbour
www.barbour.com

Belgian Shoes
www.belgianshoes.com

Cesarani
www.cesarani.com

Chipp 2
www.chipp2.com

Gant
www.gant.com

Hackett
www.hackett.com

Hunter
usa.hunter-boot.com

J. McLaughlin
www.jmclaughlin.com

J. Press
www.jpressonline.com

Jack Rogers
www.jackrogersusa.com

Jack Wills
www.jackwills.com

Kiel James Patrick
kieljamespatrick.com

Lilly Pulitzer
www.lillypulitzer.com

LL Bean
www.llbean.com

Mark McNairy
www.markmcnairy.com

Michael Bastian
www.michaelbastiannyc.com

Saks Fifth Avenue
www.saks.com

Sperry Topsider
www.sperrytopsider.com

Stubbs & Wootton
stubbsandwootton.com

T. Anthony LTD
www.tanthony.com

Ralph Lauren
www.ralphlauren.com

ACKNOWLEDGEMENTS

168

The authors would like to thank those listed here whose contributions were vital to the making of the book:

Rizzoli, our publisher; especially Allison Power, our editor, who is so aptly named: for power steering our efforts, working diligently and making strong choices with a gentle voice; and Anthony Petrillose, for his impeccable taste.

Mark McVeigh, our agent, for his diplomatic skills and gentlemanly mien.

Lilly Pulitzer, the lovely Lady who launched a thousand Lillys—an early Preppy icon whose *Foreword* graces our book and whose Lillys are the eternal reminder that "it's always summer somewhere." And to Paul Prosperi for his masterful assistance.

Joseph Montebello and Jason Snyder for beautifully shaping the look of this book.

Eric Rachlis and Marcia Hoffman at Getty Images for their tireless quest for the hard-to-find photographs we sought.

Shawn Waldron at Conde Nast for his good-natured patience.

Ralph Lauren, Mary Randoph Carter, Melissa Pathay, and Charles Fagan of Polo Ralph Lauren for allowing us to mine their archives.

Brooks Brothers' Arthur Wayne and Dana Schiller for providing us with limitless resources.

The designers and their staffs: Tommy Hilfiger, Alexander Julian, Alan Flusser, Sal Cesarani, Thom Browne, Mark McNairy, Michael Bastian, and the Perry Ellis Group for sharing their archives.

Bruce Weber, Nathan Kilcer, and Sam Shahid for their generosity in granting our continuous requests.

Paul Winston of Chipp2/Winston Tailors who shared both his colorful clothing and colorful anecdotes in the most good-natured way.

Kevin McLaughlin of J. McLaughlin whose entire team pitched in on every front.

The people at universities, colleges, and schools who were generous with their time and patience in dealing with our requests: especially, Wendy Anthony at Skidmore College; John Niles at Groton School; and Elizabeth Patten at Princeton University.

Thom Gilbert for his fine photographic contributions.

Marc Fowler for his impressive IT skills.

Our friends and families who were kind enough to share their precious images with us: especially Cole Rumbough and Dianne Warner who provided generations of extraordinary family photos; in addition, Susan Andelman, Eleanor Banks, Joyce Bullen-Gay, Pamela Clarke Keogh, Margaret Knowlton, Gary Martinelli, and Jeanne Shea Russo.

169

First published in the United States of America in 2011
by Rizzoli International Publications, Inc.
300 Park Avenue South
New York, NY 10010
www.rizzoliusa.com

2014 2015 2016 / 10 9 8 7 6

Distributed in the U.S. trade by Random House, New York

Printed in China

ISBN-13: 978-0-8478-3661-1

Library of Congress Catalog Control Number: 2011927521

Design: Jason Snyder

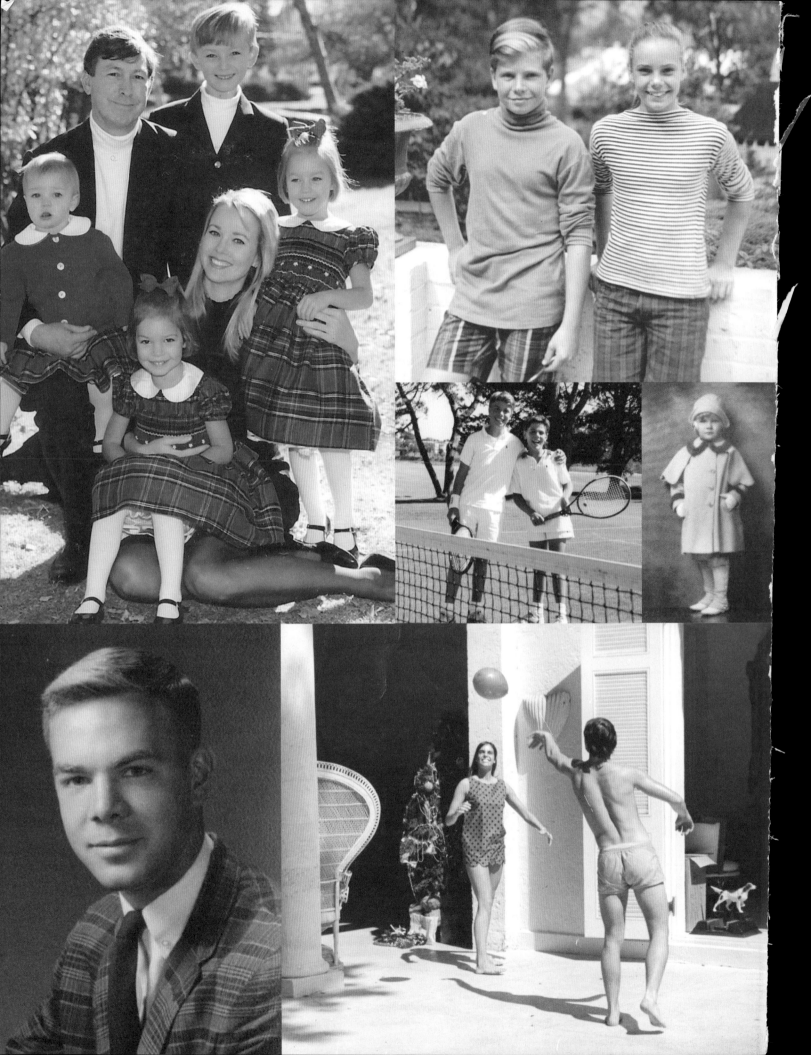